Studies in Medieval Sculpture

Edited by F. H. Thompson

NON EXTINGVETVR

SOCIETAS LONDINI REI ANTIQVARIÆ STVDIOSA
Ian: A⁰ MDCCXVIII

Occasional Paper (New Series) III

THE SOCIETY OF ANTIQUARIES
OF LONDON

BURLINGTON HOUSE, PICCADILLY, LONDON W1V 0HS
1983

TYPESET BY BISHOPSGATE PRESS
PRINTED BY WHITSTABLE LITHO

Contents

Editorial Note

The third in the series of one-day seminars organised by the Society of Antiquaries was held on 10th October 1980 and was devoted to an art-historical theme, recent work on medieval sculpture in the British Isles. Professor George Zarnecki, F.S.A., acted as general chairman, and the three sections, Pre-Conquest, Romanesque, and Gothic, were in turn chaired by Professor Rosemary Cramp, F.S.A., Dr. Alan Borg, F.S.A., and Mr. Neil Stratford, F.S.A. Ten speakers, all younger research workers in their respective fields, were invited to contribute papers and have since submitted them for publication. In addition, a simple exhibition of recently discovered material was mounted, and the opportunity has been taken to incorporate accounts of this in a final section. We express our sincere thanks to the chairmen for presiding and also for their contributions to this volume, to the speakers who both charmed and informed their listeners, and to those who supplied material for the exhibition.

The seminar was never intended to be comprehensive in its coverage but rather to give an indication of work in progress on different fronts. The enthusiasm of the audience and the willingness of the speakers to publish are, we hope, an augury of good things to come.

March 1982

F. H. THOMPSON
General Secretary

vi

Illustrations

viii

x

Prologue

The majority of the papers in this book were read at the Medieval Sculpture Seminar organized by the Society of Antiquaries on 10th October, 1980. Since then, the authors have had a chance to modify their texts in the light of the discussion which took place on that day, or to expand them slightly if new evidence required it. One or two authors, who did not take part in the Seminar, were invited to contribute short articles on the most recent discoveries.

The papers included here vary considerably in character and approach: some are the result of considerable research, others are hardly more than preliminary notes. However, all of them are of considerable interest and deserve to be printed.

At the outset, the organisers of the Seminar decided to invite young, not yet established scholars to present papers. The intention was to encourage those writers who have the greatest difficulty in having their work accepted for publication. The Society should be congratulated on this sensible and generous policy. The presence at the Seminar of many distinguished scholars demonstrated that this met with a warm response. The lively discussions which followed the papers were spontaneous and constructive and benefited both the authors and the audience.

Medieval art in England has suffered from more deliberate destruction as a result of religious conflict than in any other country and, for this reason, sculpture has come down to us usually defaced or in fragments. It requires a certain sophistication to appreciate and enjoy such mutilated pieces. Scholarly research is made infinitely more difficult when, for instance, instead of a whole cloister, such as exists at Moissac, Silos and Aosta, only a few damaged capitals are preserved as at Norwich, Reading and Winchester. Medieval tombs were not subject to the same religious iconoclasm and so they give a better idea of the quality and richness of English sculpture.

It is clear to anyone who has been working in this field that the picture of medieval sculpture in England will always be distorted and all we can hope to achieve is some glimpse of the past glory of English art in this medium. But it is because of this fragmentary preservation of sculpture that it is doubly important to study in great detail everything that has survived and to publish it adequately.

The Medieval Sculpture Seminar was an important event which will stimulate research and further our knowledge in this difficult but rewarding field. All those who share an interest in medieval sculpture will be grateful to the Society of Antiquaries for organising the Seminar and for publishing this book.

GEORGE ZARNECKI
Chairman

I. PRE-CONQUEST

Introduction

In this first section we have not produced a coherent programme which demonstrates the range of current research, but have attempted to look at some outstanding problems and to illustrate a variety of approaches.

A Corpus of the pre-Conquest stone sculpture of England is in course of preparation and with its publication there will be proposed a common terminology for describing motifs and styles. Such does not exist in the current literature nor is there a firm chronology for this period. This may be difficult to achieve, but at least the publication of the entire Corpus of this material will enable one to make judgements in relation to regional groupings and international influences in a manner not possible today. The first volume is concerned with part of the old kingdom of Northumbria—a region which James Lang surveys (p. 177).

It has been usual in the past to relate broad stylistic groups of sculpture to the English kingdoms of the pre-Viking Age. Northumbria and Mercia are the kingdoms in which the greatest body of material exists, and are generally accepted as primary in the post-Roman re-introduction and development of stone sculpture. Nancy Edwards' work in Ireland has used a method of recording monuments, and analysing ornament, which has been successfully applied to Northumbrian sculptures. Moreover, the relationship between the Northumbrians and their non-Germanic neighbours, the Picts and Scots/Irish, is crucially important for understanding the development of sculpture in mainland Britain as well as Ireland. She analyses a group of crosses which have been considered as early in the Irish series.

Dominic Tweddle reviews the sparse evidence for south-east England—a region divided politically until the ninth century but later part of Wessex. The relative importance of the two episcopal centres of Canterbury and Winchester here presents an interesting problem. Canterbury is not rich in sculpture of the period, but Winchester excavations have revealed a large quantity of important sculpture of the tenth and eleventh centuries.

The increase in material evidence since the days when Romilly Allen made the first estimate of the surviving sculpture in England, or even when T. D. Kendrick established a collection of photographs in the British Museum, must inevitably change the established chronologies based on a few major pieces.

The increase is to be explained partly by more precise knowledge of pre-Conquest forms and styles—a knowledge which is partly derived from work in other media, partly from the more intensive field-work in small areas such as

James Lang describes, and partly because excavations of ecclesiastical sites have produced not only significant additions but also monuments in dateable contexts. The possibility of more accurate dating of this material will depend heavily on the discovery of groups such as those from St. Oswald's, Gloucester, and Wells Cathedral which are discussed by Jeffrey West. Such pieces can be related to other plant scrolls in the South-West, just as the discovery of a column decorated with plant scrolls, which was still in its original position in the floor of a building at Jarrow, has provided a focus for the dating of plant scrolls in the North. The slabs decorated with Anglo-Scandinavian animal ornament discovered in post-war excavations at York are the first pieces bearing such ornament which have a dated context. In a period where little of the surviving sculpture is associated with standing structures which have an adequately recorded history, and where the field monuments have suffered a more devastating fate than those from Ireland discussed by Nancy Edwards, the archaeological discovery of major groups of new material is essential to advance the subject.

Nevertheless, the bulk of pre-Conquest sculpture consists of funerary or field monuments or architectural sculpture divorced from its context. Therefore close analysis of all aspects of the material, whether methods of production and layout, stylistic analysis of motif or iconography, is the only way towards the definition of local groupings, and the establishment of a hierarchy of monuments.

Some important monuments apparently still exist in splendid isolation, without any surviving predecessors and without influence in their region. Such a monument is the Reculver Column, the iconography of which is discussed by Dominic Tweddle. Recently, unpublished excavations at Reculver have cast some doubts on the dating of the floor in which is set the square base which is considered to have supported the column. Others have thought that the setting in the *opus signinum* floor of the seventh-century church is for an altar. If the cross stood above ground and was later, then its relationship to other sculpture might be clearer.

The columnar type of cross with figures under arcades, in the manner of the city gate sarcophagi of Gaul, is found in other monuments in the Midlands such as the Hedda stone at Peterborough, or Masham and Dewsbury in Yorkshire. It could therefore be a characteristic form of the "Carolingian" period.

Many problems remain unsolved: the origins and continental links with Anglo-Saxon sculpture; the reason why there seems to be a fruitful interchange and stimulation of new ideas involving Northumbria and its Celtic neighbours but not Wessex and its Celtic neighbours; the development of regional schools and the nature of their patronage.

ROSEMARY CRAMP

Some Observations on the Layout and Construction of Abstract Ornament in Early Christian Irish Sculpture

Nancy Edwards

The high crosses and related monumental sculpture of the modern counties of Offaly, Kilkenny and Tipperary in the Irish Midlands may be divided into three principal early groups (fig. 1). The first consists of several pieces which centre on the great monastic city of Clonmacnoise[1] situated on the eastern bank of the Shannon. The second group, concentrated in the ancient kingdom of Ossory, are chiefly to be found in the Slievanaman hills. They cluster at the sites of Ahenny and Kilkieran (monastic foundations whose backgrounds are obscure) but there are also outliers associated with this group further to the north. The third group is much smaller, consisting of the two crosses at Kilree and Killamery. These have usually been associated with the second group (Henry 1965, 139–40; Roe 1962) but their ornamental repertoire is different. In the course of reassessing the eighth-century context into which these three groups of sculpture are usually placed (Henry 1965, 139)[2], it was necessary to make a detailed analysis of the abstract ornament by considering not only the repertoire of patterns used but also their construction and layout.

In contrast with their more northerly counterparts, for example the monuments at Kells and Monasterboice (Roe 1966; Macalister 1946), which are for the most part decorated with figural scenes from the Scriptures, these three groups have a repertoire of ornament which is predominantly abstract. What figural representation there is, whether Biblical iconography, hunting scenes, or fabulous beasts, takes very much a secondary place, usually appearing on the base. Where figural scenes are found on the shaft or cross-head they are almost always on a small scale and in low relief and therefore appear greatly subordinate to the abstract orna-

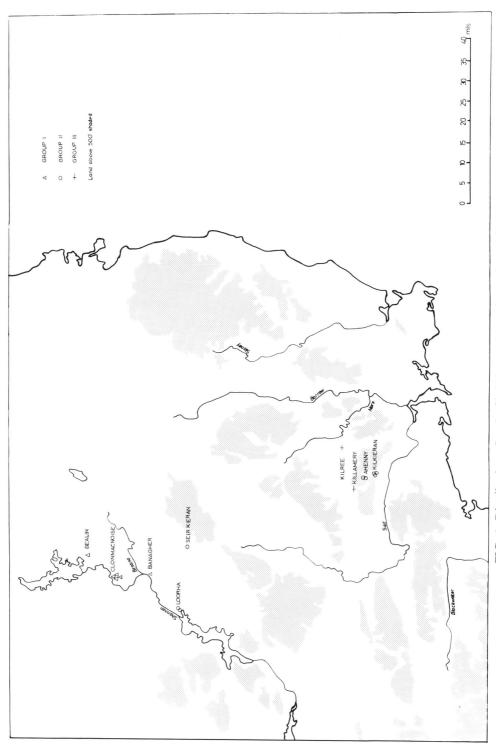

FIG. 1. Distribution of early Christian sculpture in south-east Ireland

ment. The importance of the abstract ornament is well illustrated by the South Cross, Clonmacnoise where the figural subjects are confined to the Fall and a possible hunting scene on the base and a tiny Crucifixion in very low relief at the top of the shaft on the west face (pl. V*a*).

J. Romilly Allen, in his great work on the early Christian monuments of Scotland (Allen and Anderson 1903, Pts. II and III), was the first to attempt a detailed analysis both of the repertoire of abstract ornament found on sculpture and the possible methods employed in its construction. Later Bain (1951) indicated how the modern artist might turn his hand to construct such Celtic patterns and Bruce-Mitford (1960, 221–31) showed that the abstract decoration of the Lindisfarne Gospels was drawn out with geometric grids for guidance, some of these being still traceable as pinpricks on the other side of the page. More recently Gwenda Adcock (1974; 1978, 33–46) has made a study of the interlace repertoire employed by Northumbrian sculptors. She realised that in Northumbria interlace patterns were constructed on a horizontal/vertical grid of squares and that the dimensions of this grid could be calculated by measuring the horizontal or vertical distance between the crossing points of pairs of strands. The distance between two crossing points is called the 'unit measure'. She also discovered that some groups of sculpture not only used a similar ornamental repertoire but also that certain monuments were using the same grid measurements for the construction of these patterns. Wherever possible I have applied these methods to the Irish material and the following observations illustrate some of the results.

First, it seems possible to demonstrate the importance of constructional grids to the successful planning of a scheme of geometric ornament. Secondly, unlike the Northumbrian sculptural interlace, which seems to have been constructed exclusively on a horizontal/vertical grid of squares (Adcock 1974), these three groups of Irish sculpture seem to have made use of both horizontal/vertical and diagonal constructional grids. Thirdly, it is possible to show that, within a group, monuments may be linked not only by their repertoire of ornament but also by the dimensions of the constructional grids used for their execution.

The importance of constructional grids to the successful planning of geometric ornament is best shown by examining the layout and decoration of the North Cross, Ahenny. The sculptor's mastery of design may be illustrated by the complex spiral patterns which form the background ornament round the bosses on the crosshead on the east face (pl. I*a*). Kilbride-Jones (1937, 394), in his study of the Tara brooch, was certain that such a skilful piece of metalwork must have been planned in advance 'on paper' and Robert Stevenson (1955, 113) has also suggested this with reference to the sudden appearance of the early Class II monuments of Pictland in their fully fledged state. A similar sense of forethought must account for the confidence with which this spiral design is executed.

The entire cross-head has been planned on a horizontal/vertical grid of squares. Two lines, one passing vertically down the centre of the cross, the other horizontally along the cross arms, may be seen quite clearly. If horizontal and vertical lines are added so that the centre of each spiral is constructed it will be found that a complex grid of squares will result. The distance between these grid lines is approximately 2.5 cm. and this distance may be called the 'unit measure'. All the spirals have diameters which are multiples of this unit ranging from approximately 5 cm. to 12.5 cm. The diameters of the bosses also correspond to this system; for

example the diameter of the central boss is approximately 20 cm. at the bottom, decreasing to 15 cm. across the top. Furthermore, the cross-head dimensions, in so far as it is possible to estimate them on a monumental structure, seem also to conform to this grid. For example, the width of the top cross arm is 25 cm; on the left hand horizontal cross arm it has been increased to 29 cm. but there is a corresponding gap between the bottom of the carving and the perimeter moulding. The perimeter mouldings also fit into this general pattern, being approximately 5 cm. in width, although they do vary somewhat in places presumably to provide the required width for the pattern on the cross face.

This grid gave the sculptor the basis for the execution of a fine spiral pattern in a style characteristic of chip-carved metalworking designs. The pattern is simple but the variety is achieved by constant change both in the size of the spiral according to its position in the pattern and in the decoration of its terminals.

The ornament on the cross-head of the west face is equally well planned. (pl. I*b*). The intricate interlace design used is based on a plaitwork mesh, the pattern being enlivened in some places by the breaking of certain strands which are then joined with others, the result being a variety of small knots. This pattern also seems to have been constructed on a horizontal/vertical grid of squares using an approximately 2.5 cm. unit measure. The careful use of this grid system enabled the sculptor to fill the irregular shape of the cross-head with an even carpet of ornament. In some places the unit measure and the width of the interlace strand have become slightly stretched or decreased in order to fit the pattern into the space available. One example of this is the slightly uneven interlace on the left hand horizontal cross arm at the point where it broadens out. However, the changes are so subtle that the unevenness of the pattern is barely perceptible.

In contrast to the obvious careful planning and execution of the decoration on this cross, some of the interlace ornament on other monuments from Group II is very much less accomplished. This may be exemplified by the West Cross, Kilkieran (pl. II*a*) which, like Ahenny North, employs a simple repertoire of plaitwork motives in preference to more complex knotwork designs, but many of the patterns appear uneven and the orderliness of the plaitwork mesh on some panels seems to have broken down completely. An example of this may be seen on the base of the south face (pl. II*b*) where an attempt at changing the design seems to have been tried actually during the course of execution. Thus planning and careful construction of the patterns may be seen as an essential part of the successful execution of the complex ornament on these crosses.

Secondly, the geometric patterns on these three groups of Irish sculpture seem to have been constructed on both horizontal/vertical and diagonal grids of squares. Romilly Allen (Allen and Anderson 1903, II, 143–5) first suggested that interlace patterns could be constructed on diagonal grids and in the case of simple plaitwork this seems logical since the line of the plaitwork would actually follow the line of the grid. The possibility of interlace patterns set out on diagonal grids first presented itself when examining the plaitwork on the monuments of Group II. The plaitwork on the west face of Ahenny North is evenly spaced and seems to have been constructed on a horizontal/vertical grid. In contrast, it was noted that on Ahenny South (pl. III*a*), although the patterns contained within a regular area were tackled with a fair degree of competence, the sculptor had experienced obvious difficulties when faced with the ornamentation of irregular areas which

PLATE I

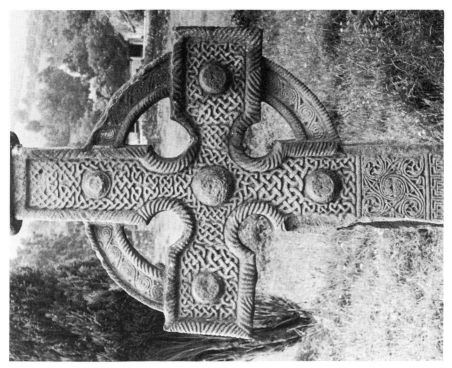

b. West face

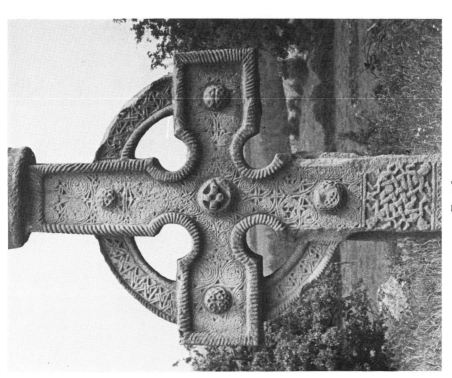

a. East face

North Cross, Ahenny

PLATE II

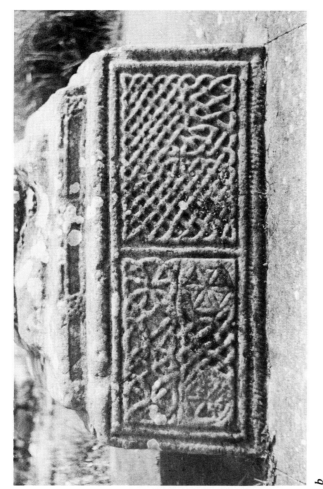

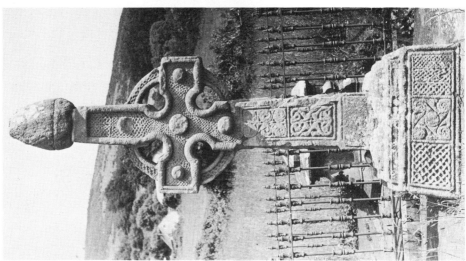

b

a

a. West face
b. South face
West Cross, Kilkieran

PLATE III

b. East Cross, Lorrha: west face

a. South Cross, Ahenny: east face

PLATE IV

b. East face

Kilree

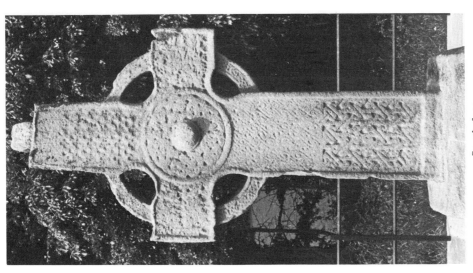

a. South face

PLATE V

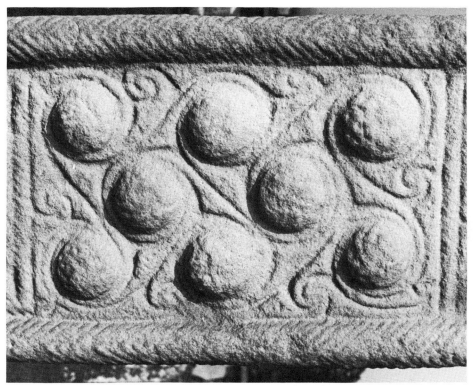

b. East face

South Cross, Clonmacnoise

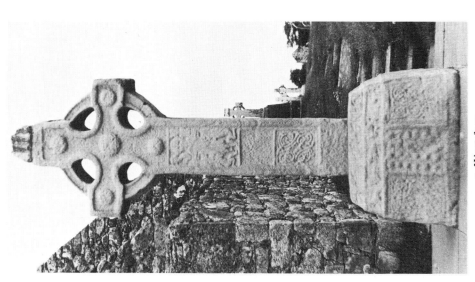

a. West face

PLATE VI

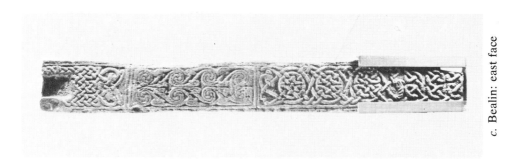

c. Bealin: east face

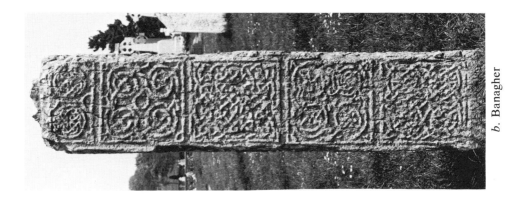

b. Banagher

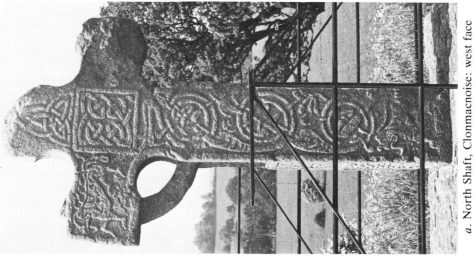

a. North Shaft, Clonmacnoise: west face

resulted in an uneven pattern. It is impossible to be absolutely certain whether any grid more complex than a mark at the crossing points of pairs of strands was attempted but when careful measurements were taken it was noted that the diagonal distances between the crossing points were always more consistent than the horizontal/vertical ones. This is perhaps underlined by the use of a strand with a median groove. On other monuments within Group II, the East Cross, Lorrha, for example (pl. III*b*), a diagonal grid is suggested by the fact that the plaitwork strands do not cross at right angles. The horizontal and vertical distances between the strands thereby differ considerably but the diagonal unit measure remains surprisingly uniform.

Interlace ornament is not as extensively employed on the Group III monuments. At Kilree (pl. IV*b*) the use of a diagonal grid as the constructional basis of a plaitwork pattern can perhaps be directly demonstrated since fragments of the original grid system are still to be seen. The panel is situated on the south face of the cross under the wheel arc, a sheltered position which has reduced weathering to a minimum. The pattern, six strand plaitwork, is therefore in an excellent state of preservation and it is still just possible to see fragmentary incised lines marked along the centres of the strands in the manner of a median line. These lines, however, instead of following under and over each other like the strands, continue, thus indicating the crossing points on a diagonal grid.

In contrast to Groups II and III where it seems that both horizontal/vertical and diagonal grids may have been used in the construction of the interlace patterns, the Clonmacnoise monuments seem to have employed only the former. However, it may be suggested that all three groups make use of diagonal grids in the execution of other types of abstract ornament. For example, a fret pattern on the shaft at Kilree (pl. IV*a*) is quite clearly constructed on a diagonal grid. This is also true of some spiral ornament, for example a panel on the east face of the South Cross, Clonmacnoise (pl. V*b*).

Thirdly, each group of monuments is bound together by its own particular repertoire of ornament. Furthermore, in some instances monuments within each group are also linked by the dimensions of the grids used in the construction of such ornament. This dual link may best be demonstrated by looking at the interlace patterns employed amongst the monuments of Group I. This group makes extensive use of complex interlace knotwork although, surprisingly, the actual repertoire is very small[3], there being only nineteen identifiable patterns[4] in all (Table 1). As can be seen the same patterns are found on a number of different monuments within the group and frequently the same constructional dimensions are also favoured. For example, a shaft panel on the west face of the cross at Bealin is decorated with an interlace pattern, Encircled and Turned E (fig. 2a). The pattern is constructed on a horizontal/vertical grid of squares, the unit measure being 1.5 cm. with a strand width of approximately .75 cm. Exactly the same pattern is used at the bottom of the North Shaft, Clonmacnoise, using the same unit measure but a slightly broader strand width (fig. 2b; pl. VI*a*). The same pattern occurs again in a slightly different guise on the Banagher shaft (fig. 2c; pl. VI*b*). Here the dimensions of the panel are different, being long and narrow instead of square, so the pattern units are now single and the pattern has become extended to three registers in height. The sculptor has also introduced birds' head terminals at the top and bottom in order to fill up the vertical space available.

TABLE I
Interlace patterns on Group 1

PATTERNS	Banagher	Bealin	Clonmacnoise, North Shaft	Clonmacnoise II	Clonmacnoise III	Clonmacnoise, South Cross
Plaitwork						
4 strand plait						X
6 strand plait		X		X		
A						
Basic A	X	X		X		X
Spiralled A			X			X
B						
Basic B					X	
Turned B			X			X
Half B		X				
Simple B						X
Spiralled B						X
C						
Basic C		X	X			X
Turned C	X			X	X	X
Encircled C						X
D						
Turned D	X				X	X
E						
Basic E	X	X				
Turned E				X		
Encircled & Turned E	X	X		X		
F						
Simple F		X				
Closed Circuit F					X	
Misc.						
Triquetra		X				X

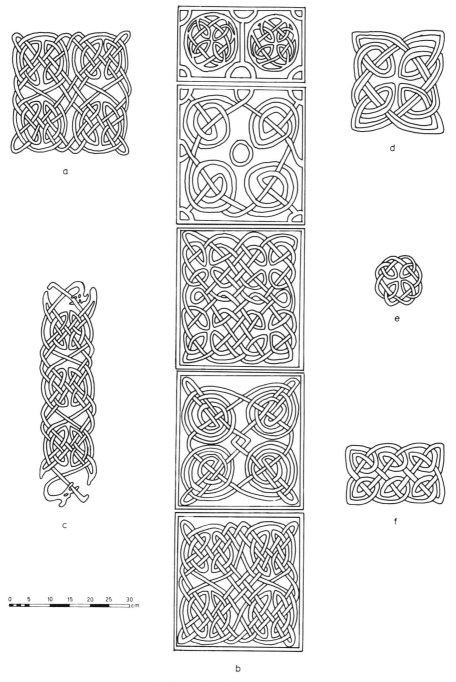

FIG. 2. Interlace patterns

However in essence the pattern is still the same and the same constructional grid has been used. The unit measure of 1.5 cm. and the strand width of approximately .75 cm. is identical with Bealin.

A further example is provided by examining the use of interlace element C amongst this group. Basic element C is used several times on Bealin, both on a rectangular panel and adapted to fill a roundel shape (pl. VIc; fig. 2d & e). For the former, situated on the crosshead of the east face, a unit measure of 3 cm. is used. For the latter, situated on the crosshead of the west face, this has been halved to 1.5 cm. Basic C adapted as a roundel, using the same unit measure and an equal strand width, is found again on the top panel of the North Shaft, Conmacnoise (fig. 2b). On this shaft element C is used in a number of more complex ways to decorate square panels. On the second panel down the element has been spiralled in a rather incompetent fashion so as to emphasize the cross symbol in the centre. This emphasis seems deliberate as it appears in many interlace patterns[5] and may perhaps be compared with the use of crosses as a basis for the patterns on carpet pages in Hiberno-Saxon manuscripts. Robert Stevenson (1974, 39–40), in his study of the Hunterston brooch, has also suggested the possible significance of the cross symbol and the adaptation of the abstract ornament to emphasize the cross is also apparent on some of the Pictish monuments, for example Aberlemno II (Allen and Anderson 1903, III, fig. 227a).

Element C is found again on the North Shaft on the third panel down, here set four elements abreast. On this panel a different unit measure is used, 2 cm., which is found on all the Clonmacnoise monuments except Bealin and it is employed extensively on Banagher. Indeed element C patterns play a significant part on all the monuments of the Clonmacnoise group. Basic C using a 2 cm. unit measure is found even on the South Cross, Clonmacnoise (fig. 2f). The fact that this cross may be included within Group I is particularly interesting since to the superficial view such features as the influence of metalworking techniques and the high relief cable roll mouldings may be compared with the Group II crosses, and indeed Françoise Henry (1965, 139) placed it with that group. In addition the Crucifixion iconography and the use of inhabited vine scroll may be compared with the South Cross, Kells (Roe 1966, pls. IV, VIa). But in fact both the repertoire of interlace patterns and the dimensions of the constructional grids employed place it firmly with the other Clonmacnoise monuments.

Therefore it may be demonstrated that all three groups make use of constructional grids, some horizontal/vertical and some diagonal, in the layout of the abstract ornament. The use of such grids undoubtedly aided the sculptor in the successful construction of complex geometric patterns. Each of these groups is characterized not only by its own repertoire of abstract decoration but also, in some instances, as has been shown among the Clonmacnoise monuments, by the use of particular constructional grids where certain unit measures seem to have been consistently followed.

Acknowledgements

I would like to thank Professor Rosemary Cramp and Frances Lynch for reading this article and for their helpful advice, and Tom Middlemass for his careful production of my photographs. Plate VI*b* is reproduced by kind permission of the National Museum, Dublin.

NOTES

1. The pieces of sculpture from Clonmacnoise itself consist of the North Shaft, the South Cross and two smaller pillars, Clonmacnoise II and III. The former is now in the National Museum, Dublin, while the latter remains at Clonmacnoise.
2. There have been various attempts to date the second group, and particularly the crosses at Ahenny, to the tenth century (Porter 1931, 112; Sexton 1946, 7–8). However I do not find this a tenable hypothesis in the light of the close similarity of the ornamental details with Vernacular Period metalwork motives.
3. The repertoire of interlace ornament amongst certain groups of Pictish and Northumbrian sculpture would seem to be considerably larger (Allen and Anderson 1903, II and III; Adcock 1974).
4. Interlace patterns are classified throughout using Gwenda Adcock's terminology (1974; 1978, 33–46).
5. For example cross voids may be seen on the North Shaft on the first and fourth panels also.

BIBLIOGRAPHY

Adcock, G. 1974. *A Study of the Types of Interlace on Northumbrian Sculpture,* M.Phil. Thesis, Durham University, unpublished.
—— 1978. 'The theory of interlace and interlace types in Anglian sculpture', *Anglo-Saxon and Viking Age Sculpture* (ed. J. Lang), B.A.R. 49 (British Series), pp. 33–46.
Allen, J. R. and Anderson, J. 1903. *The Early Christian Monuments of Scotland,* Edinburgh.
Bain, G. 1951. *Celtic Art, the Methods of Construction,* London.
Bruce-Mitford, R. L. S. 1960. 'The methods of construction of Celtic ornament', *Evangeliorum Quattuor Codex Lindisfarnenis* (T. Kendrick *et al.*), Olten/Lausanne, pp. 221–31.
Henry, F. 1965. *Irish Art in the Early Christian Period (to 800 A.D.),* London.
Kilbride-Jones, H. E. 1937. 'The evolution of the penannular brooch with zoomorphic terminals', *Proc. Royal Irish Academy*, lxiiic, 379–455.
Macalister, R. A. S. 1946. *Monasterboice,* Dundalk.
Porter, A. K. 1931. *The Crosses and Culture of Ireland,* Newhaven (U.S.A.)
Roe, H. 1962. *The High Crosses of Western Ossory*, 2nd edn., Kilkenny.
—— 1966. *The High Crosses of Kells*, 2nd edn., Dublin.
Sexton, E. H. L. 1946. *Irish Figure Sculpture of the Early Christian Period,* Portland, Maine (U.S.A.)
Stevenson, R. B. K. 1955. 'Pictish art', *The Problem of the Picts* (ed. F. T. Wainwright), Edinburgh and London, pp. 97–128.
—— 1974. 'The Hunterston Brooch and its significance', *Med. Arch.* xviii, 16–42.

Anglo-Saxon Sculpture in South-East England before *c.* 950

Dominic Tweddle

Despite the large number of early ecclesiastical foundations in south-east England, Anglo-Saxon sculpture dating to before *c.* 950 from the region is rare, even if its boundaries are generously drawn (fig. 3). What little material there is has received scant attention in the scholarly literature. Of the surviving pieces those from St. Peter's, Bedford,[1] and Elstow (Beds.)[2] are outliers of Mercian art and are, therefore, excluded from further discussion. Apart from these two pieces, and isolated examples from Surrey and Oxfordshire, the rest of the sculpture is distributed in two distinct groups in Hampshire and Kent. This distribution is probably partly a reflection of the fact that the heavily forested, and therefore lightly settled, *Andredesweald* occupied much of Sussex and Surrey; but sculpture is also largely absent from heavily settled areas such as the Sussex coast and the Thames valley. It is, therefore, possible that this distribution is of more than geographical significance, conceivably reflecting regional groups of sculpture. It is the purpose of this paper to examine such a possibility, as well as to introduce some little known pieces and to identify the sources and relationships of their decoration.

Within the Hampshire material the cross shaft fragments of square section from Steventon,[3] and the 'Southern Echo' building, Winchester,[4] and a possible impost block from the Old Minster, Winchester,[5] can be immediately isolated. These pieces are decorated with animals having ribbon-like bodies which are contoured and hatched or pelleted, and which develop into interlace. They form part of a group of similarly-decorated pieces, first identified by F. Cottrill, whose distribution is firmly south-western, the principal examples being those from Ramsbury and Colerne, Wilts.; Shaftesbury, Dorset; Rowberrow and West Camel, Somerset; Dolton, Devon; and Tenbury, Worcs.[6] The dating of the group is problematic, but on the basis of comparisons with the manuscripts Cottrill prop-

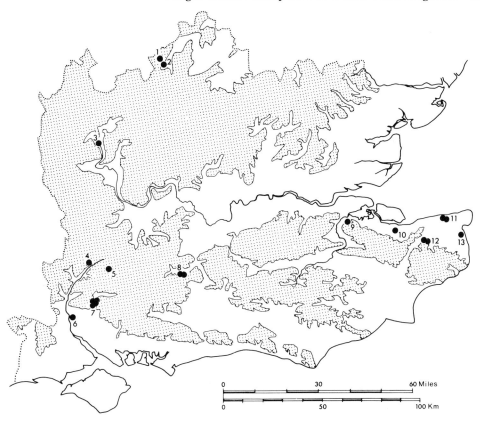

FIG. 3. Distribution of Anglo-Saxon sculpture dating to before *c.* 950 in south-east England.
1. Bedford; 2. Elstow (Beds.); 3. Oxford; 4. Whitchurch (Hants); 5. Steventon (Hants); 6.
Romsey (Hants); 7. Winchester (Hants); 8. Godalming (Surrey); 9. Rochester (Kent); 10.
Preston-by-Faversham (Kent); 11. Reculver (Kent); 12. Canterbury (Kent); 13. Sandwich
(Kent).

osed an eighth- to ninth-century date for the material.[7] More recently Prof. Cramp
has pointed out that its origins seem to lie in south-west Mercian sculpture.[8] In
particular, a cross shaft of square section from St. Oswald's Priory, Gloucester,[9] is
decorated on three of its faces with semi-naturalistic animals having hatched or
textured and contoured bodies similar to those on other pieces of south-west
Mercian sculpture such as the Cropthorne (Worcs.) cross head,[10] or the Acton
Beauchamp (Herefordshire) slab.[11] On the fourth side of the St. Oswald's piece,
however, although the animals retain the hatching and contouring they have
become ribbon like, and are viewed from above, and it is similar ribbon-like
animals which are used on the Steventon and Winchester pieces. This combination
of semi-naturalistic and ribbon-like animals viewed from above occurs also in the
arcades framing the Canon tables of the mid to late eighth-century Leningrad
Gospels, a manuscript which shows numerous links with southern English art.[12]
This comparison reinforces Cramp's suggestion that the south-west Mercian

material should be dated to *c.* 800, which would place the derivative material such as the Steventon and Winchester pieces firmly in the ninth century. The end date for the group of south-western sculptures to which the Steventon and Winchester pieces belong is equally problematic, but the occurrence of similar animals on a shaft of late ninth- or early tenth-century date from St. Alkmund's, Derby,[13] provides a possible indicator.

Among the remaining Hampshire sculptures the most elaborate is the re-cut fragment from the triforium collection of Winchester Cathedral.[14] On the L-shaped main face, the only one on which decoration now remains, there is a tree-scroll[15] with only a single pair of branches, each inhabited by an inward-facing bird, and with another bird perched on the junction between the two branches. The scroll is contained within a semi-circular field which has a small pointed extension at the top (fig. 4). Above it is a figural group consisting of an outward-facing figure to the left, behind which is an animal with a bulbous body. To the right there is another figure, now heavily damaged. The scene is incomplete but has been identified as Jonah and the whale.[16] Again the dating is difficult, but the use of a tree scroll with only a single pair of branches and within a semi-circular frame occurs in one of the bases of the arcades containing the Canon tables in the Leningrad Gospels.[17] It is found also in metalwork as on the Tessem[18] and Lilleby mounts,[19] and on the Komnes disc (fig. 4).[20] These pieces of insular metalwork have all come from ninth-century graves in Norway and on this basis have been dated to the eighth century,[21] but the survival of the tree scroll within a semi-circular frame into the ninth century is suggested by its occurrence on a fragmentary gilt bronze disc from Ixworth (Suffolk), which employes a distinctively ninth-century leaf form.[22] The ninth-century disc added to the silver casing of the portable altar of St. Cuthbert also employs semi-circular fields containing debased plant ornament.[23] Certainly the form of the frame on the Winchester piece would be best placed in the ninth century, the only real comparison being with the arch heads of one of the Canon table arcades of the Canterbury manuscript B.L. Royal I.E.VI, probably dating to *c.* 820–40.[24]

The combination of a tree scroll and figure sculpture used on the Winchester piece occurs also on a grave marker from Whitchurch (pl. VIIa,b).[25] This has a semi-circular head which on the back is filled with an incised tree scroll, again having only a single pair of branches and confined within a semi-circular frame (fig. 4). On the front face a recessed field contains a high relief, half-length figure identified by its cruciform nimbus as the figure of Christ. Originally the sculpture must have been highly accomplished, but it is now heavily weathered. On the edge of the stone, running over the semi-circular head is the framed inscription + HIC CORPUS FRI[Ð]BVRGAE REQVIESCIT IN [PA]CE[M] SEPVLTVM.[26] As on the Winchester piece the use of a leafless tree scroll within a semi-circular frame suggests a ninth-century date, a suggestion supported by comparison with a ninth-century *pressblech* disc from Hedeby (W. Germany) (fig. 4).[27] This disc, like those from Ixworth and from the St. Cuthbert altar, is decorated with a free-armed Anglian cross having in each of the angles of the arms a semi-circular field, but in this case the fields are filled with interlace rather than plant ornament. The interlace is, however, almost identical in form to the scroll at Whitchurch, and must originally have been derived from a similar leafless tree scroll. The Hedeby piece was found in a ninth-century grave, and although T. Capelle has suggested

FIG. 4. Tree scrolls.
a. Whitchurch (Hants); b. Triforium collection fragment, Winchester Cathedral; c, d. Lilleby mount; e, f. Komnes disc; g. Hedeby disc; h. Tessem mount. Not to scale.

that it is Irish its close links with the Ixworth piece and with the disc from the St. Cuthbert altar strongly suggest an Anglo-Saxon origin.

The motif of the leafless tree scroll used on both the Winchester and Whitchurch pieces occurs again on a fragment of a round shaft from the National Westminster Bank, High Street, Winchester (pl. VIIc).[28] Here the plant has a stepped base and a single pair of median incised branches, although the shaft has been broken away above and there may originally have been several more pairs of branches. This type of continuous plant scroll has a very wide date range, from the late eighth century, as in the Barberini Gospels,[29] or on the Alstad mount,[30] to the tenth century, as on the East Stour (Dorset) shaft.[31] After this date the form persisted but reclothed in acanthus foliage, as in the borders of the Presentation scene in the New Minster foundation charter, for example.[32] One of the most convincing parallels to the scroll on the National Westminster Bank fragment is on a ninth-century shaft from West Camel (Somerset)[33] where the scroll, similarly without leaves, also has a segmented stem. A similar date would be acceptable for the National Westminster Bank fragment.

From Priors Barton on the outskirts of Winchester comes another fragmentary round shaft,[34] decorated in this case with four vertical fields separated by plain relief mouldings on stepped bases. One of the panels is filled with interlace—now largely destroyed—and another with a heavily weathered stag enmeshed in inter-lace. Separating these two fields are panels each filled with a single plant. One of these plants is a bush scroll, a form related to the tree scroll in that it has a central stem with a pair of outurned branches at the base. Above them, however, is a series of paired inward-facing branches. On the Priors Barton example the plant has the pair of out-turned branches developing into interlace, while one pair of inward-facing branches are thickened and terminate in animal heads. The stem has a palmate top (pl. VIIIa). The other plant on the shaft is defaced apart from a pair of out-turned stems at the base which end in berry bunches and have acanthus foliage. Originally, therefore, it could have been either a tree scroll or a bush scroll.

This use of acanthus foliage is significant and would, at first sight, suggest a tenth-century date for the shaft, since acanthus foliage does not generally appear in Anglo-Saxon art until that date.[35] However, the combination of animal, plant, and interlace ornament, with the different types of ornament alternating with each other, is more reminiscent of late eighth- and ninth-century art. The late eighth-century embroideries from the church of St. Catherine, Maaseick (Belgium),[36] for example, have a series of arches filled alternately with plant and animal ornament, while the columns supporting the arch heads are decorated alternately with animal, plant, and interlace. These embroideries were probably made in southern England. Similarly, the arcades framing the Canon tables in the early ninth-century manuscript B.L. Royal I.E.VI are decorated with rectangular fields filled alternately with different types of ornament. As on the Priors Barton shaft the plant ornament develops animal heads, although this feature is not confined to the ninth century, and is seen on the eighth-century Björke mount, for example.[37]

Disregarding the leaf form, the organisation of the partially defaced plant on the Priors Barton shaft, with the branches ending in a leaf and berry bunch, is best paralleled in ninth-century art; in particular on the Mosnaes brooch,[38] a Scandinavian type trefoil brooch with plant ornament based on an Anglo-Saxon exemplar.

PLATE VII

a,b. Whitchurch, Hants: grave marker

c. National Westminster Bank, Winchester: cross shaft fragment

a

b

c

PLATE VIII

b. New Examination Schools, Oxford: grave slab

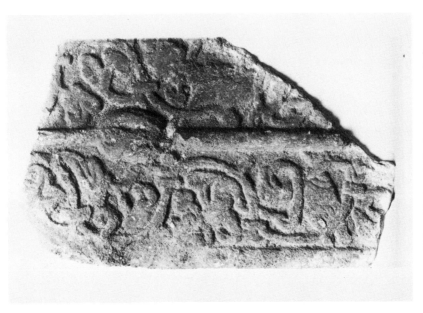

a. Priors Barton, Winchester: cross shaft

PLATE IX

a

b

a,b. Sandwich, Kent: memorial (?) stones

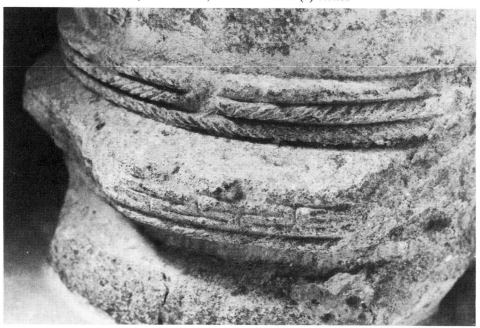

c. Reculver, Kent: column base

PLATE X

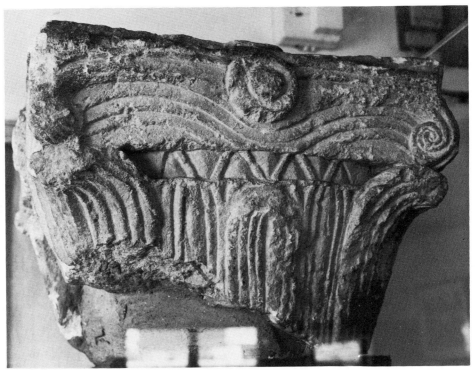

a. St. Augustine's Abbey, Canterbury: debased Corinthian capital

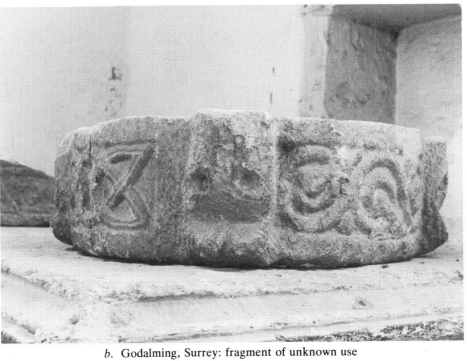

b. Godalming, Surrey: fragment of unknown use

PLATE XI

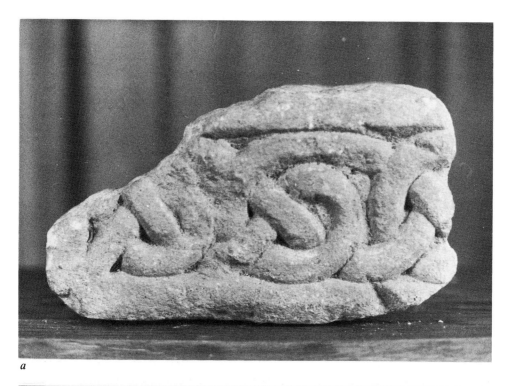

a

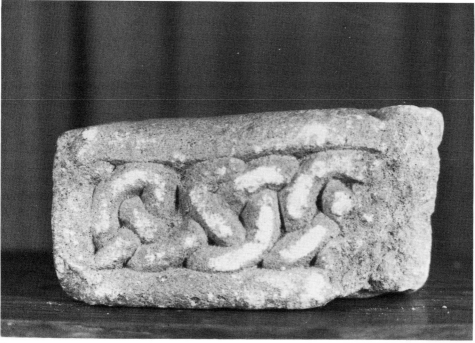

b

a,b. Preston-by-Faversham, Kent: cross shaft fragment

There is no precise equivalent to this arrangement in the tenth century, although there is something similar on the cross shaft from Littleton Drew (Wilts.).[39] The margins of the presentation scene of the *Vita Cuthberti,* made in Winchester *c.* 935–9, also contain bush scrolls and simple scrolls with acanthus leaves in combination with berry bunches.[40] Arguing against a ninth-century date is a grave slab from St. Oswald's Priory, Gloucester, discussed more fully by J. West below (pp. 41–53). It is decorated with a bush scroll with acanthus foliage very similar to that on the Priors Barton shaft. This piece has been dated to the first half of the tenth century, as has a similar slab with an acanthus tree scroll from Wells (Somerset),[41] and it is, therefore, possible that the Priors Barton shaft is not a ninth-century piece, but represents the survival into the tenth century of earlier decorative traditions which were then combined with newer elements such as acanthus foliage.

Related to the ornament on the Priors Barton shaft is the decoration of a grave slab from the site of the New Examination Schools, Oxford (pl. VIII*b*).[42] The slab has a median ridge on either side of which is an inhabited simple scroll with large, ragged acanthus leaves similar to those on the Priors Barton shaft. The details of the slab are obscured by heavy weathering, but the ornament is closely paralleled in the borders of the Presentation scene of the *Vita Cuthberti,* where the same simple scroll with the stem divided by collars is employed. As on the Oxford slab the scroll is inhabited by birds and has acanthus foliage (fig. 5). This close parallel may suggest a date in the first half of the tenth century for the Oxford piece, a date supported by comparison with the similar inhabited simple scroll with acanthus foliage on a shaft from Colyton (Devon).[43] A later date is, perhaps, unlikely since although inhabited acanthus scrolls do occur in the late tenth and eleventh centuries, as on the bronze openwork strap-end from Winchester,[44] or the ivory pen case from London,[45] they are usually bush scrolls. Moreover, the later examples employ full-blown Winchester style acanthus ornament which is not seen in either the *Vita Cuthberti* or on the Oxford slab.

Also closely related to the manuscript art are the acanthus sprays on the crucifixion panel from Romsey.[46] This depicts the crucified Christ accompanied by the Virgin and St. John, the figures of Stephaton and Longinus, and an angel on either side of the cross head. Acanthus sprays develop from the lower limb of the cross and the lower edge of the panel. Each consists of a stem from which emerges a pair of downturned leaves, a form which echoes the tree scroll used on the Winchester Cathedral and Whitchurch pieces. Acanthus of very similar form is used to decorate the lower corners of the frame of the second Christ in Majesty page of the Aethelstan Psalter,[47] and similar acanthus sprays are used as scene separators on the St. Cuthbert stole.[48] The stole is dated by inscription to *c.* 909–16, and there is little reason to doubt the traditional association of the Psalter with King Aethelstan (924–39). These parallels for the foliate ornament would, therefore, place the Romsey panel in the first half of the tenth century, although the possibility of a slightly earlier date should not be discounted, particularly since Cramp has pointed out the strong stylistic links between the piece and west Midland styles of the ninth century.[49] These links are particularly noticeable in the round staring eyes and the flat treatment of the drapery with the details picked out by shallow incised lines.

In summary, in dealing with this group of Hampshire material with its outlier in

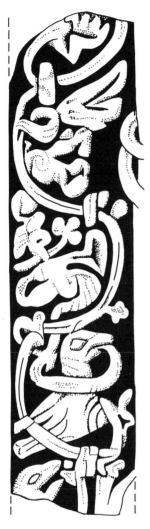

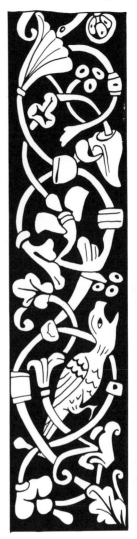

a *b*

FIG. 5. Simple scrolls with acanthus foliage.
a. New Examination Schools, Oxford, grave slab; b. *Vita Cuthberti,* Corpus Christi
College, Cambridge, MS.183, f. 1v. Not to scale.

Oxfordshire, it is possible to isolate a group of three sculptures—from Steventon, and from the 'Southern Echo' building and the Old Minster, Winchester—which form the eastern outliers of a larger group of sculptures centred on south-west England. Among the remaining pieces there are some links including the preference for tree or bush scrolls, sometimes within a semi-circular frame, and sometimes with acanthus foliage. Other traits include the preference for small-scale figure sculpture, and the use of round shafts. These links are far too weak, and the sculptures too few, to suggest a single school of sculpture, but combined with the restricted distribution and date of the pieces they are enough to suggest that the pieces at least belong to a single evolving sculptural tradition. The distribution of

the pieces suggests that this tradition was based on Winchester, a conclusion supported by the close links between the sculptures and works in other media which were probably produced at Winchester, such as the *Vita Cuthberti*, the Anglo-Saxon additions to the Aethelstan Psalter, and the St. Cuthbert stole and maniple.

The material is also important in that in it is possible to trace the assimilation of Carolingian acanthus ornament into Anglo-Saxon art. On the Oxford slab, for example, a straightforward simple inhabited vine scroll has been transformed by the addition of acanthus leaves, and the supression of the berry bunches charac-teristic of the vine scroll. This transformation was not always wholly convincing, and in the margins of the presentation scene of the *Vita Cuthberti* the very similar acanthus scroll still retains the berry bunches of the vine scroll (fig. 5). This phenomenon is paralleled on the Priors Barton shaft, where again a retained ninth-century plant form, in this case a bush scroll, has been transformed by the addition of acanthus foliage. If the late ninth-century date tentatively proposed here for the Priors Barton shaft can be accepted, then the first appearance of acanthus foliage in Anglo-Saxon art, normally placed in the tenth century, can be pushed back into the ninth where it can be placed alongside the small-scale classicising figure sculpture which is also a new feature in ninth-century art, and may similarly be derived from Carolingian exemplars. The plausibility of this suggestion is further reinforced by the occurrence of strong Carolingian influences on Kentish sculpture of the ninth century, discussed more fully below.

The sculpture from Kent dating to the period before *c.* 950 is more diverse in form than that from the Hampshire region. Early dates have been suggested for some of the pieces including the two tapering stones of square section from Sandwich (pl. IX*a,b*),[50] which have been assigned to the Pagan Anglo-Saxon period on the grounds that they appear to be memorial stones but lack any Christian symbols.[51] Their memorial function is suggested by the runic inscription on one of them, usually interpreted as the personal name 'Raehabul.'[52] Both the archaic *h* rune, and the retention of the intervocalic *h* would support a date in the seventh century.[53] Similarly a fragmentary inscription from St. Martin's, Canter-bury is dated to the seventh century as it is built into the jamb of a doorway which is apparently of that period.[54] The two columns from Reculver with their bases decorated with cable and fret (pl. IX*c*) originally supported the triple arcade separating the nave and chancel, and appear to have been primary features of the church which was built in the late seventh century.[55] They must, therefore, be of similar date.

Also frequently dated to the seventh century are the fragments of a drum-built round shaft from Reculver, possibly part of the cross seen in the church by Leland *c.* 1540.[56] Six drums survive,[57] two of them decorated with narrative scenes identified by Beckwith as the Baptism and Ascension of Christ.[58] In the Baptism scene (fig. 6*c*, bottom left) the presence of an altar with a flame on it, and the hand of an apparently kneeling figure suggest an alternative interpretation as the Sacrifice of Isaac. This scene does occur elsewhere on pre-Conquest sculpture as on shafts from Dacre (Cumb.) and Breedon (Leics.).[59] On both monuments Abraham and Isaac are placed on either side of the altar, an arrangement paral-leled at Reculver, although here the possible figure of Isaac is kneeling, not standing. Apart from the placing of the altar, presumably dictated by the need to

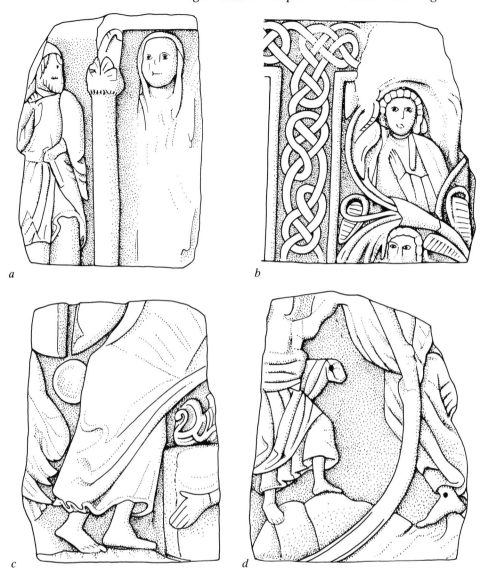

FIG. 6. Four of the Reculver fragments including
c, The Sacrifice of Isaac, and d, The Ascension (?).

save space, the iconography of the Reculver piece with the robed figure of Abraham leaning towards the kneeling Isaac can be paralleled in Early Christian art as on an engraved gold glass in the Vatican Museums, Rome.[60] In the Ascension scene (fig. 6d, bottom right) the occurrence of a second figure larger than that of Christ and leaning into the scene also presents the possibility that the scene can be interpreted differently, for example, as Moses receiving the Law, although elements of the iconography may be borrowed from that of the Ascension.[61] Of the remaining four Reculver drums two have decoration consisting of a pair of figures separated by a classical column supporting a flat entablature (fig. 6a, top

left). The third is decorated with three robed figures separated by mouldings of square section rebated to take metal fittings. The remaining drum is decorated with a simple scroll containing human busts, the whole contained within an interlace frame which survives on two sides (fig. 6*b*, top right). A fragment belonging to a similarly-decorated drum, and part of a lorgnette cross head[62] are now lost.

This is not the place to embark on anything more than an outline discussion of the dating of the Reculver fragments, but the seventh-century date proposed for them seems untenable. This dating was originally based on two fundamental assumptions, firstly that all of the fragments were part of the monument seen by Leland standing in the chancel arch of the church, and secondly that the base discovered by Peers in front of the triple arcade was that on which the monument described by Leland originally stood.[63] The base was dated to the seventh century, as the *opus signinum* floor which stopped against it was believed to be contemporary with the first church built soon after the foundation of the minster in 669.[64] Recent excavations by B. J. Philp have, however, demonstrated that the *opus signinum* floor in the supposed seventh-century nave is almost identical with that in the eighth-century north aisle, and is, therefore, probably of eighth-century date or later.[65] Moreover, H. M. Taylor has pointed out that the shape of the base would be more appropriate to an altar, and has demonstrated that in some early pre-Conquest churches, such as the Old Minster, Winchester, the altar was placed in the nave in front of the chancel arch in the position of the Reculver base.[66]

The archaeological evidence for the seventh-century dating of the Reculver fragments, therefore, seems dubious, and there is certainly no English context in the seventh century into which the material would fit. As noted above, the only seventh-century pieces from Kent, and indeed from south-east England as a whole, are decorated extremely simply and do not bear comparison with the Reculver pieces in either complexity of design or technical competence. Nor is there necessarily any equivalent sculptural tradition in northern England at this period since, as Prof. Cramp has pointed out, it is possible that the late seventh-century and early eighth-century material from Northumbria was either architectural or consisted of simple funerary slabs, and it was not until the mid eighth century that large figure-decorated cross shafts with elaborate iconography, such as those at Ruthwell and Bewcastle, emerged.[67] Even if the Ruthwell and Bewcastle crosses are late seventh-century pieces, as some would argue,[68] there seems no reason to assume that the course of sculptural development in Northumbria should be paralleled by that in Kent.

This lack of sculptural context in southern England in the seventh century into which the Reculver sculptures would fit may simply be a problem of survival. This is certainly the case in considering works in any other medium, since no manuscript, ivory, or piece of metalwork dating to before about the mid eighth century survives from southern England. The only work, therefore, which may throw some light on the art of southern England in the seventh century is the St. Augustine's Gospels, a late sixth-century Italian manuscript traditionally thought to have been brought to England by St. Augustine himself,[69] and consequently available in Canterbury for copying in the seventh century. Although the dating of the manuscript permits such a possibility, the first positive evidence for its presence in England is provided only by its eighth-century English marginalia.

The St. Augustine's Gospels do have a number of points of comparison with the Reculver fragments. In particular, they employ a series of small-scale narrative scenes which are divided by plain coloured frames,[70] paralleled at Reculver by the plain frames of square section dividing the series of standing figures on one of the drums. Moreover, in the St. Luke portrait in the Gospels[71] the evangelist is seated under a flat entablature supported by classical columns, an arrangement seen on the remaining two drums at Reculver which are decorated with ranges of standing figures. Little weight can, however, be placed on such comparisons since these features recur in later Anglo-Saxon manuscript art. For example, the use of the flat entablature supported by classical columns is seen again in the eighth-century *Codex Aureus*,[72] and also in the late tenth-century Benedictional of St. Aethelwold.[73] The use of narrative scenes re-emerged in the ninth century, as in B.L. Royal I.E.VI.,[74] and plain coloured framing occurs again in the early tenth-century Anglo-Saxon additions to the Aethelstan Psalter.[75] The recurrence of these motifs is the direct result of Anglo-Saxon copying of late Antique exemplars, or of exemplars which in turn had drawn on late Antique sources. The *Codex Aureus*, for example, may draw at least in part on the St. Augustine's Gospels,[76] and, as noted below, B.L. Royal I.E.VI. exhibits close links with Carolingian manuscript art, which itself used late Antique art as one source of inspiration. Recently Alexander has pointed out the possibility that the Anglo-Saxon additions to the Aethelstan Psalter are a direct copying of a late Antique exemplar, a possibility suggested by the unusual iconography of the Ascension and Nativity scenes, and the remnants of classical space construction and landscape conventions in the manuscript.[77]

Stylistically there is little comparison between the figure drawing of the St. Augustine's Gospels, and that of the Reculver fragments. In the narrative scenes of the St. Augustine's Gospels the figures are short and stocky with expressionless faces and sketchily indicated garments, all the attention being focussed on the action of the scene. At Reculver in contrast the figures are carefully drawn in great detail, and in particular every fold of the garments is carefully delineated. Except in the Codex Amiatinus, itself a direct copying of a late Antique exemplar,[78] this naturalistic treatment is not paralleled elsewhere in seventh- or eighth-century Anglo-Saxon manuscript art. For example, in the Lindisfarne Gospels[79] the garments are treated in a flat linear fashion, and the folds are picked out with hard dark lines, and are reduced to a series of curves which form a surface pattern which has begun to lose contact with the shape of the body beneath. This process reached its logical conclusion in the portrait of St. Luke in the Gospels of St. Chad[80] where the body of the saint has been totally lost under a garment which is reduced to a series of symmetrical curves. It is this linear tradition, although not in such an extreme form, which is seen in the first surviving figural miniatures in southern English art, in the Vespasian Psalter[81] and the *Codex Aureus*,[82] both works of the eighth century from Canterbury.

In fact the closest parallels to the figure decoration of the Reculver fragments seem to be with early tenth-century Winchester material, in particular with the Aethelstan Psalter[83] and the St. Cuthbert stole and maniple.[84] Both works exhibit the same small-scale figure decoration with elaborate iconography which occurs at Reculver, and, as at Reculver, the figures are naturalistically treated without the linear emphasis apparent in earlier manuscript art. On the St. Cuthbert stole, as on

most of the Reculver fragments the figures are compartmentalised, and similar figures in plain rectangular frames are among the Anglo-Saxon additions to the Aethelstan Psalter.[85] Furthermore, on the first Christ in Majesty scene of the Aethelstan Psalter[86] the figures are divided into registers in the same way that the decoration of the Reculver cross must originally have been divided. These general parallels in the organisation of the decoration are augmented by more specific comparisons. For example, one of the figures on the most complete of the two drums from Reculver decorated with pairs of figures separated by a classical column can be compared directly with the figure of the prophet Daniel on the St. Cuthbert stole. Both figures are placed frontally, turning slightly to the right, and with the right hand raised in blessing. Both figures are bearded and wear a full-length robe with an overgarment gathered over the left shoulder and falling obliquely across the legs from left to right. Similar figures occur in the lower register of the first Christ in Majesty scene in the Aethelstan Psalter.

Interesting although these comparisons in organisation and detail between the Aethelstan Psalter, the St. Cuthbert stole and the Reculver fragments are, it is difficult to assess their importance, particularly since no late ninth-century or early tenth-century manuscript from Canterbury, and no ninth-century figure decorated manuscript from Winchester, survives. It is, therefore, difficult to establish whether the Aethelstan Psalter and St. Cuthbert stole stood at the end of a longer tradition, or whether they represent something relatively new in the early tenth century. Certainly the Reculver fragments do have close links with the only ninth-century figure-decorated Canterbury manuscript to survive, B.L. Royal I.E.VI. This manuscript is the mutilated Gospel remnant of a particularly splendid bible probably made at St. Augustine's Abbey, Canterbury, *c.* 820–40.[87] On the one surviving Evangelist page[88] the tympanum of the arch framing the opening of St. Luke's Gospel is filled with a naturalistic half-length bull which is fully modelled, while in the centre of the head of the arch is a roundel containing a human bust which, like the bull, is treated in a naturalistic, classicising manner which precisely parallels the handling of the Reculver figures. Moreover, the bust in the roundel can be directly compared with the busts in the vine scroll at Reculver. Like the Reculver pieces Royal I.E.VI. had an elaborate iconography including a number of full-page miniatures. Although these scenes are now lost, the facing inscriptions survive to identify the subjects, which included the Baptism of Christ[89] and the Annunciation to Zachariah.[90] The Reculver fragments and B.L. Royal I.E.VI. are further linked by their use of the single-lobed pointed leaf which is turned back under its own stem, a feature seen on the vine scroll at Reculver, and in the Canon table arcades of Royal I.E.VI., as well as on other ninth-century works such as the Fuller brooch.[91] These comparisons between the Reculver fragments and Royal I.E.VI. on the one hand, and the Aethelstan Psalter and the St. Cuthbert stole on the other, may serve to suggest a date bracket for the Reculver fragments which would thus be placed in the ninth century.

The link between the Reculver fragments and B.L. Royal I.E.VI. is also significant as the manuscript reveals the sources which seem to lie behind the strongly classicising tendency of both works, sources which appear to be Carolingian. This influence is apparent in the organisation of the manuscript which employs the Carolingian innovation of full-page miniatures in the text.[92] There are also specific links between the miniatures in Royal I.E.VI. and Carolingian art, for example, a

probable lost page with the symbols of the Evangelist surrounding the lamb in Royal I.E.VI. is paralleled in manuscripts of the Tours school.[93] The use of illustrations of the Baptism of Christ and the Annunciation to Zachariah prefacing the Gospels of St. Mark and St. Luke respectively is also best paralleled in Carolingian art. Both the Soissons and Harley Gospels—products of the Court school—have historiated initials with these scenes prefacing the Gospels.[94] There are also detailed resemblances between Royal I.E.VI. and Carolingian manuscript art. For example, on the decorated page opening St. Luke the initial *Q* with an excessively long downstroke resembles some Carolingian initials, while in the Canon tables the lists of numbers run straight down the columns without the usual horizontal dividing lines, again an innovation of Carolingian manuscript art.[95]

The presence in Kent of these two strongly classicising works—B.L. Royal I.E.VI. and the Reculver fragments—which seem to reflect Carolingian artistic trends may provide a context for the classicising capitals from St. Augustine's Abbey, Canterbury (pl. X*a*). These were discovered built into the foundations of the screen of the Romanesque Abbey church during excavations in 1915–16,[96] and consequently have no good archaeological context. They have, therefore, proved difficult to date. The capitals are of a debased Corinthian form, and although there are no comparable pieces from Anglo-Saxon England, debased Corinthian capitals were produced in France from at least the seventh century right up to the eleventh century.[97] The problem with the Canterbury capitals has been to find an historic context into which the introduction of such capitals into England would fit. For this reason they have usually been connected with the building of the octagon by Abbot Wulfric (1047–59), since the design of the building is known to have been influenced by William de Volpiano's St. Benigne at Dijon, begun in 1001, where debased Corinthian capitals are used.[98] H. M. Taylor has, however, pointed out the very close resemblance between the Canterbury capitals and one in the crypt of St. Germain, Auxerre, which can be dated to the period 841–65.[99] Although no ninth-century building is known at St. Augustine's, the production there in the early ninth century of Royal I.E.VI. argues for very strong Carolingian connexions, and provides circumstantial evidence for the ninth-century dating proposed for these capitals by Taylor. In this context it is perhaps worth noting that the columns on two of the Reculver drums also have classicising Corinthian capitals (fig. 6*a*, top left).

Although B.L. Royal I.E.VI. has Carolingian derived elements, it also has a strong Anglo-Saxon element in its ornament, and it is this Anglo-Saxon element which is closely paralleled on a piece of sculpture from Godalming (Surrey) (pl. X*b*).[100] The Godalming piece consists of a stone ring of rectangular section which has a chamfered upper inner edge, and a shallow rebate along the lower inner edge. The outer face of the ring is divided by four equally-spaced animal masks into rectangular fields, each with a broad plain frame. Two of the fields are filled with interlace, one with a biped whose tail develops into interlace, and the fourth with a simple scroll with elongated triangular leaves.

The layout of this scheme very closely resembles that of the arcades containing the Canon tables in B.L. Royal I.E.VI. (fig. 7), which also have the decoration split into a series of rectangular panels with broad, and usually plain frames. As on the Godalming piece each panel is filled either with interlace, animal, or plant ornament. The animals are bipeds, as at Godalming, although here their bodies develop

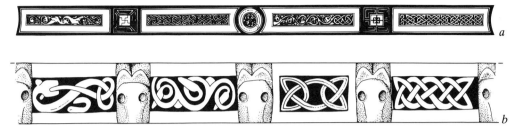

FIG. 7. Comparison of a, the ornament from the Canon table arcades of BL Royal
1.E.VI, f. 41 (slightly simplified), and b, the Godalming piece. Not to scale.

into vine scroll, not interlace. The simple scroll with triangular leaves is also used.
The fields themselves are separated from each other by small square or circular
fields serving the same purpose as the animal masks at Godalming. Animal masks
are used as separators in the arcades framing the Canon tables of B.L. Royal
I.E.VI.,[101] but here they usually divide the ornament within a single field. These
parallels are sufficient to suggest a ninth-century date for the Godalming piece, a
date which is supported by comparison of its animal masks with other examples in
the corpus of southern English pre-Conquest sculpture. Such masks are uncom-
mon, but are found at Limpley Stoke (Glos.),[102] and Deerhurst (Glos.),[103] used as
label stops on hood mouldings. Taylor, following Wilson,[104] regards them as of
eighth- or ninth-century date as such heads can be paralleled in metalwork dating
to before *c.* 900, as on strap-ends from Whitby[105] and Talnotrie,[106] as well as on the
Alfred Jewel.[107] A ninth-century date can also be proposed for a second, fret-
decorated fragment from Godalming.[108]

There remain two fragments of sculpture in Kent which potentially date to
before *c.* 950; the interlace-decorated fragmentary cross shafts from Rochester[109]
and Preston-by-Faversham.[110] The Rochester piece was discovered during exca-
vations at Prior's Gate House near the Cathedral, but was not dateable
archaeologically. The interlace on the remaining decorated face has recently been
reconstructed as an encircled pattern with bifurcating strands,[111] but these bifur-
cating strands are an unnecessary and unlikely complication, and the pattern can
be reconstructed without them. Whatever the precise reconstruction the fine
strand of the interlace can be compared with that used on one of the Reculver
drums, and the piece may, therefore, be tentatively placed in the ninth century.
Similarly, the fragmentary cross shaft of square section from Preston-by-
Faversham (pl. XI*a,b*) is interlace decorated, half patterns of Adcock's types A
and C being used alternately.[112] The use of half patterns is unusual in south-east
England, being paralleled only on one of the Reculver fragments where a half
pattern of Adcock's type D is used. The interlace of the Preston-by-Faversham
shaft has a thicker strand than that used at Reculver, but the design is well worked
out, and may by analogy with the Reculver fragment be assigned to the ninth
century.

Despite the diversity of Kentish sculpture, therefore, there are strong links
between some of the pieces, and in particular between the Reculver fragments, the
Canterbury capitals, and the Godalming pieces. To them the fragments from

Rochester and Preston-by-Faversham are more distantly related. As with the Hampshire material these relationships are not strong enough to suggest that the pieces belong to a single school, but they do appear to belong to the same artistic milieu. As in Hampshire the sculpture of the region is focussed on a major ecclesiastical centre, in this case Canterbury, with the manuscript art of which the sculpture has close relationships. Again the material has a classicising element apparently derived from Carolingian art, although that element is much stronger in Kent than in Hampshire. The parallels and links between the two regions are significant, but it remains to be seen whether these conclusions, based upon a handful of surviving pieces, are substantiated by further discoveries.

Acknowledgements

I am grateful to Dr. D. M. Wilson and Prof. R. J. Cramp for their help and advice during my research. I owe a particular debt of gratitude to Miss M. Budny for discussing with me her work on B.L. Royal I.E.VI. and the manuscripts of the Canterbury school, and for allowing me to use some of her conclusions here. The text has greatly benefited from criticisms offered by Prof. Cramp and Miss Budny. Miss H. M. Humphreys has kindly prepared the figures.

NOTES

[1] T. P. Smith, 'The Anglo-Saxon churches of Bedfordshire', *Beds. Arch. J.* iii (1966), 9, fig. 3.

[2] D. Baker, 'Excavations at Elstow Abbey, Bedfordshire, 1966–8, second interim report', *Beds. Arch. J.* iv (1969), 30–1, pl. Ib.

[3] A. R. and P. M. Green, *Saxon Architecture and Sculpture in Hampshire* (Winchester, 1951), pp. 44–5, pl. XIII.

[4] R. Cramp, 'Anglo-Saxon sculpture of the Reform period', in *Tenth-Century Studies,* ed. D. Parsons (London and Chichester, 1975), p. 192.

[5] *Ibid.*

[6] F. Cottrill, 'Some pre-Conquest stone carvings in Wessex', *Antiq. J.* xv (1935), 144–51.

[7] *Ibid.,* 145–9.

[8] R. Cramp, 'Schools of Mercian sculpture', in *Mercian Studies,* ed. A. Dornier (Leicester, 1977), p. 230.

[9] *Ibid.*, figs. 62f and i, 63g.

[10] *Ibid.*, fig. 61b.

[11] *Ibid.*, fig. 61d.

[12] Leningrad, State Public Library, F.v.I.8. J. J. G. Alexander, *Insular Manuscripts, 6th to the 9th Century,* A Survey of Manuscripts Illuminated in the British Isles, I (London, 1978), no. 39. In particular the two animals seen from above in one of the spandrels of the arcades containing the Canon tables on f.16r, *ibid.,* pl.190, closely resemble the pair of animals seen from above on the St. Oswald's piece.

[13] T. D. Kendrick, *Anglo-Saxon Art to A.D. 900* (London, 1938), pl. XCVII.

[14] M. Biddle and B. Kjølbye-Biddle, *Winchester Saxon and Norman Art* (Winchester, 1973), no. 9, pl. II.

[15] The terminology for animal plant and interlace ornament used here is that to be employed in the forthcoming *Corpus of Anglo-Saxon Sculpture* being prepared for the British Academy by a group of scholars headed by Prof. R. J. Cramp. I am grateful to Prof. Cramp for letting me have a copy of this terminology, and for allowing me to use it here.

[16] *Op. cit.* in n.14, no.9.

[17] F.12v. *Op. cit.* in n.12, no.39, pl. 188.

[18] E. Bakka, 'Some English decorated metal objects found in Norwegian graves', *Årbok for Universitetet i Bergen, Humanistisk Serie*, i (1963), figs. 56–7.

[19] *Ibid.*, figs. 40–3.

[20] *Ibid.*, figs. 44–5.

[21] *Ibid.*, 57–65.

[22] D. A. Hinton, *A Catalogue of the Anglo-Saxon Ornamental Metalwork 700–1100 in the Department of Antiquities, Ashmolean Museum* (Oxford, 1974), no. 18, pl. VIII. If this is a ninth-century piece the unusual spiral form of the scrolls would probably place it in the early part of the century, since by the time B.L. Royal I.E.VI. was made, probably *c.* 820–40, the spiral had dropped out of use in manuscript art. M. Budny and J. Graham-Campbell, 'An eighth-century bronze ornament from Canterbury, Kent', *Arch. Cant.* (forthcoming).

[23] C. A. R. Radford, 'The portable altar of St. Cuthbert', in *The Relics of St. Cuthbert,* ed. C. F. Battiscombe (Oxford, 1956), p. 334, fig. 3, pl. XIX.

[24] *Op. cit.* in n. 12, no. 32, pls. 160–4. Here Alexander dates the manuscript to the late eighth century, but there can be little doubt about its relationship with Trewhiddle style metalwork. D. M. Wilson, *Anglo-Saxon Ornamental Metalwork in the British Museum*, Catalogue of the Antiquities of the Later Saxon Period, I (London, 1964), pp. 25–7. Accordingly I have followed the ninth-century dating proposed by Miss M. Budny who is currently studying the manuscript.

[25] *Op. cit.* in n. 3, pp. 53–4, pl. XVIII.

[26] E. Okasha, *A Handlist of Anglo-Saxon Non-Runic Inscriptions* (Cambridge, 1971), no. 135, pl. 135.

[27] T. Capelle, *Der Metalschmuck von Haithabu* (Neumünster, 1968), no. 72, Taf. 25.1.

[28] Unpublished. It is now on display in the bank. I am grateful to the manager for allowing me access to the piece.

[29] Vatican, Bibl. Apostolica, Barberini Lat. 570, f. 18r. *Op. cit.* in n. 12, no. 36, pl. 170.

[30] *Op. cit.* in n. 18, 37–40, figs. 32–3.

[31] *Op. cit.* in n. 4, pp. 189–91, fig. 19j, pl. XVIII.

[32] B.L. MS. Cotton Vespasian A. VIII, f. 2v. T. D. Kendrick, *Late Saxon and Viking Art* (London, 1949), pl. II.

[33] *Op. cit.* in n. 6, pl. XVIII, 2.

[34] C. Close, 'A cross base at Winchester', *Proc. Hants F.C.* ix (1922), 219–20.

[35] The first well-dated large-scale use of acanthus is on the St. Cuthbert stole and maniple, dated to *c.* 909–16. R. Freyhan, 'The place of the stole and maniple in Anglo-Saxon art of the tenth century', in *op. cit.* in n. 23, pp. 409–32.

[36] M. Calberg, 'Tissus et broderies attribués aux saintes Harlinde et Relinde', *Bulletin de la Société Royale d'Archéologie de Bruxelles,* October 1951, 1–26. D. Tweddle and M. Budny are currently working on these embroideries.

[37] *Op. cit.* in n. 18, 12–15, fig. 8.

[38] J. Graham-Campbell, *Viking Artefacts* (London, 1980), no. 438. Graham-Campbell suggests that the piece may have been made in York, or by an Anglo-Scandinavian craftsman trained in York.

[39] *Op. cit.* in n. 13, pl. LXXXIV, 2 and 3.

[40] Cambridge, Corpus Christi College MS. 183, f.lv. D. T. Rice, *English Art 871–1100* (Oxford, 1952), pl. 47.

[41] W. Rodwell, *Wells Cathedral: Excavations and Discoveries* (Wells, 1980), pl. 7.

[42] R.C.H.M. *Oxford* (London, 1939), p. xix, pl. 9.

[43] *Op. cit.* in n. 32, pl. XXXIV.

[44] E. Roesdahl *et al.* (eds.), *The Vikings in England* (London, 1981), J18, pl. on p. 168.

[45] *Op. cit.* in n. 32, pl. XXXVI, 1.

[46] *Ibid.*, pl. XL, 3.

[47] B.L. MS. Cotton Galba A. XVIII, f.35r. The manuscript is briefly discussed in J. J. G. Alexander, 'The Benedictional of St. Aethelwold and Anglo-Saxon illumination of the Reform period', in *Tenth-Century Studies*, ed. D. Parsons (London and Chichester, 1975), pp. 170–2, pl. IV.

[48] *Op. cit.* in n. 35, pl. XXXIV.

[49] R. J. Cramp, 'Tradition and innovation in English stone sculpture of the tenth and eleventh centuries', *Kolloquium über spätantike und frühmittelalterliche Skulptur*, iii (Mainz, 1972), p. 146.

[50] R. W. V. Elliott, *Runes, an Introduction* (Manchester, 1959), pl. 81.

[51] *Ibid.*

[52] This interpretation is by no means certain. See V. I. Evison's (review of) *Runes, an Introduction*, by Ralph W. V. Elliott, *Antiq. J.* xl (1960), 242–4.

[53] *Op. cit.* in n. 50, p. 81.

[54] *Op. cit.* in n. 26, no. 22, pl. 22.

[55] C. R. Peers, 'Reculver, its Saxon church and cross', *Archaeologia,* lxxvii (1927), 244–6.

[56] L. T. Smith, *The Itinerary of John Leland* (London, 1964), iv, pp. 59–60.

[57] Five of the pieces were probably discovered when in 1876 Hillsborough church, built from the material of the demolished Reculver church, was itself rebuilt. J. Newman, *The Buildings of England, North-East and East Kent* (Harmondsworth, 1976), p. 427. The cross head and leaf-decorated fragment were found during Peers's excavations. *Op. cit.* in n. 55, 253. The last fragment was discovered by Canon Livett in a Canterbury garden. G. M. Livett, 'Sculptured stone from Reculver', *The Kentish Gazette and Canterbury Press,* January 9th 1932, 8, cols. 3–4. For full illustrations see *op. cit.* in n. 55, figs. 7–9, pls. XLI, XLIII, XLIV, XLVI.

[58] J. Beckwith, 'Reculver, Ruthwell and Bewcastle', *Colloquium über spätantike und frühmittelalterliche Skulptur,* i, ed. V. Milojčić (Mainz, 1968), 18, Taf.10.1 and 11.1.

[59] R. N. Bailey, 'The meaning of the Viking-Age shaft at Dacre', *T.C.W.A.A.S.* lxxvii (1977), 61–74.

[60] P. du Bourget, *Early Christian Art* (London, 1972), pl. on p. 165. The iconography of the Sacrifice of Isaac is fully discussed in, A. M. Smith, 'The iconography of the Sacrifice of Isaac in early Christian Art', *American Journal of Archaeology,* ser.2, xxvi (1922), 159–73, and I. S. van Woerden, 'The iconography of the Sacrifice of Abraham', *Vigiliae Christianae,* xv (1961), 214–55.

[61] I am grateful to Ms. M. Gibson for this suggestion.

[62] For a definition and discussion of this type see W. G. Collingwood, *Northumbrian Crosses of the Pre-Norman Age* (London, 1927), pp. 8, 94–8.

[63] *Op. cit.* in n. 55, 247.

[64] *Ibid.*

[65] D. M. Wilson and D. G. Hurst, 'Medieval Britain in 1969', *Med. Arch.* xiv (1970), 161.

[66] H. M. Taylor, 'The position of the altar in early Anglo-Saxon churches', *Antiq. J.* liii (1973), 52–8.

[67] R. J. Cramp, *Early Northumbrian Sculpture* (Jarrow, 1965), p. 3.

[68] E.g. A. W. Clapham, *English Romanesque Architecture before the Conquest* (Oxford, 1930), pp. 56–64.

[69] Cambridge, Corpus Christi College MS. 286. K. Weitzmann, *Late Antique and Early Christian Book Illumination* (London, 1977), pls. 41–2.

[70] F.125r. *Ibid.,* pl. 41.

[71] F.129v. *Ibid.,* pl. 42.

[72] Stockholm, Kungliga Biblioteket MS. A.135. ff. 5r and 150v for example. *Op. cit.* in n. 12, no. 30, pls. 154 and 147.

[73] B.L. Add. MS. 49598, f.4r. F. Wormald, *The Benedictional of St. Aethelwold* (London, 1959), pl. 2.

[74] See p. 36, below.

[75] As on f.2v. *Op. cit.* in n. 47, pl.IVb.

[76] *Op. cit.* in n. 12, no. 30.

[77] *Op. cit.* in n. 47, pp. 170–1.

[78] Florence, Biblioteca Medicea Laurenziana, MS. Amiatinus I. Its exemplar is thought to have been the *Codex Grandior.* R. L. S. Bruce-Mitford, *The Art of the Codex Amiatinus* (Jarrow, 1967), pp. 8–9.

[79] B.L. MS. Cotton Nero D. IV. *Op. cit.* in n. 12, no. 9.

[80] Lichfield, Cathedral Library, un-numbered, p. 218. *Op. cit.* in n. 12, no. 21, pl. 82.

[81] B.L. MS. Cotton Vespasian A. I, f.30v. *Op. cit.* in n. 12, no. 29, pl. 146.

[82] Ff. 9v and 150v. *Op. cit.* in n. 12, no. 30, pls. 147 and 153.

[83] The Psalter is a Carolingian work with additional Anglo-Saxon material, including four miniatures. One is detached, Oxford, Modleian Library MS. Rawlinson B484, f.85. See *op. cit.* in n. 47, p. 171, pl. IVb.

[84] Fully discussed in *op. cit.* in n. 35.

[85] As, for example, on f.3r.

[86] F.2v.

[87] See note 24.

[88] F.43r.

[89] F.30v.

[90] F.44r.

[91] *Op. cit.* in n. 24, no. 153, pl. XLIV.

[92] *Op. cit.* in n. 12, p. 58.

[93] *Ibid.*

[94] *Ibid.*

[95] My thanks to Miss M. Budny for pointing this out to me.

[96] W. St. J. Hope, 'Recent discoveries in the Abbey Church of St. Austin at Canterbury', *Arch. Cant.* xxxii (1917), 24.

[97] D. Fossard, 'Les chapiteaux de marbre du VIIe siècle en Gaule, style et evolution', *Cahiers Archéologiques,* ii (1947), 69–85.

[98] C. R. Peers, 'St. Augustine's Abbey church at Canterbury before the Norman Conquest', *Archaeologia,* lxxvii (1927), 215. For a discussion of St. Bénigne, Dijon see K. J. Conant, *Carolingian and Romanesque Architecture 800–1200* (Harmondsworth, 1974), pp. 149–53.

[99] H.M. and J. Taylor, 'Architectural sculpture in pre-Norman England', *J.B.A.A.* ser. 3, xxix (1966), 47–9, fig. 20.

[100] Unpublished except for a short note in A. Bott, *A Guide to the Parish Church of St. Peter and St. Paul, Godalming* (Godalming, 1978), pp. 12–14, pl. 23.

[101] As on f.4r.

[102] H. M. and J. Taylor, *Anglo-Saxon Architecture* (Cambridge, 1965), p. 390.

[103] E. A. Fisher, *The Greater Anglo-Saxon Churches* (London, 1962), pls. 77 and 80.

[104] H. M. Taylor, *Anglo-Saxon Architecture,* iii (Cambridge, 1978), p. 1057.

[105] *Op. cit.* in n. 24, p. 195, pl. XIX.

[106] *Ibid.,* pl. IVd.

[107] *Op. cit.* in n. 22, no. 23, pls. X, XI.

[108] *Op. cit.* in n. 100, pp. 13–14, pl. 23. Two other pre-Conquest sculptures discovered at the same time are now lost.

[109] A. C. Harrison and D. Williams, 'Excavations at Prior's Gate House, Rochester, 1976–77', *Arch. Cant.* xcv (1979), 34–5, fig. 7, pl. VI.

[110] S. Robertson, 'Preston church, next Faversham', *Arch. Cant.* xxi (1895), 126, and fig. opposite.

[111] *Op. cit.* in n. 109, fig. 7.

[112] G. Adcock, 'Theory of interlace and interlace types in Anglian sculpture', in *Anglo-Saxon and Viking Age Sculpture* (British Archaeological Reports, British Series, 49), ed. J. Lang (Oxford, 1978), fig. 2, 7.

A Carved Slab Fragment from St. Oswald's Priory, Gloucester[1]

Jeffrey K. West

The largely ruined Priory Church of St. Oswald in Gloucester stands to the north-west of the Cathedral precinct. Excavations carried out on and near the site have revealed a number of fragments of early medieval stone carving, in all cases re-used as building material either in the church fabric itself or in the immediate vicinity of St. Oswald's.[2] Possibly the best known of these is the large fragment of a cross-shaft, decorated with animal and interlace ornament, discovered in 1890 and published by Sir Thomas Kendrick in his survey of Anglo-Saxon art up to the year 900.[3] This piece was discussed subsequently by Professor Cramp who also published two fragments of a second cross-shaft discovered separately in 1957 and 1966.[4] The current excavations at St. Oswald's under the direction of Carolyn Heighway have revealed not only a detailed sequence of building activity, but also the largest single collection of carved stone fragments from this site. The two fragments which are the subject of this paper are of particular interest for the richness of their foliate ornament. However, it must be said that the remaining fragments discovered during the current excavations constitute an extremely important collection of architectural sculpture which deserves further study.[5]

The historical data relating to St. Oswald's and to the town of Gloucester in the early middle ages have been set out by Miss Heighway in her Fourth Interim Report on the excavations.[6] It is sufficient here to say that in, or shortly before, the year 909 a minster dedicated to St. Oswald, the seventh-century Northumbrian king and martyr, was founded by Aethelflaed, daughter of King Alfred and wife of Aethelred, ealdorman of Mercia. It was to this minster in 909 that the sacred relics of St. Oswald were brought from their resting place in Bardney.[7]

The current series of excavations on the site has revealed ten successive phases in the history of the fabric of St. Oswald's, dating from its foundation to its post-medieval use as a parish church (fig. 8).[8] It is those phases identified by Miss

41

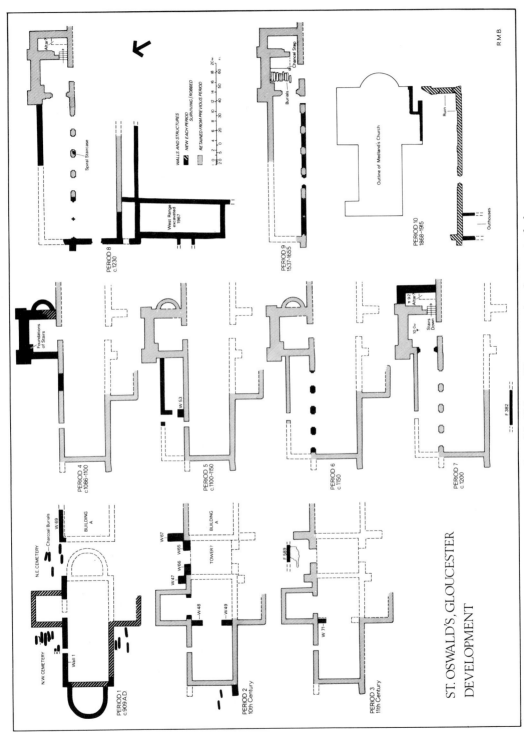

FIG. 8. St. Oswald's Priory, Gloucester: development of plan

Heighway as Periods 2 and 3 which are relevant here. The archaeological evidence for the dating of Period 2 is inconclusive, but it is certain that it post-dates Period 1 of the early tenth century and Miss Heighway considers it unlikely to be later than the mid tenth century.[9] The presence of a floor contemporary with the Period 3 alterations to the fabric, and the existence of a later floor (Floor 4) containing early to mid eleventh-century pottery, indicate a date in the late tenth to early eleventh century for Period 3 work at St. Oswald's.[10]

Additions made to Aethelflaed's minster in Period 2 consisted of the building of a crossing wall, which was straight-jointed onto the nave wall to the west of the north and south porticus. This crossing wall, like the Period 3 crossing wall which superseded it, consisted of limestone blocks and rubble set in mortar.[11] Among the constituent blocks of the north spur of the Period 2 crossing wall (Wall 48) were several re-used fragments, including a small fragment, no. 72, decorated with foliate ornament (pl. XIIa). Similarly, amongst the rubble of the Period 3 crossing wall (Wall 71), the north spur contained a large re-used slab fragment, no. 38 (pl. XIIb), decorated with foliate ornament analogous to that on the smaller fragment no. 72. The re-use of these fragments indicates that they must pre-date the walls in which they were found, thus giving a *terminus ante quem* on stratigraphic grounds of the (?) mid and late tenth to early eleventh centuries respectively.[12] The stratigraphic evidence may be a misleading indication of the date of the primary re-use of the slab fragment, no. 38, as it is likely that material from the Period 2 crossing wall was re-used for a second time in the later Period 3 rebuilding.

Despite their re-use as building material, both the slab fragment no. 38 and the smaller fragment no. 72 are in an easily legible condition. Both fragments are of a local limestone: no. 38 of a coarse 'shelly' limestone known as Minchinhampton stone and no. 72 of a fine oolite known as Painswick stone. These labels do not imply specific quarries, but refer only to types of limestone found on the Gloucestershire escarpment. Both types are still is use and when worked have a similar appearance.[13]

The upper end of the slab is cleanly cut at right-angles to the longitudinal axis (pl. XIIb), whilst the lower end has been broken across the width of the slab, resulting in the right-hand edge being longer than the left. The slab tapers from the upper to the lower end. Three surfaces are decorated: the main upper panel and the chamfered sections of the edges which are separated from the main upper panel by a rounded fillet (pl. XIII). The vertical sides and the back are undecorated and show no evidence of attachment. The smaller fragment no. 72 is badly broken (pl. XIIa), but it has nevertheless retained a good finish on the worked surfaces whose measurements are exactly comparable with those of the slab: namely those of the fillet, decorated chamfer and the undecorated vertical side.[14]

The decorated surfaces of the slab fragment are almost entirely covered with foliate ornament carved in relief and set against a plain background. That of the upper panel is a roughly symmetrical arrangement of foliate motifs around a central element of some complexity. This central stem is broken at two points, at the lower end by a cluster of dots arranged as on a die, and at the upper end by a tri-lobed leaf emanating from a semi-circular cup. From these two points spring the side shoots whose stems and foliate terminals decorate the two halves of the panel. The chamfers carry a two-strand running scroll ornamented with small side shoots which curl back to overlie the main stems. On the right-hand edge the scroll

is continuous, but that on the left-hand edge is interrupted at two points. The first is caused by a four-lobed leaf 'collar' which covers the transition of the scroll from a two-strand to a plain stem. The plain stem is, in fact, the neck of an animal head which curls back to bite the stem just below the leaf collar.[15] The resultant loop causes the second interruption in the running scroll, whilst at the same time acting as a point of departure for a new section of two-strand scroll which is 'hooked' through it. A similar two-strand scroll decorates the chamfered edge of fragment no. 72 and compares well with the scroll above the animal head on the left-hand edge of the slab. The similarities in ornamental detail and the close correspondence of measurement between fragments 38 and 72 is such that it is reasonable to suggest that they were carved in the same workshop, if not by the same hand.[16]

The original function of the slab is uncertain, but so far as is known there is no architectural sculpture of this period which adopts the tapering form. It is therefore more likely that it originally formed part of a piece of church furniture, or that it is a large fragment of a grave cover. Relatively few pre-Conquest decorated slabs survive in southern and midland England and of these perhaps the best known are the three carved slabs on the west tower at Barnack (fig. 9).[17] Here the function of the slabs may be purely decorative and whilst they share with the St. Oswald's example a number of ornamental details, they do not have its tapered shape. The shape of the St. Oswald's slab may be compared with a group of grave

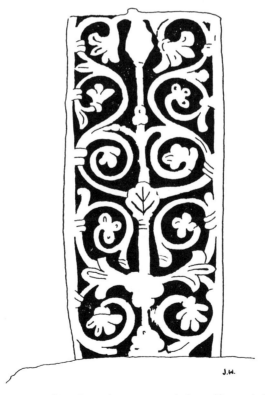

FIG. 9. Barnack (Northants.) tower, south face. Decorated slab.

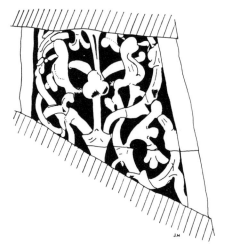

FIG. 10. Braunton (Devon). Decorated slab.

covers located in the Cambridge area (e.g. Milton Bryan, Beds.) even though these are decorated with panels of lattice ornament placed on either side of a longitudinally placed band.[18] Closer comparisons may be drawn with two unpublished slabs, the first from Oxford, now in the Ashmolean Museum, and the second re-used as a lintel in the south tower at Braunton, north Devon (fig. 10). Both of these slabs are tapered and are decorated with foliate ornament. One may also cite the recently discovered slab from the excavations at Wells Cathedral.[19] This piece, although rather crude in execution, has a number of similarities with the St. Oswald's slab.

The design of the main upper panel of the slab is characteristic of tenth-century foliate ornament in southern England. The symmetrical tree scroll of this panel is comparable to those on a number of objects executed in a variety of media dating from the last years of the ninth to the mid tenth century. In addition to those examples executed in stone, namely the slabs from Barnack, Braunton and Wells, and the cross-shafts from Littleton Drew, Todber and Winchester,[20] examples survive in minor art work, notably the engraved back plate of the Alfred Jewel (fig. 11), the Winchester strap-end and the second maniple of the Cuthbert embroideries.[21] The tree scroll used as a border ornament for the dedicatory miniature of the New Minster Charter is more sophisticated, but nevertheless it not only adheres to the symmetrical layout of the earlier examples but also employs early tenth-century foliate motifs with only slight modification.[22]

In nearly all examples of the tree scroll, the central element is presented as a stem punctuated by leaves, clasps or semi-circular cups from which side shoots emerge. While these feature break the continuity of the main stem, they also serve to shield or contain the attachment of side shoots (figs. 9, 10, 12). The use of a cluster of 'dots', or possibly berries, at the lower end of the St. Oswald's slab is most unusual in this context (pl. XII*b*). The Braunton slab, although worn, may represent a second instance of this feature and possibly the foliate panel on the south face of the Barnack tower, a third (figs. 9, 10); however in both cases this detail is barely legible and the outlines suggest that three dots were used rather

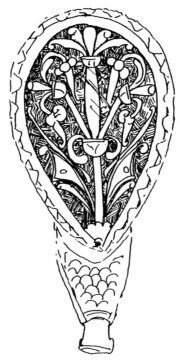

FIG. 11. Alfred Jewel, back plate. Ashmolean Museum, Oxford.

than five. If this identification is correct then one should be wary of attributing to the Gloucester sculptor the innovation of using the berry cluster, which is a motif normally used for subsidiary stem decoration, to enrich the main central stem.

More typical of the devices used to shield the junction of side shoots to the central stem is the three-lobed leaf placed in a semi-circular cup at the upper end of the slab (pl. XII*b*). The cup may be paralleled, in some cases in conjunction with three-lobed leaves, amongst the foliage of the border of the frontispiece to Bede's Life of St. Cuthbert (Cambs. Corpus Christi Coll. MS. 183, fol 1 ᵛ) of the third decade of the tenth century, or the earlier Alfred Jewel back plate (fig. 11).[23] A similar motif occurs on the Wells slab and as a side shoot terminal in the decoration of the tree scroll on the slab on the south face of the Barnack tower (fig. 9).[24] The three-lobed leaf of the Gloucester example is represented as if hollowed out and the side shoots and the continuation of the main stem issue from within it. An analogous arrangement has been used at the lower end of the second maniple of the Cuthbert embroideries (fig. 12).[25] Hollowed out leaves are also used for the leaves of the side shoots in the upper part of the panel and together with that on the main stem are representative of the classicizing, Carolingian-derived leaves found in early tenth-century manuscripts such as the Corpus Christi MS. 183 border panels and the initials of the Junius psalter (Oxford, Bodleian Lib. MS. Junius 27).[26]

Two other significant leaf types occur on the St. Oswald's slab. The first are the 'angled tendrils' terminating the side shoots which emerge from the three-lobed leaves already mentioned, and the second are the blossoms or leaf flowers which

PLATE XII

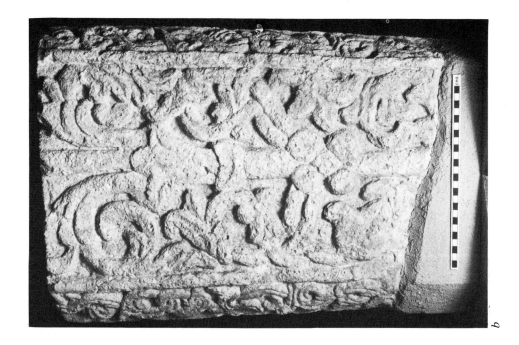

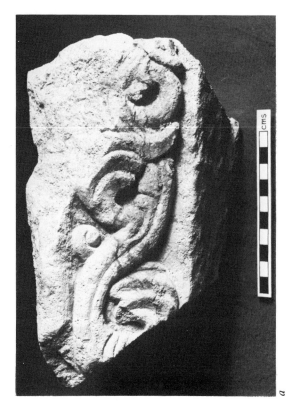

a. Slab fragment no. 72
b. Fragment no. 38

St. Oswald's Priory, Gloucester

PLATE XIII

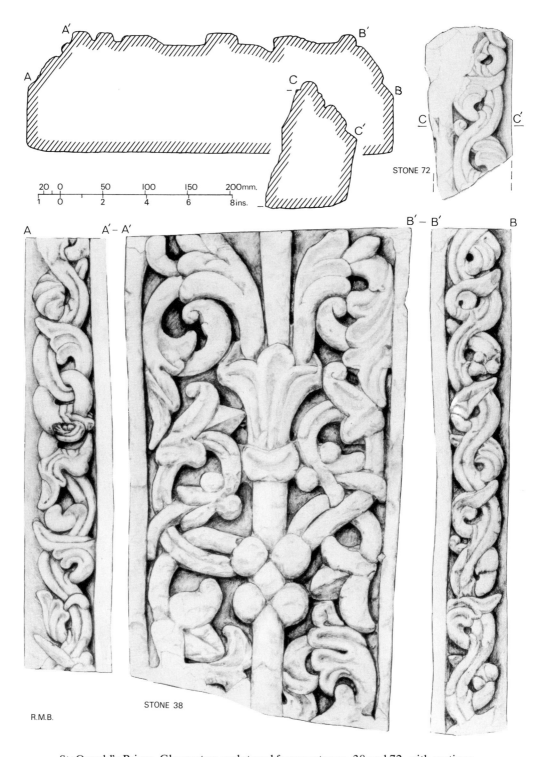

STONE 72

20 0 50 100 150 200mm.
1 0 2 4 6 8ins.

A A' – A' B' – B' B

STONE 38

R.M.B.

St. Oswald's Priory, Gloucester: sculptured fragments nos. 38 and 72, with sections

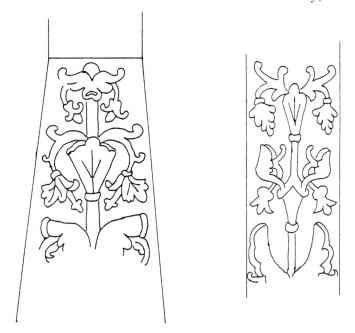

FIG. 12 (left). Cuthbert embroideries, Maniple II, tab (after Mrs. Crowfoot).
FIG. 13 (right). Cuthbert embroideries, Maniple II, detail (after Mrs. Crowfoot).

lie on either side of the semi-circular cup towards the middle of the slab (pl. XII*b*). The tendrils, with their tightly scrolled ends, have stems modified on one side by an angular projection. This motif, which Hinton calls a 'lobed pelta-leaf', has parallels in late ninth- and early tenth-century objects, but seems to have gone out of fashion in this form by the mid tenth century.[27] Again, it is the Alfred Jewel back plate and the Cuthbert embroideries, in this case the first maniple, which provide comparable motifs (fig. 11).[28] Other examples may be found on the crest of the tenth-century beast-head label stop at Deerhurst, Glos., the East Stour cross-shaft (now in the British Museum) and an initial 'D' from the Junius psalter (f. 118).[29]

The Cuthbert embroideries also provide a comparison for the blossoms of the second type. This motif is altogether more rare than the angled tendrils. It is made up of a two-petalled flower with an elongated pistil with two lobes or circular leaves replacing the sepals at the base of the flower, one on either side of the stem. The eastern origin of this motif has already been pointed out by Freyhan in his discussion of the second maniple which provides a particularly close comparison (fig. 13).[30] However, while it shares a number of similarities with the Byzantine composite flower noted by Freyhan, it lacks its exuberance and variety. Comparable blossoms may be found in the ornament of the carved fragments from the bath at Khirbat al-Mafjar, built by the Umayyad caliph Hisham, between 724 and 743,[31] and in the gold setting of an early seventh-century pectoral, now in Berlin, but thought to have been made in Constantinople.[32] In both cases the blossoms share with the Cuthbert maniple and the Gloucester slab the same simplicity of treatment and the same arrangement of component leaves.

Even though this 'eastern derived' blossom was not widely used in tenth-century ornament, other examples may be seen in the Corpus Christi MS. 183 frontispiece border panels and the Junius psalter initials.[33] However, with the possible exception of the Cuthbert maniple, none of these examples has the clearly defined circular lobes at the base of the flower. The single leaved Mercian flowers, themselves of eastern origin, seen on the ninth-century slab at Acton Beauchamp (Hereford) have lobes similar to that on the Gloucester slab, but the flower as a whole is quite different.[34] Although the influence, or adaptation, of Mercian ornament must not be rejected, the Cuthbert maniple and the St. Oswald's slab may represent a fresh, albeit short-lived, wave of eastern influences.

On the evidence of the comparisons drawn for the upper panel alone, the St. Oswald's slab must be dated to the early tenth century. The ornament of the chamfers and the smaller fragment no. 72 does not detract from this view (pl. XIII). The foliate ornament of the chamfers and fragment 72 is for the most part comparable with that on the upper panel. The two strand stem of the scroll and the double folds which bind the side shoots to the main stem are similar to that used in the mid ninth-century cross-shaft fragment from St. Oswald's published by Professor Cramp.[35] The same double binding is used for the same purpose in the scrolls of the Corpus Christi MS. 183 border panels.[36] The single animal head on the left-hand chamfer of the slab has no particularly distinguishing features and appears to be of a common early tenth-century type such as can be seen in the initials of the Junius psalter.[37]

In view of the similarities between the decoration of the St. Oswald's slab and the Cuthbert embroideries, it is interesting to speculate on their possible significance. The familial relationship between Aethelflaed, founder of St. Oswald's, and Aelfflaed who commissioned the embroideries, suggests in the light of the comparisons drawn between the slab and the second maniple that they also shared a common artistic taste.[38] Admittedly both pieces employ foliate motifs in common with other early tenth-century objects and yet the second maniple displays the earliest extant use of the eastern derived blossom known to me in English ornament. The inclusion of such an innovatory motif in the decoration of the Gloucester slab suggests, if not a direct connection between these works, then a common source of ornamental motifs which may in all probability be attributed to workshops associated with these two patrons. One might perhaps air the largely overlooked suggestion made by C. F. Battiscombe in the publication of the Relics of St. Cuthbert, that the embroideries might alternatively be attributed to Aethelflaed of Mercia,[39] even though no documentary evidence can be cited to demonstrate that Aethelflaed either used, or was referred to, by the name Aelfflaed, embroidered into the end panels of the stole and the first maniple.[40]

Comparisons with other tenth-century works, in particular the Corpus Christi MS. 183 frontispiece, further suggest that the ornament of the St. Oswald's slab and the smaller fragment no. 72 should be seen as being contemporary with the comparative material cited. The stratigraphic evidence and the close correspondence between the fragments in measurement and ornamental detail indicate a possible date for their re-use in the mid tenth century. Taken together, the evidence suggests that the slab and the fragment no. 72 should be dated to the early tenth century and a date in the early 930s seems most likely.

NOTES

[1] This paper is entirely based on an earlier article which formed part of the fifth interim report on excavations at Gloucester: J. West, "The sculpture" in C. Heighway 'Excavations at Gloucester: Fifth Interim Report. St. Oswald's Priory 1977–78', *Antiq. J.* lx (1980), 207–26. I should like to express my thanks to Carolyn Heighway and Richard Bryant for allowing me to re-use the material prepared for that publication of the stones which are the subject of this paper, and for the use of the illustrations which appear here as pls. XII, XIII and fig. 8. My thanks are also due to Professor R. Cramp who made several helpful comments on the first draft of the earlier article and who acted as chairman for the section of the seminar in which this paper was presented. I should also like to thank those whose comments at the seminar have enabled me to make some modifications to my original lecture.

[2] C. Heighway *et al.*, 'Excavations at Gloucester: Fourth interim report. St. Oswald's Priory, Gloucester 1975–1976', *Antiq. J.* lviii (1978), 107. The reference in n. 10 to H. Medland 'St. Oswald's Priory, Gloucester', *Trans. Bristol and Glos. Arch. Soc.* xviii (1888–9), should read: xiii (1888–9). For clarification of the location of these finds, see Heighway, *op. cit.* (1980), n. 16.

[3] T. D. Kendrick, *Anglo-Saxon Art to A.D. 900* (London, 1938), p. 187, pl. LXXXVII; Heighway, *op. cit.* (1980), 16.

[4] R. Cramp, 'Schools of Mercian sculpture' in A. Dornier (ed.), *Mercian Studies* (Leicester, 1977), p. 230, figs. 62, 63; *ibid.*, p. 255; and R. Cramp 'Anglo-Saxon sculpture of the Reform period' in D. Parsons (ed.), *Tenth Century Studies* (London and Chichester, 1975), pp. 189–91.

[5] In addition to the fragments of architectural sculpture, excavations of the Period 7 alterations revealed a number of re-used stones, amongst them a beast's head label stop possibly of the late eleventh century, in perfect condition (Heighway, *op. cit.,* 1980).

[6] Heighway, *op. cit.* (1978), 118–25.

[7] *ibid.*, 118.

[8] Heighway, *op. cit.* (1980), 208 ff.

[9] *Ibid.*

[10] *Ibid.* and A. Vince in Heighway, *op. cit.* (1978), Appendix I.

[11] Heighway, *op. cit.* (1980), *loc. cit.*

[12] *Ibid.*

[13] Fragment no. 38 was less deeply buried when re-used than no. 72, which may account for the greater degree of weathering.

[14] Dimensions. No. 38:- length: right, 58 cm., left, 50 cm.; width: 39–43cm.; average thickness: 13.5 cm. Panel:- length: as slab; width: 27–29.5 cm. Fillet:- width: 2 cm.; height: approx. 2 cm. Chamfer:- length: as slab; width: 7 cm. Side:- length as slab; width: 8 cm. No. 72:- length: approx. 17 cm. Fillet:- width: 2 cm.; height: approx. 2 cm. Chamfer:- width: 7 cm. Side: width 8 cm.

[15] This is the only instance of animal ornament on either fragment 38 or 72.

[16] In my original discussion of this aspect of the St. Oswald's fragments I suggested that this correspondence was sufficient to indicate that the fragments came from a single work. Professor Zarnecki has pointed out to me that the identification of two types of stone might equally indicate the probability that the fragments come from two stylistically related objects. I am unaware of any instances in which more than one type of stone has been identified in the production of a single object from the early medieval period. The analysis of stones used in objects composed of more than one block would clarify this question, especially when, as here, the different stones take on a similar appearance when worked.

[17] For the most recent discussion of the Barnack slabs see R. Cramp, in D. Parsons (ed.), *op. cit.* (1975), pp. 192ff.; see also *idem*, 'Tradition and innovation in English stone sculpture of the tenth and eleventh centuries' in K. Milajcik (ed.), *Kolloquium über spätantike und frühmittelalterliche Skulptur,* iii (Mainz, 1972), pp. 139–48.

[18] T. D. Kendrick, *Late Saxon and Viking Art* (London, 1949), p. 82, pl. LIV; C. Fox, 'Anglo-Saxon monumental sculpture in the Cambridge district', *Cambs. Antiq. Soc. Proc.* xxiii (1920–21), 15ff.

[19] 'Medieval Britain in 1979', *Med. Arch.* xxiv (1980), 230. I am grateful to Dr. Richard Gem for drawing my attention to this piece and to Dr. Warwick Rodwell for supplying me with photographs.

[20] Littleton Drew: T. D. Kendrick, *op. cit.* (1938), pl. LXXXIV; Winchester: *ibid.*, pl. LXXXV; Todber: R.C.H.M., *Dorset* iv (1972), p. 114, pl. 2.

21 For the Alfred Jewel, see D. Hinton, *A Catalogue of the Anglo-Saxon Ornamental Metalwork 700–1100 in the Department of Antiquities, Ashmolean Museum* (Oxford, 1974), cat. no. 23, pp. 41ff., pl. XI. For the Winchester strap-end, see D. Wilson 'A Late Anglo-Saxon strap-end' in M. Biddle, 'Excavations at Winchester 1968', *Antiq. J.* xlix (1969), 326–8, pl. LXVII. For the Cuthbert embroideries, see C. F. Battiscombe (ed.), *The Relics of St. Cuthbert* (Durham and Oxford, 1956), pls. XXXI. 3, XXXII.

22 B.L.MS. Cott. Vesp. A. VIII, f. 2ᵛ,, E. Temple, *Anglo-Saxon Manuscripts 900–1066* (London, 1976), cat. no. 16, illus. 84.

23 Temple, *op. cit.* (1976), cat. no. 6, illus. 29; see also an important recent article by J. Higgitt, attributing this manuscript to a Glastonbury scriptorium, J. Higgitt, 'Glastonbury, Dunstan, monasticism and manuscripts', *Art History*, ii, no. 3 (Sept. 1979), 275ff., esp. 278; for the West Country interests in St. Cuthbert, see C. Hohler, 'Some service books of the later Saxon church', in D. Parsons (ed.), *op. cit.* (1975), p. 70.

24 Fig. 9, left-hand side, bottom row.

25 Battiscombe (ed.), *op. cit.* (1956), pl. XXXI. 3

26 F. Wormald, 'Decorated initials in English manuscripts from A.D. 900 to 1100', *Archaeologia*, xci (1945), 107ff., esp. 116–9, and F. Wormald, in P. Clemoes and K. Hughes (eds.), *England before the Conquest* (Cambridge, 1971), p. 307; Temple, *op. cit.* (1976), illus. 29 and illus. 1, 23, 26.

27 Hinton, *op. cit.* (1974), p. 7; e.g. the Abingdon Sword: *ibid.,* pl. Ia; the Alfred Jewel back plate: *ibid.,* pl. XIc; the East Stour cross-shaft: R. Cramp, in D. Parsons (ed.), *op. cit.* (1975), pl. XVIIIb. The latest example of the angled tendril known to me is on the decoration of the arches of f. 1ᵛ of the Rabanus Maurus MS. (Cambs. Trinity Coll. MS.B.16.3), Temple, *op. cit.* (1976), cat. no. 14, illus. 48.

28 Battiscombe (ed.), *op. cit.* (1956), pl. XXXIV, in particular those above and below Deacons Peter and Lawrence.

29 H. M. and J. Taylor, *Anglo-Saxon Architecture,* i (Cambridge, 1965), p. 196, illustrated by G. Zarnecki, *Later English Romanesque Sculpture 1140–1210* (London, 1953), pl. 8; R. Cramp, *op. cit.* (1975), pp. 89–91, pl. XVIIIb; Temple, *op. cit.* (1976), illus. 26.

30 R. Freyhan, 'The place of the stole and maniples in Anglo-Saxon art of the tenth century' in Battiscombe (ed.), *op. cit* (1956), pp. 413–4, pl. XXXI. 3, third branch counting from the tab at the bottom end of the maniple; see also review of Battiscombe (ed.), *op. cit.* by D. H. Wright, *Art Bulletin*, xliii, no. 2 (June 1961), 141–60, esp. 155ff.

31 R. W. Hamilton, *Khirbat Al Mafjar* (Oxford, 1959), pp. 7, 144ff., figs 94, 104, 105, 199, pls. XXVI, XXVII. I am grateful to Katherine Galbraith for drawing my attention to this publication.

32 K. Weitzmann (ed.), *Age of Spirituality: Late Antique and Early Christian Art, Third to Seventh Century* (New York, 1979), cat. no. 296, pl. VIII.

33 Temple, *op. cit.* (1976), illus. 29; in particular the top left- and the top right-hand side panels; *ibid.,* illus. 20; also the Helmingham Orosius (B.L.MS. Add. 47967), *ibid.,* cat. no. 8 and Wormald, *op. cit.* (1945), pl. Va. A similar blossom occurs on the Barnack slab (fig. 9), second row from the top, left-hand side.

34 Two examples occur on the Cuthbert stole above the prophets Joel and Amos: *Relics,* pl. XXXIV; for Acton Beauchamp see R. Cramp in A. Dornier (ed.), *op. cit.* (1977), p. 230, fig. 61 d; see also the Ormside cup, *ibid.,* p. 206, and T. D. Kendrick, *op. cit.* (1938), pl. LX (centre). Even though this motif occurs in insular manuscripts, e.g. the Book of Kells (Durham Trinity Coll. Lib. MS.A. 1.6f. 114ʳⁱ; F. Henry, *The Book of Kells* (1974), p. 209, pl. 45) it is also of eastern origin; see for example the eighth-century wooden panels from Masjid al Aqçâ in L. Golvin, *L'architecture religieuse musulmane*, ii (1971), pl.25.2, and the reverse of the reliquary cross of Justin II (565–78), W. Volbach, *Propyläen Kunstgeschichte,* Band 3 (1968), p. 194, pl. 69; and O. M. Dalton, *Byzantine Art and Archaeology* (1961), p. 548. For a discussion of this motif see M. Schapiro, 'Decoration of the Leningrad Manuscript of Bede', *Late Antique, Early Christian and Medieval Art: Selected Papers,* iii, (London, 1980), pp. 199ff., esp. p. 205 (first published in *Scriptorium,* xii, no. 2 (1958), 191f.). An early example of this motif can be seen on the side panel of a limestone coffin from Jerusalem, of the first century A.D., now in the British Museum.

35 R. Cramp in A. Dornier (ed.), *op. cit.* (1977), p. 225, pl. 61 a.

36 Temple, *op. cit.* (1976), ilus. 29, upper panel left-hand side.

37 *ibid.,* illus. 20–22.

38 Heighway, *op. cit.* (1978), 118; and Battiscombe (ed.), *op. cit.* (1956), 13; Aethelflaed was the

sister-in-law of Aelfflaed, wife of Edward the Elder; see D. Whitelock, *English Historical Documents,* i (1979), Table 2 b; see also F. M. Stenton, *Anglo-Saxon England* (Oxford, 1971), pp. 324ff.

[39] Battiscombe (ed.), *op. cit.* (1956), 13, n. 3

[40] The entry in the Dictionary of National Biography (1889) under Ethelfleda gives three spellings for Aethelflaed of Mercia, one of which is Aelfled.

II. ROMANESQUE

Introduction

If the papers in this section do not give a balanced picture of current research in the field (there are, for example, no contributions dealing with the north of England), they may be said to be thoroughly representative of the type and quality of research that is being done. They share a number of elements in common, notably the fact that in all but one case the works considered are totally new discoveries. Even the contribution that does not fall into this category, Jill Franklin's discussion of the sculpture from Norwich cathedral cloister, is a sort of discovery out of neglect. One of these capitals was published by George Zarnecki in *English Romanesque Sculpture* in 1951, but up to now no one has followed this lead and investigated the group as a whole. The two other papers delivered at the seminar are concerned with actual discoveries resulting from archaeological excavations. Jane Geddes reminds us that fragments of Romanesque sculpture frequently turn up in excavations carried out for the Department of the Environment, but that all too often such discoveries do not receive the attention they deserve, and their publication is limited to the appendix of an excavation report. Clearly, an occasional review of the sort presented here is a valuable exercise, and we may hope that such a survey can be undertaken regularly. A spectacular archaeological discovery is a quite different matter, and it is with one such that Deborah Kahn deals. In what is an important, but none the less only preliminary, presentation of the material from the St. Alban's chapter house we are introduced to one of the most exciting discoveries of recent years. The quality of this sculpture is immediately apparent, and it is already clear that the St. Albans material will have to be taken into account in any future assessment of English Romanesque style as a whole.

Section IV includes two papers on Romanesque material which were not delivered at the seminar, both of which deal with what might be termed accidental discoveries (pp. 190, 198). Eileen Roberts continues the St. Albans theme, with a discussion of the two voussoirs found in a hotel during building works, and which very probably came from St. Albans abbey. Richard Morris introduces us to a still more remarkable chance find, a virtually complete tympanum by a sculptor of the Herefordshire school. This again is only a preliminary publication, and we await the full study which will deal with other recent discoveries of Herefordshire sculpture.

Another factor which links several of the contributions is the existence of quite extensive traces of paint on a number of the pieces. It is always difficult, and normally impossible, to be certain that paint on medieval sculptures is original, but in the case of excavated pieces we at least know that it is old. The importance of paint in medieval sculpture is becoming more and more apparent, and the number of recorded examples is now very large. It seems almost certain that some at least of this paint is original, and it may very well be that subsequent repaintings adhered largely to original colours. There is clearly considerable scope for extensive scientific investigation of the nature of these painted surfaces, and it is also perhaps time that some brave soul undertook an overall survey of surviving painted sculpture, in order to see if any general conclusions can be drawn.

Within the overall framework of Romanesque sculpture, current research in England can be seen to be extending the range of material available for study. However, the framework itself remains that established in the immediate post-war period by George Zarnecki. Inevitably, this has required occasional adjustment, in terms of re-datings and re-assessments, and many of these alterations have been the work of George Zarnecki himself or of his students. They have not called into question the basic structure. Perhaps, therefore, the only cause for regret is that English Romanesque sculpture has yet to achieve the recognition which its distinctive characteristics deserve. It is of course true that there is nothing to match Moissac or Autun in England, but it is increasingly clear that we are not dealing with a purely provincial and debased version of a style which achieved its true and pure expression in France. English Romanesque manuscript painting has long been regarded as the equal of anything found on the Continent, while the idiosyncratic virtues of English Romanesque architecture have gained an increasing following over the years. As more research is done, and as more discoveries of the quality of those presented here are made, perhaps English Romanesque sculpture will come to be generally appreciated for its own, very special, qualities.

ALAN BORG

The Romanesque Cloister Sculpture at Norwich Cathedral Priory

Jill A. Franklin

When in 1150 the Norwich monk, Thomas of Monmouth succeeded in persuading his superiors to authorise the translation of St. William's remains from the monks' cemetery to the Chapter House,[1] he undoubtedly hoped thereby to have increased the Cathedral Priory's prestige and financial prospects. In pressing for the translation to take place and later recording its circumstances and consequences, Thomas was perhaps unaware that the recently murdered child's eligibility for sainthood was extremely questionable. His account of William's life and miracles is nevertheless of value in that it includes incidental references to the otherwise undocumented Romanesque cloister at Norwich.[2]

None of the Cathedral Priory's original conventual buildings has a documented date. The church itself was begun in 1096 by Bishop Herbert de Losinga.[3] Before his death in 1119,[4] Herbert had built westward in the nave to the altar of the Holy Cross, having also constructed the episcopal palace.[5] He was succeeded in 1121 by Bishop Eborard who completed the church before leaving office in 1145.[6] It is generally assumed that the construction and decoration of the cloister took place during Eborard's episcopate.

Apart from its refaced perimeter walls, nothing of the twelfth-century cloister survives intact. Its masonry arcades were gradually dismantled and replaced by the existing, partially glazed structure between 1279 and 1430.[7] In the summer of 1900, while the Gothic cloister buttresses were undergoing repairs, it was discovered that a number of elaborately carved, twelfth-century double capitals had been trimmed and redeployed as building material during the construction of the later arcades.[8] A total of fourteen Romanesque double capitals were eventually brought to light, together with five nook-shaft capitals and a large number of decorated voussoir and jamb fragments.[9]

The fourteen damaged double capitals are presumed to have belonged to the

56

arcades of the Romanesque cloister. With two exceptions, one member of each pair would originally have been a historiated block capital and the other an undecorated 'cushion'. The capitals show that the arcades were supported by twin, cylindrical shafts and provide the only evidence for such an arrangement in an English cloister which is datable to the first half of the twelfth century.

A wide range of motifs and themes occurs on the capitals and the character of the relief sculpture varies accordingly from a type that is shallow and calligraphic to one which is carved to a depth of three or four centimetres. Despite this diversity, it is possible to see the decoration on eight of the capitals as the work of a single, gifted sculptor. Included in this group of eight is one bearing a design of adorsed and interlaced dragons. This motif has been likened to that on the Pitney brooch,[10] thereby linking the capital to the small group of objects whose common characteristics constitute the 'English Urnes' style. In that it is the only surviving piece of sculpture at Norwich which could be said to exhibit Scandinavian taste or influence, this capital typifies the preference for variety demonstrated by the entire series. It is representative again in that the best parallel for its delicacy and decoration is to be found in the realm of the 'minor arts'.

Three of the capitals bear somewhat undistinguished scenes of combat or hunting but on several of the others, despite the poor condition of much of the sculpture, the imagery is more suggestive. Still discernible on the decorated faces of one capital, for example, are the vestiges of a centaur, a naked figure and a seated archer with a quiver strapped to his back. Various episodes from pagan mythology are suggested by characters of this kind, such as the killing of Nessus by Hercules after the centaur's attempted abduction of Deianira. Whatever the identity of the archer on the Norwich capital, the posture he adopts is certainly intriguing (pl. XIV*a*). Unlike the seated crossbowmen depicted at Moissac and elsewhere who use their feet simply to brace the bow while loading an arrow,[11] the Norwich archer is actually firing his three arrows with the aid of his feet. There seems to be no close or contemporary European parallel for this example of 'pedestrial archery',[12] although its practice among Brazilian Indians was observed and recorded in the nineteenth century (pl. XIV*b*). The foot bow is, however, referred to by several authors in antiquity who plainly regarded it as unorthodox, if effective, and peculiar to specific non-Hellenic peoples.[13] It was undoubtedly a powerful weapon and one that might well have impressed a twelfth-century iconographer as the perfect symbol with which to epitomize the strength of an exceptional archer such as Hercules.

The similarity between some of the Norwich sculpture and the Romanesque cloister doorways of Ely Cathedral has been recognised for a considerable time.[14] The connection is seen at its strongest when the decoration on the jambs of the Prior's doorway at Ely (pl. XV*a*) is compared with a group of carved fragments at Norwich, also presumably from the jambs of a cloister doorway (pl. XV*b*). Despite differences of detail, in both cases the vertical scroll motif is rendered in a similar manner.

Given the proximity of the two East Anglian cathedrals, the inference has been that the carving at both represents the output of a single, locally based sculpture workshop.[15] For several reasons, the position is not explicable in quite these terms. For example, within that same group of fragments at Norwich where the affinity with the Ely carving is most appreciable, a distinctive motif occurs which cannot be

found at Ely but which does appear on one of the capitals believed to have come from Hyde Abbey (pl. XVIa,b). It consists of a fruit cluster, hooded by a scalloped leaf with a tiny volute, and on both the Winchester capital and the Norwich fragment it takes a very similar form. In a number of respects, in fact, the Ely sculpture cannot be regarded as the sole stylistic source for the Norwich capitals and fragments, nor are several of the features which characterise the Ely carving taken up at Norwich in the way that one might expect, had they been products of a single regional workshop. For instance, the treatment of foliage at Ely is so idiosyncratic that it stands out as the hallmark of the sculptors who executed the cloister doorways. Nevertheless, it was not reiterated at Norwich. The elaborated trefoil ornament, often referred to as the Byzantine Blossom, occurs frequently and in many forms at both Ely and Norwich but it is not in itself a reliable indicator of regional affiliation. Within the first half of the twelfth century, examples of it in stone sculpture can be found in places as far apart from each other as Winchester, Durham, Reading and Northampton.[16] Moreover, there is one variety of trefoil at Norwich for which Hyde Abbey again, rather than Ely, provides the closest parallel (pl. XVIIa,b).

Above all, it is the figure sculpture at Ely and Norwich which is not closely comparable and the disparity is only partly attributable to differences of scale and architectural context. There are two discrete figure styles at Norwich, the more successful of which is very fine (pl. XVIIIa). On three of the capitals it occurs in conjunction with a drapery style whose distinguishing features are its double-line creases and flattened box-folds. Comparisons for this type of drapery, combined with the gentle naturalism of the finer figure style, are not forthcoming in English Romanesque stone sculpture, but some may be found among the ivory carvings with a probable English provenance which were produced during the first half of the twelfth century.

On one end panel of a whalebone portable altar in the British Museum, the Virgin and Saint John attend the crucified Christ (pl. XVIIIb). The figures of the Apostles depicted on the long sides of the altar have been convincingly compared to some of the façade sculpture of Lincoln Cathedral.[17] The treatment of the figures and drapery on the Crucifixion panel is perceptibly different from that of the Apostles, however, and is more comparable with some of the capital sculpture at Norwich. In the Deposition scene depicted on an ivory panel in the Pierpont Morgan Museum, two figures kneel at the foot of the Cross (pl. XIXa). The attitude of these figures, their dress, and the treatment of drapery and other details provide a close parallel for another example of the most skilful Norwich sculptor's work (pl. XIXb). On one other ivory carving (pl. XXa), the pierced fragment found at St. Albans in 1920, the small figure dressed in a tunic and clasping the stem which surrounds him recalls the composition on one face of a capital at Norwich, where, as on the ivory, trefoils are encircled and penetrated by symmetrical scrolls (pl. XXb). Although these last two objects differ from each other in a number of respects, no better comparison for the motif on the capital can be found in Romanesque stone sculpture. This connection between the decoration of the finest of the Norwich capitals and the ivory carving of the period would be significant even if the picture were not greatly distorted by the loss of so much English Romanesque sculpture.

None of the twenty-five decorated voussoirs at Norwich would appear to have

PLATE XIV

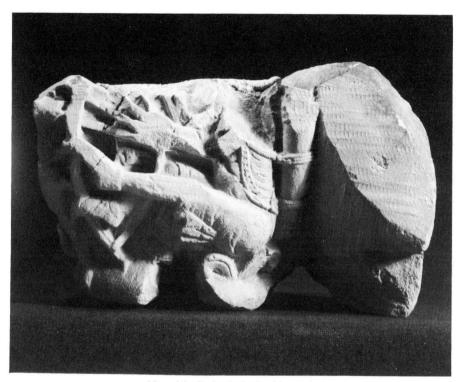

a. Norwich Cathedral: double capital

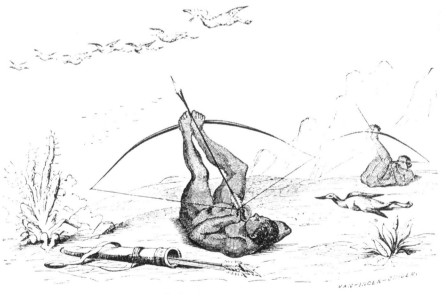

CABOCLO ARCHERS.

b. 'Pedestrial archery', after Kidder and Fletcher, *Brazil and the Brazilians* (1857)

PLATE XV

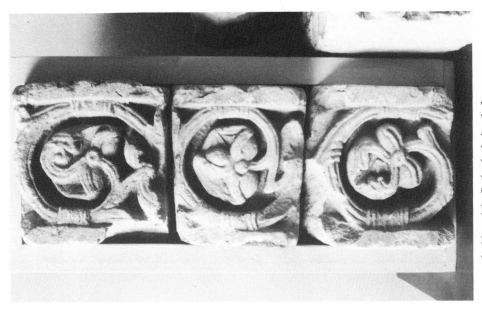

b. Norwich Cathedral: jamb fragments

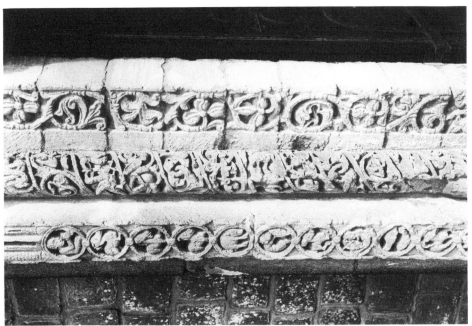

a. Ely Cathedral: Prior's doorway, west side.

PLATE XVI

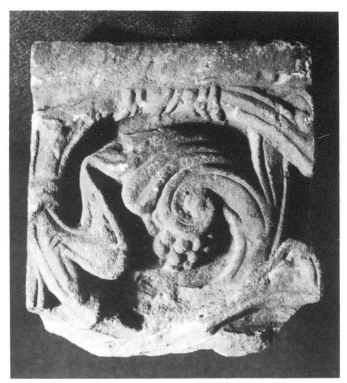

a. Norwich Cathedral: jamb fragment

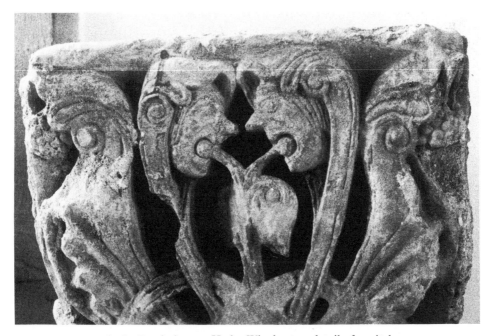

b. St. Bartholomew Hyde, Winchester: detail of capital

PLATE XVII

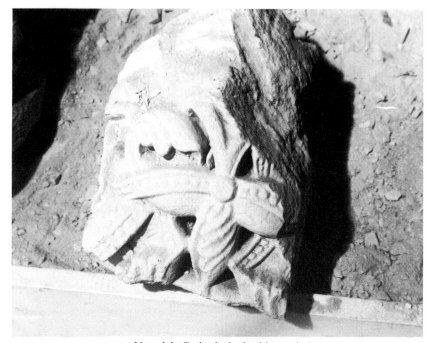

a. Norwich Cathedral: double capital

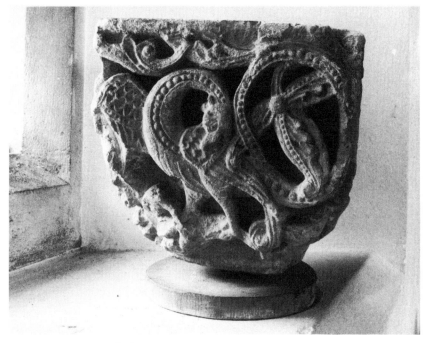

b. St. Bartholomew Hyde, Winchester

PLATE XVIII

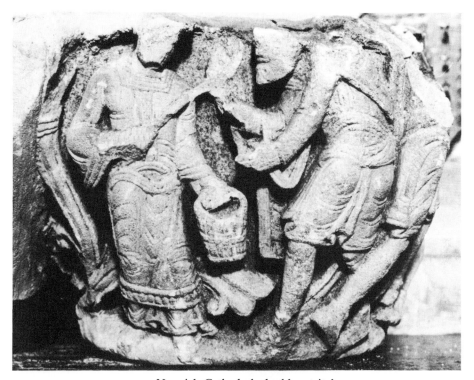

a. Norwich Cathedral: double capital

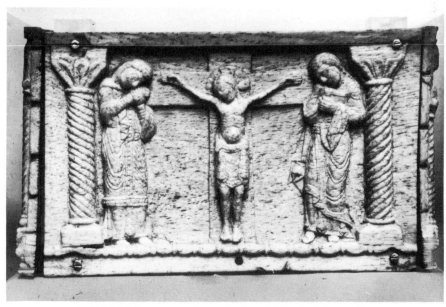

b. British Museum: end panel of portable whalebone altar

PLATE XIX

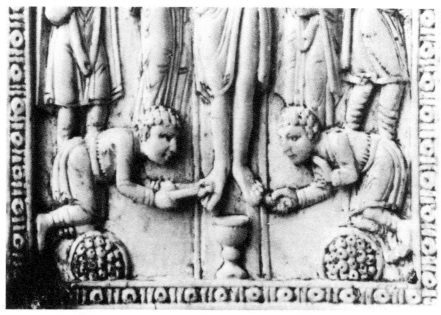

a. Pierpont Morgan Library, New York: detail of ivory panel

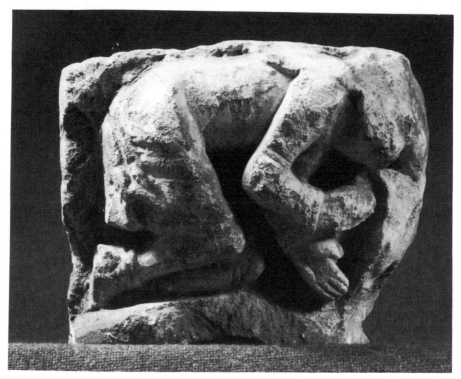

b. Norwich Cathedral: nook-shaft capital

PLATE XX

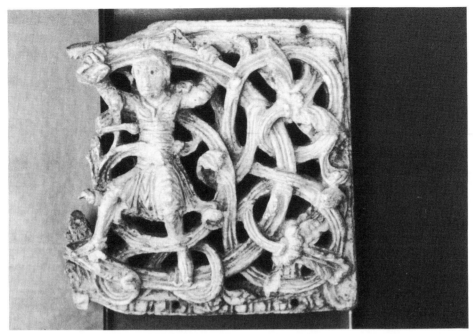

a. British Museum: pierced ivory fragment

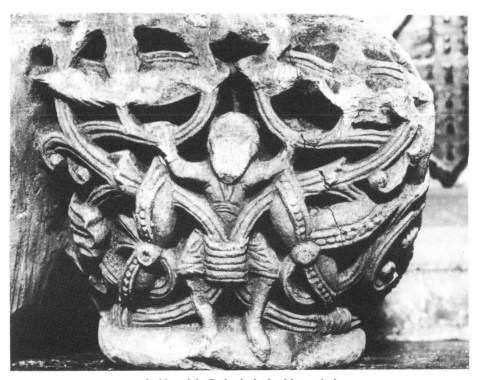

b. Norwich Cathedral: double capital

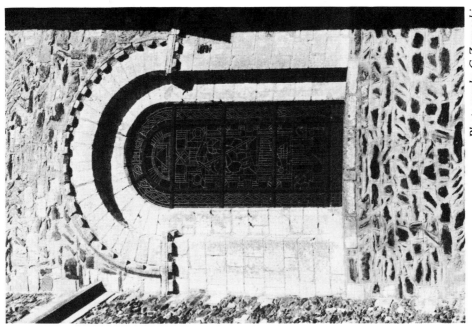

PLATE XXI

Photograph: G Zarnecki

b. Cérisy-la-Forêt; ground-floor axial windows, east end

a. Norwich Cathedral: voussoirs

belonged to the twelfth-century cloister arcades.[18] All were squared off for reuse as building material but it can still be ascertained that they constituted orders with a diameter of between two and three metres. Each of the Romanesque cloister doorways was dismantled during the fourteenth and fifteenth centuries but, in terms of scale, the only suitable provenance for orders of the size predicted by the voussoirs would seem to be the original chapter house, assuming this to have had a triple opening, as did the building which replaced it on the same site in the late thirteenth century. The voussoirs can be subdivided into five distinct categories but all twenty-five have decorative features in common and together form a fairly coherent group (pl. XXI*a*). All of them may be seen as elaborations of dice and billet mouldings, with the addition of foliate ornament in the chamfered interstices.[19] There is, incidentally, nothing at Ely which resembles them.

Since the projecting elements on some of the voussoirs are keeled, it might seem unlikely that the entire series could have been carved much before the middle of the twelfth century, given that the earliest securely datable keeled mouldings in England appear in the chapter house of Durham Cathedral between 1133 and 1140.[20] However, keeled billet occurs long before this in Normandy, on the exterior of the east end of Cérisy-la-Forêt (pl. XXI*b*), a building which is generally dated on stylistic grounds to the 1080s.[21] With late eleventh-century Norman precedent for the more ornate keeled billet at Norwich, it now seems that the carving of the Norwich voussoirs might be more appropriately located in the earlier part of the twelfth century.

Despite the fact that, as a hagiographer, Thomas of Monmouth unavoidably lacks credence, his narrative does provide a trustworthy *terminus ante quem* of 1150 for the construction and decoration of the cloister arcades. It is far less easy to determine when, during the preceding half-century, work on this project might have commenced. The estimated date of *c.* 1140 which has been ascribed to the Norwich capital sculpture derives largely from the view that the Norwich carving is stylistically dependent upon that of the cloister doorways at Ely,[22] but also from the assumption that it was Bishop Herbert's successor, Eborard, who built the cloister, after he had completed the nave of the church at some time between 1121 and 1145. The execution of the Romanesque doorways at Ely is, again, undocumented but it has been suggested that this took place *c.* 1135.[23] It is possible to argue that a somewhat earlier date than this would be more appropriate but the question warrants far more attention than may be devoted to it here. It can fairly be said, however, that there is other sculpture at Ely, very close in quality and character to that of the doorways, for which any date later than *c.* 1110 would now be considered unacceptable.[24] A point such as this, like the revised dating of Anselm's crypt capitals at Canterbury,[25] inevitably unsettles an established chronology and it is on this basis that the dating of the Norwich cloister fragments requires re-examination. Granted that sculpture of the calibre of the Ely doorways, if not the doorways themselves, was in production in England by the second decade of the twelfth century, the implications for the dating of the Norwich capitals are considerable, since the Romanesque sculpture at the two cathedrals is certainly comparable in terms of quality. The supposition implicit in this is that it was Herbert, rather than Eborard, who began the construction of the cloister arcades, having already enclosed the garth with the claustral ranges and the south nave wall. Given the size of the monastic community at Norwich,[26] the practical

and liturgical importance of the cloister walks and the length of Herbert's episcopate, these are not unreasonable assumptions. However, the relevant documentary and architectural evidence is slight and tantalisingly inconclusive.

References to both the monastic buildings[27] and the cloister[28] occur in several of Herbert's letters, but it is never clear whether these are merely metaphorical allusions or whether they in fact refer to existing physical structures. Equally ambiguous is the fact that de Losinga is credited with having 'laid down' the monastic and episcopal offices apart from one another in order to safeguard the privacy of the monks.[29] While this cannot confirm that he did any more than dictate where these buildings should lie, it can at least be said that the surviving portions of the claustral ranges contain no decorative or constructional feature which would preclude them from belonging to Herbert's building campaign. As for the south wall of the nave, only its first four or five bays are generally attributed to Herbert, the supposition being that his work on the main arcades and nave walls would have been virtually coterminous.

Before putting this assumption to the test, it may be mentioned that the south nave wall possesses the only surviving architectural feature which relates specifically to the erection of the cloister arcades, for it retains evidence that the sills of the ground floor windows overlooking the garth were raised in order that they might clear the cloister roof. Yet again, however, little can be deduced from this.[30]

It cannot, in fact, be automatically assumed that Herbert's work on the nave walls only kept pace with that on the main arcades. The relevant bays of one of the nave walls of a monastic church not infrequently went up in advance of the rest of the western arm, expressly because they also constituted one of the boundary walls of the cloister.[31] This could have been the case at Norwich also, for the architectural evidence is inconclusive.[32] Furthermore, the documented building break in the main arcades may have occurred before Herbert's death in 1119, perhaps as soon as the Bishop had achieved some limited objective such as the completion of the liturgical choir and nave sanctuary.[33] Thereafter, Herbert might have turned his full attention to the construction of the monastic buildings throughout the time that remained to him.

To conclude, it would seem at the very least that the authorship of the cloister is not unequivocally attributable to Herbert de Losinga's successor. This simply suggests that the *terminus post quem* for the carving of the cloister capitals should be pushed back from *c.* 1135[34] to some point in the second decade of the twelfth century. The decoration of these capitals is more elaborate and refined than anything assignable to Herbert within or on the Cathedral itself, but the same can be said in relation to those portions of the building which might reasonably be ascribed to Eborard. Thus the discrepancy between the sculptural ornament of the church and that of the cloister need not be indicative of any appreciable difference in date. The premise that work on the cloister sculpture was under way before the core of the Cathedral had been completed implies that the team of sculptors responsible for the decoration of the cloister was not in fact drawn from the body of stone masons engaged on the building of the church but was composed of men with a different skill. Their training appears to have been as closely allied to that of the ivory carver and metalworker as to that of the stone mason. It would also seem that the Norwich cloister sculptors were as familiar with motifs occurring at Winchester as with anything at Ely. This tends to weaken the concept of the

homogenous, East Anglian school of Romanesque carving, indicating instead that a twelfth-century sculpture workshop might have comprised a somewhat more cosmopolitan and itinerant membership, perhaps recruited *ad hoc* for the execution of a specific monument.

NOTES

[1] Thomas of Monmouth, *The Life and Miracles of St. William of Norwich,* ed. A. Jessop and M. R. James (Cambridge, 1896), p. 127.

[2] *Ibid.,* pp. 137, 188.

[3] Bartholomew de Cotton, *Historia Anglicana,* ed. H. R. Luard (Rolls Series, xvi, 1859), p. 54.

[4] H. W. Saunders, *The First Register of Norwich Cathedral Priory* (Norfolk Record Society, xi, 1939), f.9d, p. 56.

[5] *Ibid.,* f.8, p. 50.

[6] *Ibid.,* f.9d, p. 57 and f.13, p. 70.

[7] William of Worcester, *Itineraries,* ed. J. H. Harvey (Oxford, 1969), p. 396.

[8] The discovery of some of the capitals in June 1900 is recorded in extracts from the Chapter Minutes held by Mr. A. B. Whittingham.

[9] Most of the capitals and fragments are illustrated in the catalogue of the exhibition entitled 'Medieval Sculpture from Norwich Cathedral', held in 1980 at the Sainsbury Centre for Visual Arts, University of East Anglia.

[10] G. Zarnecki, *The Sources of English Romanesque Sculpture* (Actes du XVIIème Congrès international d'histoire de l'art, The Hague, 1955), p. 176, figs. 4 and 5, where both objects are illustrated.

[11] The examples at Moissac occur on a double capital in the west cloister arcade. Archers in a similar pose appear at Compostela (G. Gaillard, *Les Débuts de la Sculpture Romane Espagnole* (Paris, 1938), pl. 108) and at S. Sernin, Toulouse (R. Rey, *La Sculpture Romane Languedocienne* (Paris, 1936), fig. 65).

[12] The term is taken from W. M. Moseley, *An Essay in Archery* (1792), pp. 86 ff. I am most grateful to Robin Emmerson for his comments and suggestions on this point.

[13] Kurdish archers fired their arrows with the help of their feet, according to Xenophon, *The Persian Expedition,* book IV, ch. II. Arrian ascribes a similar method to the infantrymen of India (*Indica,* book XVI).

[14] G. Zarnecki, *The Early Sculpture of Ely Cathedral* (London, 1958), p. 33.

[15] G. Zarnecki, *English Romanesque Sculpture* (London, 1951), p. 39, n.79.

[16] For an illustration of the example at Durham Cathedral, G Zarnecki, *op. cit.* (1951), pl. 60; at Reading, L. Stone, *Sculpture in Britain in the Middle Ages* (1972), pl. 37; at St. Peter's, Northampton, H. P. Maguire, 'A twelfth-century workshop in Northampton', *Gesta,* ix, 1 (1970), 11–25, fig. 6.

[17] P. Lasko, 'An English Romanesque portable altar', *Apollo* lxxx (1964), 489–95.

[18] Between 1348 and 1349, the monastery augmented its income by selling off one hundred and fifty-nine large voussoirs (E. C. Fernie and A. B. Whittingham, *Communar Rolls of Norwich Cathedral Priory* (Norfolk Record Society, xli, 1972), Introduction, p. 38). These could well have constituted one or more of the dismantled cloister arcades which were still in the process of being replaced by the existing structure at that time.

[19] The relationship between the Norwich voussoir fragments and the decorated doorways of a small group of parish churches in south-east Norfolk is discussed and illustrated in the unpublished M.A. dissertation, J. Franklin, *The Romanesque Cloister Sculpture of Norwich Cathedral* (University of East Anglia, 1980).

[20] K. Galbraith, *Notes on Sculpture in Durham,* March 1977, p. 14 (British Archaeological Association Conference paper, unpublished).

[21] *Congrès Archéologique,* lxxv, 2 (1908), pp. 545–6.

[22] G. Zarnecki, *op. cit.* (1958), p. 49, note to pls. 66–7.

[23] *Ibid.,* p. 36.

[24] The reference is to the carved capitals in the first eastern bays of the north and south transept tribunes which are illustrated in G. Zarnecki, *op. cit.* (1958), pls. 14–16. Professor Zarnecki points out that the relationship between the carving on these capitals and that of the doorways is indeed so close that all should be seen as the work of a single sculptor. The upper storeys of the transepts were probably completed, and thus the capitals carved and in place, by *c.* 1110 (*ibid.,* p. 16).

[25] G. Zarnecki, 'A Romanesque capital from Canterbury at Chartham', *Archaeologia Cantiana,* xcv (1979), 6.

[26] H. W. Saunders, *op. cit.,* f.1d, p. 24.

[27] E. M. Goulburn and H. Symonds, *The Life, Letters and Sermons of Bishop Herbert de Losinga* (Oxford and London, 1878), i, p. 101.

[28] *Ibid.,* pp. 26, 101, 105, 136 and 139.

[29] H. W. Saunders, *op. cit.,* f.1d, p. 24.

[30] The miscalculated length of the windows was rectified by the insertion of several courses of Norman ashlar and this infill is still discernible in the original windows surviving in the west wall of the south transept, as well as in two of the south aisle windows. Evidently the cloister walks could not have been roofed until this adjustment had been made. The westernmost aisle window in which the blocking is still partially visible is that in bay six, all successive windows having been extensively remodelled. If, as is under discussion, Herbert built the first ten bays of the nave to the level of the tops of the windows at least, then he might also have corrected his own mistake. Alternatively, according to the view that Herbert and Eborard share responsibility for these ten bays, bay six might as easily represent the end of Herbert's campaign as the beginning of Eborard's.

[31] The priories at Binham and Castle Acre provide local and roughly contemporary examples of this practice (H. Ingleby, *A Supplement to Blomefield's Norfolk* (London, 1929), pp. 324–7 and 318–24).

[32] There is some indication of a building break in the nave arcades which could represent the end of Herbert's documented campaign. Above each minor pier rises a single, attached shaft. At tribune level, the second minor pier is wider to the west of the shaft than to the east. This overall increase in width is repeated above all the successive piers of the north arcade, whereas on the south side the extra width generated by the error is distributed between both minor and major piers.

On the south wall of the nave at a comparable point, the profile of the arch moulding on the blind arcading which runs beneath the aisle windows differs slightly in bays three and five from that which survives in all preceding and successive bays, that in bay four having been restored. The arch moulding in these two bays is of a type used extensively on the exterior of the building and at high levels within it. What this temporary change in moulding type in the south aisle represents, it is difficult to determine, but it cannot be taken as firm evidence that the construction of the nave wall was interrupted at this point.

[33] E. C. Fernie, 'The Romanesque piers of Norwich Cathedral', *Norfolk Archaeology,* xxxvi (1977), 383 ff.

[34] The date hitherto proposed for the Ely doorways, as mentioned above.

Recent Discoveries of Romanesque Sculpture at St. Albans

Deborah Kahn

In 1977 the Cathedral Council of St. Albans applied for permission to build a chapter house and visitors' centre on the vacant site to the south of the south transept. Their plans were approved on condition that the site first be excavated, and this was done in the following year, under the direction of Professor Martin Biddle and Birthe Kjølbye-Biddle.[1] The excavation revealed the plans of successive medieval chapter houses, the last of which was demolished soon after the dissolution of the monastery in 1539 (fig. 14).[2]

The earliest structure found on the site was an apsed chapter house built between 1077–88 by Abbot Paul of Caen (d. 1093).[3] This building was extended, probably to accommodate a growing number of monks, and work had begun on a second extension when Robert of Gorham, abbot from 1151 until his death in 1166, undertook its completion (fig. 14).[4] The *Gesta abbatum* records that Robert was buried at the feet of his predecessor, Abbot Paul, in the chapter house which he, Robert, had built from its foundations.[5] All the carved stones from the medieval chapter house, together with the fine pavement, were dismantled following the excavation and are now stored in the Verulamium Museum at St. Albans. Although so very fragmentary, the excavated remains of this chapter house give some information about the building and its decoration.[6]

From the few English Romanesque examples that survive, it is evident that the chapter house was among the most richly decorated buildings in the monastic complex.[7] In the early twelfth-century chapter house at Worcester, this was achieved with banded, multi-coloured stone, and wall paintings.[8] At Durham, about 1130–40, chevron was used in abundance, and in the apse a row of Atlas figures supported the vaults.[9] In the third quarter of the twelfth century at Bristol (pl. XXII), Much Wenlock and Rochester, the walls were enriched with tiers of blind arcading and geometric carving.[10] At the close of the century the chapter house at St. Mary's Abbey, York, seems to have been lavishly decorated. The

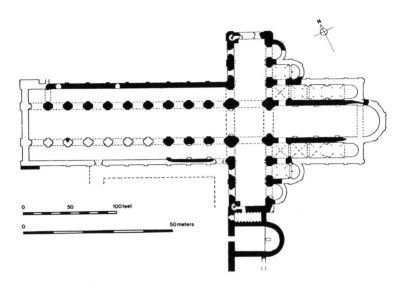

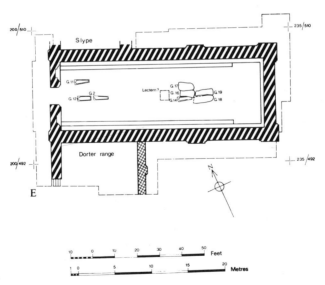

FIG. 14. *Top*. General plan of St. Albans Abbey (now Cathedral) to show position of chapter house.
Bottom. The plan of Robert of Gorham's chapter house (1154–66) as revealed by excavation in 1978 (after M. Biddle and B. Kjølbye-Biddle).

entrance arches still survive, as do the celebrated figures of prophets and apostles which probably supported the vault there, as at Durham.[11]

Chapter houses of the Romanesque period were entered from the cloister through a doorway in the west wall and, depending on the position of the cloisters, the chapter house was to the south, as in most cases, or to the north of the church. Flanking the entrance of Romanesque chapter houses were two (occasionally more) window-like openings (pl. XXII). Such openings doubtless improved the lighting of the interior which, because of its position between other buildings, received little direct light. In most cases the windows were in the east end, or high in the west wall above the cloister roof. The principal function of these lower openings on either side of the doorway was, however, to allow brethren in the cloister and those in the chapter house to communicate on certain occasions, as for instance that described in Lanfranc's *Monastic Constitutions*:

> When the servers rise from supper they go into the church past the chapter house. As they pass the chapter house they shall bow profoundly. But at the door of the chapter house they shall draw themselves up and bow towards the east in the usual manner. The brethren who are sitting in the chapter house shall rise and bow profoundly to them as they pass.[12]

No doubt partly because of the ceremonial function of the chapter house doorway and its adjoining arches, they were frequently richly decorated. In some cases they were even more sumptuous than the main entrance to the church, as at St. Georges de Boscherville in Normandy, where the church doorway has carved capitals and arches, but plain columns, while the chapter house entrance and flanking openings not only have richly decorated arches and elaborate historiated capitals, but also column figures.[13]

The excavations at St. Albans supplied little information about the appearance of the west wall of the chapter house as seen from the cloister. The only decoration on the west wall which came to light was an exterior buttress at the extreme north of the west wall carved with two bands of beaded fret confronted at the angle (pl. XXIII*a*). Similar complex geometric motifs exist on the castle doorway at Durham of about 1165.[14] I know of no parallel for carving in this position; certainly the use of sculpture on an external buttress suggests that it was a lavishly decorated building.

Apart from the fact that there was a central doorway flanked by openings nothing is known about their enrichment, but it can be assumed by analogy with other such doorways that it was the focus of the whole decoration. We are on firmer ground as regards the eastern, internal face of the doorway, for from the surviving bases it is clear that there were columns, no doubt richly carved, and these must have supported appropriately decorated capitals and arches. The surviving chapter house doorway at Rochester, roughly contemporary with that at St. Albans, is decorated on both its east and west faces as well as on the inner faces supporting the arch (pl. XXIII*b*), and it is likely that the inner faces of the arches at St. Albans were also carved.

Two complete lower courses of masonry were found *in situ* in the angle of the north and west walls of the building (pl. XXIV*a*). The jamb carved with two bands of beaded chevron confronted at the angle was clearly part of the inner arch of the north opening.[15] A half-colonette carved with veined and beaded stalks, forming a

curled, interlacing pattern, supported another arch in this opening. Plinths exca-
vated on the south side of this opening corresponded to the chevron jamb and
carved colonette on the north. Adjoining the corner jamb and colonette, at a
slightly higher level on the north internal wall, other carved stones were found *in
situ* (pl. XXIV*a*). These have three-dimensional chevron, each V of which is filled
with a leaf. The blocks rested on the bench on which the monks sat and may have
formed the outer arch of the north recess, since they correspond to the plinth on
the south side of the north opening which projects furthest into the chapter house.

In most surviving chapter houses elaborate carved decoration is found only on
the external, west face of the west wall, while the internal walls had, at best,
intersecting arches as their principal decoration. The position of the fragmentary
sculpture at St. Albans demonstrates, however, that in this case carving was also
applied to the east face, and that it was extended almost to floor level and included
delicately carved colonettes and jambs.

Two historical facts help to date the chapter house. Robert of the Chamber, the
father of the English pope, Adrian IV, was a monk at St. Albans and died at the
abbey during his son's pontificate, that is between 1154 and 1159.[16] He was
buried in the chapter house, and his grave was found beneath the tiled floor which
Professor Biddle believes is contemporary with the twelfth-century structure.[17]
From this it can be deduced that the rebuilding was executed between 1154/9 and
1166.[18]

Abbot Robert gained new privileges for his monastery, obtaining complete
exemption from episcopal supervision so that the abbey was subject to Rome
alone.[19] After an investigation, the king assented to the abbot's wearing full
episcopal garb, which Robert did for the first time at Easter Mass, 1163.[20] This was
obviously a moment of great significance for the abbey. Perhaps it is not too
fanciful to suggest that the rebuilding of the chapter house to so sumptuous a
design was begun in anticipation of the new status of the abbey, about 1160.

Carved fragments of varying sizes were discovered immediately within the west
doorway, lining a grave. There is some uncertainty about the person for whom this
grave was intended. Professor Biddle has suggested to me that it may have been
constructed for Abbot Thomas de la Mare (d. 1396) who bought a stone for his
own grave at the entrance to the chapter house but who was in fact buried in the
church.[21] Since the motifs and style of several of the pieces recovered from the
lining of the grave are remarkably similar to the carved stones found *in situ* in the
chapter house it follows that they might originally have formed part of the chapter
house. However, there is no evidence of any work being done on the chapter house
between Abbot Robert's reign and the middle of the fifteenth century. From the
character of the pieces lining the grave, it can be deduced that at least some of
them were part of a doorway with engaged shafts, or possibly a cloister arcade. It is
known that Thomas' successor, John de la Moote, while still prior and thus before
1396, rebuilt both the range of the cloister outside the chapter house, and a chapel
dedicated to St. Nicholas.[22] As it happens, the predecessors of both this cloister
range and the chapel were structures which had been built by Abbot Robert. It is
therefore likely that at the time of Thomas de la Mare's death the debris from one
of Abbot Robert's buildings was at hand for making the grave.

Many of the pieces found in the grave retain traces of pigment. The lining of the
grave was made with a mixture of tile, brick and mortar, and the broken pieces of

PLATE XXII

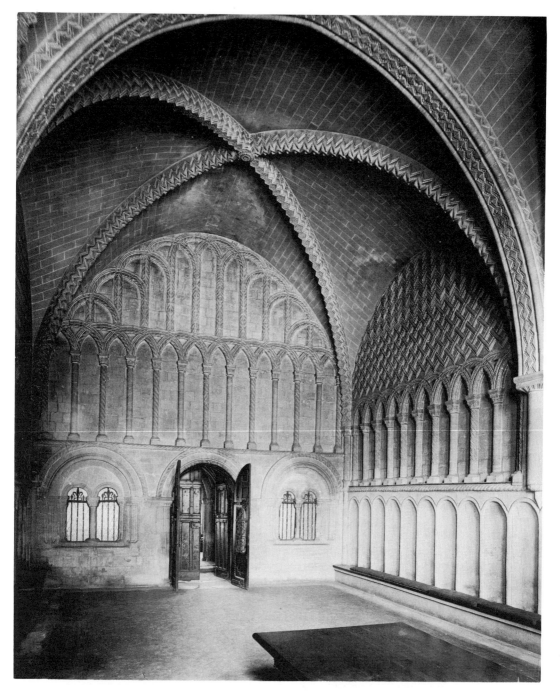

Bristol Abbey (now Cathedral): north and east walls of chapter house

PLATE XXIII

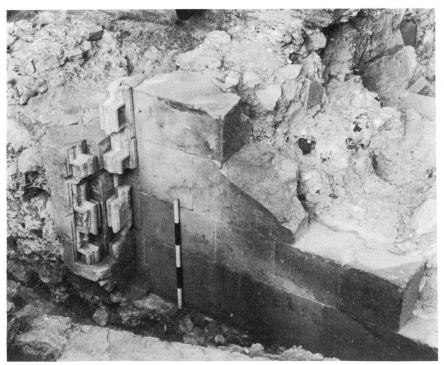

Photograph: M. Biddle

a. St. Albans Abbey (now Cathedral): decorated buttress on west wall of chapter house

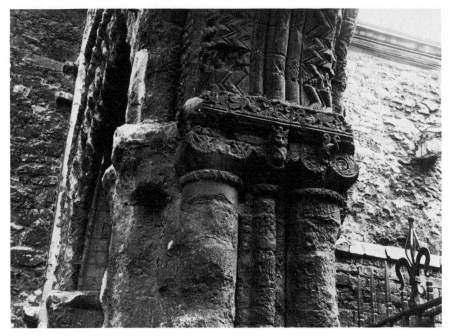

b. Rochester Cathedral: north side of chapter house entrance

PLATE XXIV

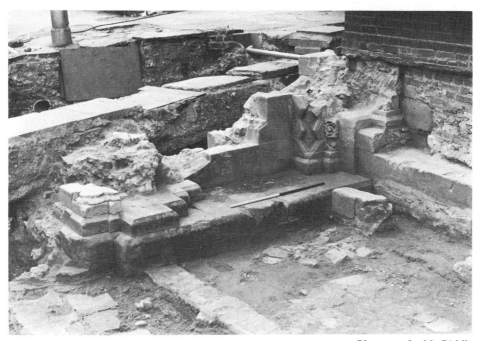

Photograph: M. Biddle

a. St. Albans: north and east interior walls of chapter house

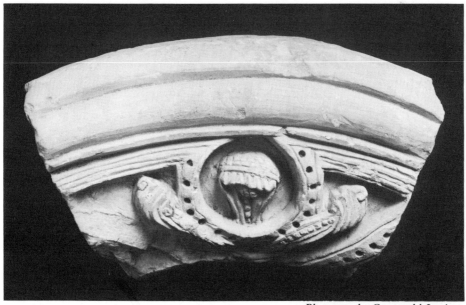

Photograph: Courtauld Institute

b. St. Albans: fragment 2024

PLATE XXV

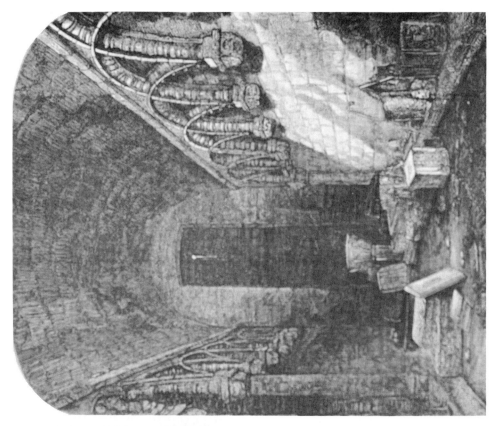

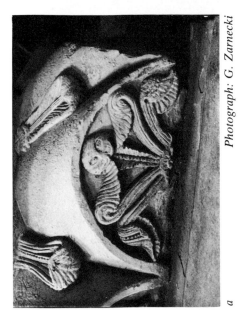

Photograph: G. Zarnecki

a. St. Mary, Aylesbury: detail of font base
b. St. Albans Abbey: engraving of slype (*The Builder*,
xiv (1856), 331)

a

b

PLATE XXVI

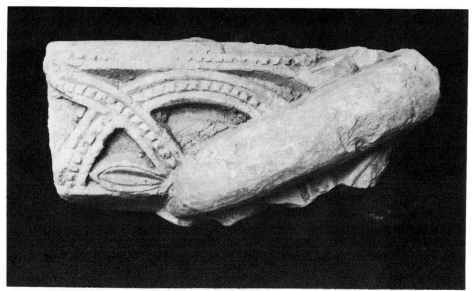

a. Fragment 2067

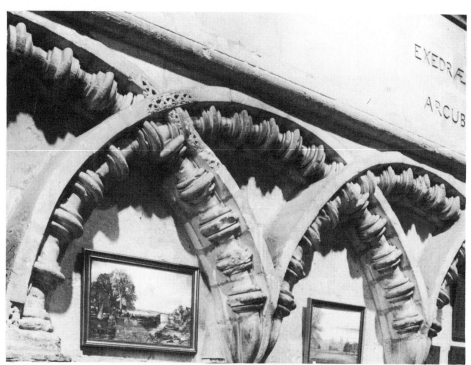

b. Detail of south wall of slype before demolition in 1980

St. Albans Abbey

Photographs: Courtauld Institute

PLATE XXVII

a. Fragment 2212

b. Fragments 2221 and 2222

b. Fragment 2224

St. Albans Abbey

Photographs: Courtauld Institute

PLATE XXVIII

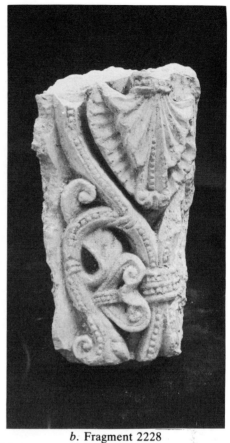

a. Fragment 2210

b. Fragment 2228

St. Albans Abbey

Photographs: Courtauld Institute

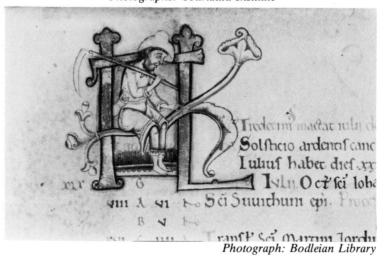

Photograph: Bodleian Library

c. Bodleian Library, Oxford: detail of MS. Auct. D. 2.6, f.4ᵛ

PLATE XXIX

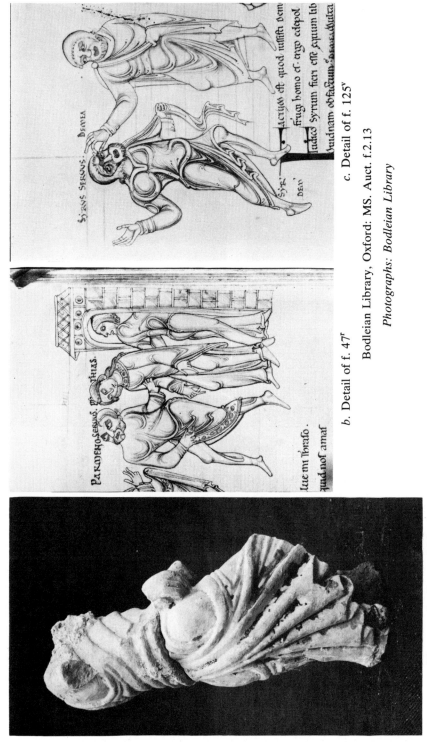

b. Detail of f. 47ʳ

Bodleian Library, Oxford: MS. Auct. f.2.13

Photographs: Bodleian Library

c. Detail of f. 125ᵛ

Photograph: Courtauld Institute

a. St. Albans Abbey: fragments 2154 and 2155

PLATE XXX

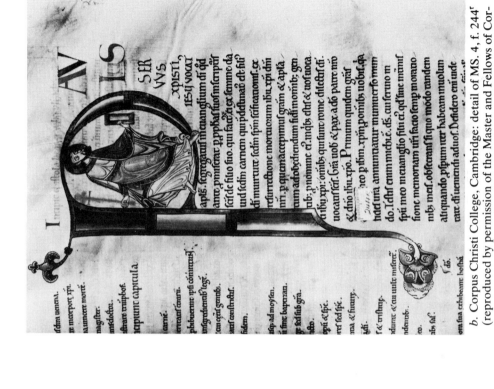

b. Corpus Christi College, Cambridge: detail of MS. 4, f. 244ʳ
(reproduced by permission of the Master and Fellows of Corpus Christi College)

Photographs: Courtauld Institute

a. St. Albans Abbey: fragments 2150, 2151
and 2152

PLATE XXXI

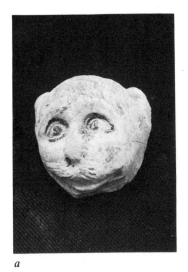

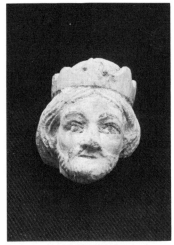

a

b

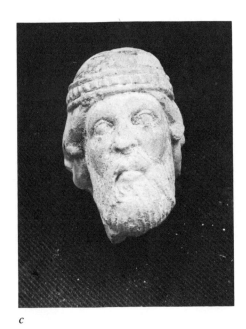

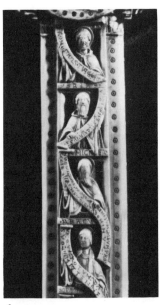

c

d

a–c. St. Albans Abbey: fragments 2147, 2148 and 2149
Photographs: Courtauld Institute
d. Metropolitan Museum, New York: detail of the so-called Bury Cross in the Cloisters
Collection

stone were inserted with the carved and painted sides facing the earth and their flat sides, usually redressed, facing the grave and it is thanks to this arrangement that paint has survived. However, at the time the grave was being built, the Romanesque carvings were nearly two hundred and fifty years old, and it is therefore far from certain that the paint with which the fragments are embellished is twelfth-century.

Among these fragments were several curved stones, probably from archivolts. Two of these have twisted cables, flanked by beading, while other archivolt pieces are carved with straight central rolls flanked by beading. More elaborate is a fragment moulded on its outer rim, with a drilled ribbon-like band twisted along its inner curve. This ribbon creates triangular fields, one of which survives, filled with a circle flanked by striated leaves with curled tips, and within the circle a single leaf with a canopied head bowed over a berry bunch (pl. XXIV*b*). This fragment differs from the other finds in that the ornament is drilled. Strikingly similar foliage survives on a number of fonts in the region, for example that at Aylesbury (pl. XXV*a*), and also on the doorway at St. Albans which led from the cloister to the slype. This doorway was reset in the south transept by Lord Grimthorpe during the nineteenth century. The doorway is difficult to date, particularly as it was restored according to Lord Grimthorpe's 'own design'.[23] Although the foliage which decorates it has parallels in some of the fragments, the design of the doorway suggests that it was produced slightly later.

The St. Albans slype may have been the *locutorium*, or parlour, which is recorded as being the work of Abbot Robert.[24] The sculpture associated with it seems to be somewhat later than that found *in situ* in the chapter house, but if the building was due to Abbot Robert, it was probably erected shortly before his death in 1166 (pl. XXV*b*).[25]

A number of fragments carved with delicate flowers and beaded arcs were found in the excavations, but not in the grave and these are remarkably similar to the decoration of the slype, where they were used as hoods around intersecting arches moulded with bobbins (pl. XXVI*a*). Such a blind intersecting arcade existed in the slype until it was dismantled in 1980 (pl. XXVI*b*). Another was moved from the slype by Lord Grimthorpe in the nineteenth century and reset high on the interior face of the south wall of the south transept where exquisite carved capitals, also moved from the slype, are incorporated with it.[26] The intersecting arches on the facade of Dunstable Priory repeat the bobbin arcades used at St. Albans, but at Dunstable the blind arches rest on capitals of a later Romanesque style, and very likely date from 1170–80.[27]

Several fragments of what were probably semi-shafts or colonettes were found in the lining of the above-mentioned grave, and these can be grouped according to their decoration. Fragments in the first group are carved with a figure of eight pattern decorated with a band of beading, through which shorter beaded stalks, studded with leaves enclosing berry bunches, are woven (pl. XXVII*a*). Some of the leaves, so-called 'island leaves', have cross-hatched enclosures and indented petals. The next group, consisting of three fragments, has a rounder profile, and is carved with a 'Union-Jack' motif (pl. XXVII*b*). The spandrels are beaded, and some are filled with leaves with central veins of beading and curled tips. One of these fragments is ringed by an annulet carved with leaves with bowed heads, and clasped stalks (pl. XXVII*c*).

The same type of annulet exists on a fragment from the third group carved with leaves and beaded stalks (pl. XXVIII*a*). Another stone from this group is better preserved and the stalks enclose 'fan-orchid' blossoms with beaded central petals and curled tips (pl. XXVIII*b*). Curled trilobe and spiral leaves spring from the beaded stalks, completing the pattern. The fact that fragments with different patterns have identical annulets confirms that these pieces were probably shafts from the same decorative scheme. Shafts with similar annulets carved in low relief exist elsewhere, for example in the infirmary cloister at Canterbury, *c.* 1170.[28] Only a small number of shafts as lavishly carved as these survive in England. Fragments of such shafts were found, for example, at Reading, Lincoln and Crowland, and remain *in situ* at Ely and Shobdon.[29] They occasionally decorated blind niches as at Rous Lench (Worcs.) or windows as, for instance, at the now destroyed Moot Hall at Colchester.[30] None of the above examples have annulets; however, highly decorated shafts with flat annulets were used frequently in manuscripts and metalwork.

The dating of the fragments to within the years of Robert's abbacy (1151–66) is confirmed by certain manuscript parallels. For example, a St. Albans manuscript, dated between 1140 and 1158, now in the Bodleian Library in Oxford, has calendar illustrations with foliage including 'fan-orchid' leaves, and 'island' and trilobe leaves (pl. XXVIII*c*).[31] The foliage found in the manuscripts of the succeeding abbot, Simon (1167–83), are in an entirely different style, which is closely related to that of the Channel School.[32]

Little figural sculpture was found, but what did come to light is of fine quality. The headless figure (pl. XXIX*a*), made up of two pieces, is 18 cm. high. Paint remains on the lower fragment; the background is red, and there are traces of blue and green drapery. The figure is broken on one side, where it was attached, but it is carved virtually in the round. It is a figure of great movement and vigour. The hips are pivoted as if running, while one hand clutches the hem of its garment. There is some dampfold drapery, but more remarkable are the circular patches which highlight the figure's shoulders and buttocks. This technique is used in the famous Terence manuscript, produced at St. Albans in the mid twelfth century, as on folio 47r (pl. XXIX*b*) where one of the figures is shown from behind, as he enters an arch.[33] The segmental coils of drapery carved across the chest also correspond to the drapery of the Terence illustrations. Similar too are the pleats of the skirt and the hem which rises in a diagonal line, as on folio 125v (pl. XXIX*c*). Segmental coils were used almost to excess in the large-scale sculpture at Malmesbury Abbey, *c.* 1160.[34]

Another figure which came to light is in three pieces, and also measures roughly 18 cm. (pl. XXX*a*). Against the left shoulder of the nearly complete figure appear traces of the shoulder of a second figure. The figure stands on a curved beaded base, the bottom of which is flat. There are three other fragments from this base, on one of which is a nearly complete foot, on another a toe, so clearly the complete figure was flanked by others in similar positions. On the bases of the flat surface the diameter of the bottom of the object can be determined as approximately 14 cm. The pieces are too incomplete to identify the object with certainty, but it is unlikely to have been a capital because it lacks an astragal. The fact that the figure is carved in the same plane as the block might suggest that it was part of a small shaft, or of a piece of furniture. The figure holds its twisted hem in one hand, and a

book in the other. The crisp nested V folds on the figure's chest are unusual in being inverted. Otherwise the drapery patterns are standard, with teardrop-shaped dampfold enclosures on the legs, and triangular dampfold and nested V folds on the left side. The dampfold and nested V drapery in the Dover Bible provides a close stylistic parallel for this St. Albans figure. The manuscript was dated by Dodwell to 1150, but has more recently been put at 1160 (pl. XXX*b*).[35] The traces of colour that remain indicate that the figure's cloak was white, and that it stood against a red background, with brown or black ground around the feet, and a blue moulding.

Three small heads were found; a cat (pl. XXXI*a*), a king (pl. XXXI*b*), and what is probably a prophet (pl. XXXI*c*). All are roughly 5.5 cm. high and considerable paint remains on the king's and cat's head. The king has a short cap of bobbed hair, a grooved beard, prominent nose, and small thin mouth. His eyes are surrounded by a thick reddish-brown outline, the pupils are black, and the lips are highlighted in red. The cat head is white, with brown and black on the eyes, and red on the nostrils and tongue. It is fancifully carved with its tongue stuck out, and a handlebar moustache.

There is no indication of the original setting of these heads. All three are broken at their necks and at the back of their heads. They are slightly too small to have fitted the figures found in the excavation. However, if they came from similar figures they might have decorated small capitals, shafts, or pieces of furniture. Alternatively, they might have been small label stops, similar to those recently found at Canterbury.[36]

The small scale of the fragments suggests a relationship with metalwork. Contemporary sources describe St. Albans as an important centre at which metalwork of high quality was produced, but no mid twelfth-century objects survive which can be attributed to St. Albans with certainty.[37] The delicate execution of the fragments indicates that the sculptors may have been familiar with ivory carving techniques. The small prophet head, for example (pl. XXXI*c*), with its beaded cap, long beard and drooping moustache, closely resembles several of the busts of prophets on the back of the so-called Bury Cross, now in the Metropolitan Museum of Art, New York (pl. XXXI*d*).[38] The heads are similarly modelled and have slightly protruding eyes, with undrilled pupils, full lips and noble, serene expressions.

This paper is intended only as a prelude to a thorough study of all the newly discovered fragments. However, even this brief account should be sufficient to show that this is a major discovery as far as English Romanesque sculpture is concerned, which will increase our knowledge of the High Romanesque period during the reign of Henry II. The quality of this sculpture is of the finest. St. Albans emerges not only as a major centre of Romanesque book illumination and metalwork, but of stone sculpture as well.

NOTES

(*TSAHAAS = Transactions of the St. Albans and Hertfordshire Architectural and Archaeological Society*)

[1] For a summary of the excavation finds see M. Biddle and B. Kjølbye-Biddle, 'England's premier abbey: the medieval chapter house of St. Albans Abbey, and its excavation in 1978', *Expedition*,

22 (1980), 17–32. The excavation will be published in full in the forthcoming report. Professor George Zarnecki will contribute a section on the Romanesque sculpture, with which I hope to help. I am most grateful to Professor Martin Biddle for allowing me to discuss the sculpture in advance of the publication of the report and for his careful reading of this manuscript. I would also like to express my thanks to Mrs Helen Patterson, the Finds Supervisor. Above all I am indebted to Professor Zarnecki for his considerable and very kind help.

[2] Previous excavations in 1920 and 1937 uncovered portions of the chapter house walls and of the tiled floor. E. Wigram, 'The chapter house at St. Albans', *TSAHAAS* (1924–6), 35–42; *The Builder* 122 (1922), 404–5: J. C. Rogers 'Some notes on excavations in and about St. Albans Cathedral during the summer of 1937', *TSAHAAS* N.S. v (1936–8), 140–3.

[3] *Op. cit.* in n. 1, 22–3, fig. 7.

[4] There is scant information as to the number of monks at St. Albans before 1190, at which time there were approximately fifty. D. Knowles, *The Monastic Order in England* (Cambridge, 1976), p. 713.

[5] *Gesta abbatum monasterii sancti Albani*, ed. H. T. Riley, i (Rolls Series, London, 1867), p. 182. For a discussion of the chronicle see R. Vaughan, *Matthew Paris* (Cambridge, 1958), pp. 182–9. Between 1452 and 1492 the building was given new windows and fan vaulting. The Gothic fragments which came to light during the excavation are being studied by Dr. Richard Morris.

[6] The architectural history of St. Albans is described in various sources, among them: C. and C. A. Buckler, *A History of the Architecture of the Abbey Church of St. Albans* (London 1847); V.C.H. *Hertfordshire*, ii (London, 1908), pp. 469–515; R.C.H.M. *Hertfordshire* (London, 1910), pp. 177–88.

[7] For a list of many of the chapter houses surviving in England see the Rev. W. A. Wickham, 'Some notes on chapter houses', *Transactions of the Historical Society of Lancashire and Cheshire*, lxiv (1913), 143–248.

[8] N. Stratford, 'Notes on the Norman chapterhouse at Worcester', *Medieval Art and Architecture at Worcester Cathedral* (British Archaeological Association Conference Transactions, 1975), pp. 51–70.

[9] J. E. Bygate, *The Cathedral Church of Durham* (London, 1894), pp. 32–4.

[10] For the chapter house at Bristol see N. Pevsner, *North Somerset and Bristol* (The Buildings of England, London, 1958), pp. 384–5; for Much Wenlock see Rev. D. H. S. Cranage, 'The Monastery of St. Milburg at Much Wenlock, Shropshire', *Archaeologia*, lxxii (1922), 116–18; for Rochester see W. H. St John Hope, *The Architectural History of the Cathedral Church and Monastery of St. Andrew, Rochester* (London, 1900), p. 172.

[11] See C. Wilson, pp. 100–21, in this volume.

[12] *The Monastic Constitutions of Lanfranc*, ed. D. Knowles (London, 1951), p. 77.

[13] L. M. Michon, "L'abbaye de St Georges de Boscherville", *Congrès Archéologique* (1926), 531–49; L. Musset, *Normandie romane*, ii (Paris, 1974), 147–57.

[14] Ms. Kit Galbraith believes, with certain reservations, that this is the approximate date of the doorway. I am most grateful to her for her views on the subject.

[15] I am grateful to Mr Richard Halsey for suggesting this.

[16] R. W. Southern, 'Pope Adrian IV', *Medieval Humanism and Other Studies* (New York, 1970), pp. 234–52; R. L. Poole, 'The Early Lives of Robert Pullen and Nicholas Breakspear', *Essays In Medieval History presented to T. F. Tout,* ed. A. G. Little and F. M. Powicke (Manchester, 1925), pp. 64–9.

[17] *Op. cit.* in n. 1, 25.

[18] *Ibid.,* 30.

[19] *Gesta abbatum,* i, p. 137; L. F. R. Williams, *A History of the Abbey of St. Albans* (London, 1917), pp. 70–1. The full privileges were finally obtained from Adrian IV's successor, Alexander III, Adrian having been poisoned in 1159.

[20] *Gesta abbatum,* i, p. 158.

[21] *Gesta abbatum,* iii, pp. 389 and 423.

[22] *Gesta abbatum,* iii, p. 442. The chapel of St Nicholas was a little distance south of the chapter house adjoining the infirmary court. See Rev. H. Fowler, 'The boundary wall of the monastery of St. Albans,' *TSAHAAS* (1876).

[23] The Rev. T. Perkins, *The Cathedral Church of St. Albans* (London, 1903), p. 52; P. Ferriday, *Lord Grimthorpe* (London, 1957), p. 156. I am extremely grateful to Professor Joseph M. Crook for his kind help in exploring Lord Grimthorpe's restoration.

[24] *Gesta abbatum,* i, p. 179.

[25] Professor Biddle informs me that his excavation of the original site of the doorway, that is leading from the cloister to the slype, revealed that the doorway and west wall of the chapter house were one build.

[26] See 'St. Albans Abbey Church: passage to the chapter house', *The Builder,* 14 (1856), 325, pl. 331.

[27] R. C. Marks, *The Sculpture of Dunstable Priory c. 1130–1272,* unpublished M.A. thesis, University of London (1970).

[28] The shafts probably date to *c.* 1170, as I intend to show in my Ph.D. thesis.

[29] For Reading, see S. Jónsdóttir, 'The portal of Kilpeck Church: its place in English Romanesque sculpture', *Art Bulletin,* xxxii (1950), 177. For Lincoln, G. Zarnecki, *Romanesque Sculpture at Lincoln Cathedral* (1970), pp. 16–18. The fragments from Crowland are as yet unpublished. For Ely, G. Zarnecki, *Early Sculpture of Ely Cathedral* (London, 1958), pp. 33–4. For Shobdon, G. Zarnecki, *Later English Romanesque Sculpture 1140–1210* (London, 1953), pp. 9–10.

[30] For Rous Lench, N. Pevsner, *Worcestershire* (The Buildings of England, London, 1968), p. 255. For the Moot Hall, G. Zarnecki, 'The Sculpture of the Old Moot Hall, Colchester', in P. Crummy, *Aspects of Anglo-Saxon and Norman Colchester* (C.B.A. Research Report 39, 1981), pp. 63–7.

[31] Oxford, Bodleian MS. D.2.6. See C. M. Kauffmann, *Romanesque Manuscripts 1066–1190* (London, 1975), entry 71.

[32] W. Cahn, 'St. Albans and the Channel Style in England', *The Year 1200: a Symposium* (The Metropolitan Museum of Art, 1975), pp. 187–223.

[33] Oxford, Bodleian MS. Auct. F.2.13. See Kauffmann, *op. cit.* in n. 31, entry 73; L. W. Jones, C. R. Morey, *The Miniatures of the Manuscripts of Terence* (1931).

[34] F. Saxl, *English Sculptures of the Twelfth Century* (London, 1954), pls. LIV–LXXIII, pp. 57–64.

[35] C. R. Dodwell, *The Canterbury School of Illumination* (Cambridge, 1954), pp. 48–59; E. Kitzinger, 'Norman Sicily as a source of Byzantine influence on western art in the twelfth century', *Byzantine Art – An European Art* (1966), p. 137; also G. Zarnecki, 'The Eadwine portrait', *Études d' art médiéval offertes à Louis Grodecki* (Paris, 1981), pp. 93–8.

[36] Professor George Zarnecki discussed these fragments, which he believes to have been from the choir screen of 1180, at the British Archaeological Association Conference held at Canterbury in 1979.

[37] C. C. Oman, 'The goldsmiths at St. Albans Abbey during the twelfth and thirteenth centuries', *TSAHAAS* (1930–2), 221 ff.

[38] T. Hoving, 'The Bury St. Edmunds Cross', *The Metropolitan Museum of Art Bulletin* (June, 1964), 317–40; P. Lasko, *Ars Sacra* (London, 1972), p. 167; J. Beckwith, *Ivory Carvings in Early Medieval England* (London, 1972), pp. 141–3. There is controversy among these authors as to the date of the cross; perhaps the similarity with the St. Albans fragments points to a date just after the middle of the century.

Recently Discovered Romanesque Sculpture in South-East England

Jane Geddes

While inspecting various buildings and archaeological sites for the Department of the Environment, I have been fortunate enough to be shown a fair amount of newly excavated sculpture. There has been little opportunity to follow up comparisons for these pieces and what comments I can offer are mainly due to the help of Professor Zarnecki. The sites I shall deal with are Battle Abbey, St. Augustine's, Canterbury, and Dartford Priory.

Battle Abbey was founded in 1066 by William the Conqueror and the church was completed before his death. Little remains of the Norman building beyond the ground plan of the nave and chapter house, but excavations in 1978–80, directed by John Hare, have produced a few carved fragments. The large volute with a spiral but not much trace of a leaf (pl. XXXIIa), comes from a capital of the early Norman type. A similar example is found in Durham castle chapel built c. 1072, also by William the Conqueror.[1] The spiral colonette (pl. XXXIIb) reflects more delicate work of possibly mid twelfth-century date. Both pieces were found among Dissolution rubble in the reredorter. Themassive corbel (pl. XXXIIc) was found in the garden rockery. Its leering face can be compared with a corbel from nearby Icklesham, and a fragment from Staplehurst (pl. XXXIId).

The prize find from Battle so far is the fragment (pl. XXXIIIa,b) of an ivory tau cross, now on loan to the British Museum.[2] The Alcester cross is a complete example of the same type.[3] The Battle fragment is part of the shoulder; its sides are carved with beaded foliage and it has a small worn knob on the shoulder. On the side is a recess for the attachment of a metal plaque. The small holes in the surface would have been filled with stones or glass such as can be seen on the tau cross fragment in the British Museum.[4] The beaded foliage may be closely compared with the capital in the Holy Innocents chapel, Canterbury Cathedral, now dated by Professor Zarnecki to c. 1100. It has been suggested that the tau could have

PLATE XXXII

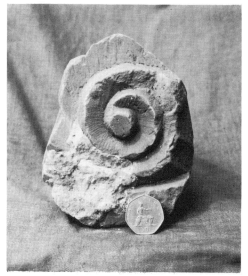

a. Battle Abbey: volute

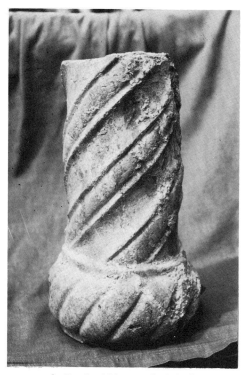

b. Battle Abbey: spiral shaft

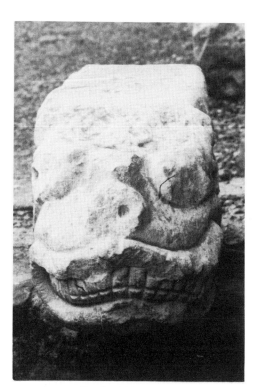

c. Battle Abbey: corbel

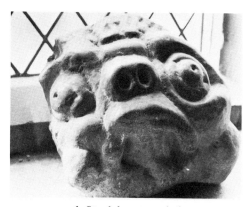

d. Staplehurst: corbel

PLATE XXXIII

a. Side view

b. Top view

Battle Abbey: fragment of ivory crozier (reproduced by per-
mission of Department of Environment)
Crown copyright reserved

PLATE XXXIV

b. St. Augustine's Abbey, Canterbury: chevron

a. St. Augustine's Abbey, Canterbury: foliage

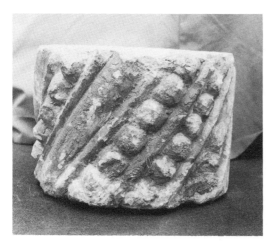

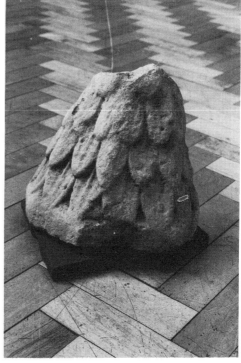

c. Barking Abbey: spiral shaft

d. Barking Abbey: finial

PLATE XXXV

b. Angel's wing

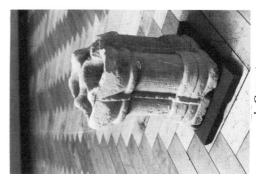

d. Cresset

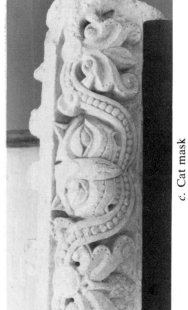

a. Diaper

c. Cat mask

Barking Abbey

belonged to Abbot Henry, a prior of Canterbury Cathedral who was appointed abbot of Battle in 1095.[5] It might have been given to him as a present when he left Canterbury. If in fact the ivory is a product of the Canterbury workshop, it might otherwise have come to Battle with Abbot Warner in 1125. Warner was also a monk of Canterbury and was particularly remembered in the Battle Chronicle for his interest in art. He spent "much time repairing and decorating the church, collecting and buying furniture for the altar and services".[6]

An interesting feature of the crozier is the way in which the carving has been worn down, and the upper surface is especially smooth (pl. XXXIII*b*). If it had merely been held between the abbot's fingers, one would expect the sides to be rubbed. However, the fragment was found in a pile of rubbish dumped into the reredorter area at the Dissolution; the rubbish itself consists of a large quantity of household pottery and a very significant collection of equipment from a library or scriptorium. There are niello book plaques, book clasps, edging strips and corner pieces for the covers, and a set of large bone pins with bronze points used for pricking out the lines on pages or holding the vellum flat. It is possible that the ivory fragment was reused in the book binding process for pressing down the pages or stretching the bindings.

The next group of sculpture was found during excavations at St. Augustine's Abbey, Canterbury, conducted by the Department of the Environment in 1974–5;[7] the stones are at present in store at Dover Castle. Perhaps the most remarkable feature of these fragments is their vivid colour. The elegant foliage capital (pl. XXXIV*a*) is painted with a dark brown background to give the impression of depth and the leaves are highlighted in sky blue and pink. The entwined asymmetrical leaves show some of the brittleness of metalwork and may be compared with similar leaves on the stone mould for a lead cast, found at Lindisfarne Abbey. They are also similar to the foliage in the Passionale BL Arundel 91, from Christchurch, Canterbury.[8] On the undercut chevron vault ribs the carving is dramatically outlined in black, red and pink, while the flat surfaces of the Vs are painted with black, red and white trefoils (pl. XXXIV*b*). These vault ribs are of the same design as those in the choir aisles of Canterbury Cathedral, built between 1174 and 1180. Lastly, there is a through block, cut flat on two opposing sides, with sculpture carved to face inwards and outwards. On one side are two fluted scallops looking like shuttlecocks, and on the other a monkey-devil clasping his knees and carrying the weight of the stone above on his shoulders like an Atlas figure. Such through impost blocks were common on small twin openings in Saxon buildings, and uncarved examples can be seen on the tower at Sompting. They were particularly used in belfries and this one would have come from the top of the great west tower at St. Augustine's, or perhaps from a smaller bell turret further east in the building.

All these fragments were found in a section of fallen wall excavated on the south side of the choir, none *in situ*. There was a fire at St. Augustine's in 1168, six years before the great fire in the cathedral. Although St. Augustine's shrine was destroyed, there is no evidence of scorching on either the surviving north wall or the collapsed south wall of the choir. It is not clear when St. Augustine's was rebuilt, though many features found in the Christchurch choir of William of Sens are also found in St. Augustine's. The undercut chevron has already been mentioned, and the two buildings also share the use of Purbeck and Kentish marble for minor

shafts and shaft rings. Discord between the St. Augustine's monks, their Abbot, Clarembald, and Henry II began in 1161 and culminated in 1173 when Henry seized the revenues of the abbey until 1176.[9] It is unlikely that much rebuilding took place during those years, so the St. Augustine's repairs probably began in the wake of Christchurch, adopting the new ideas but on a more limited scale.

The last site to be discussed is Dartford Priory where all visible remains have virtually disappeared or have been incorporated in an industrial complex. Various pieces of sculpture from here have found their way to Dartford Museum from the 1890s onwards. However, industrial developments in 1977 led to substantial excavations by the Kent Archeological Rescue Unit and Dartford District Archaeological Group.[10]

Dartford Priory was a Dominican convent founded in 1321. It was dissolved in 1539 by Henry VIII who kept the buildings and land for his personal use. He decided to convert it to a royal manor house and in 1541 began a major programme of alterations. Detailed accounts were made by the Surveyor General who plundered the much more important convent of Barking, on the opposite bank of the Thames. Lighters were hired to transport the "fairest quoin stones and others" and 110 tons of ragstone from Barking to Dartford.[11] Most of the sculpture to be discussed was found reused in a garderobe shaft at Dartford.

Barking was an abbey of far greater significance than Dartford. It was founded by Erkenwald in *c.* 666, his sister Ethelburga being the first abbess. It was destroyed by the Danes in 870 and rebuilt in the tenth century by King Edgar. A further rebuilding, without documentary evidence, began in all probability in the early twelfth century and the abbey was finally dedicated in 1215–45. William the Conqueror made Barking his temporary headquarters while the Tower of London was being built, and at the Dissolution it was the third richest convent in England.[12] Its Romanesque sculpture must therefore be important because of its proximity to London where so little sculpture has survived.

The fragments indicate the richness of the decoration. They include a pelleted string course, a spiral shaft (pl. XXXIV*c*), a finial covered in leaves (pl. XXXIV*d*) and a three-dimensional diaper pattern (pl. XXXV*a*). A flatter diaper pattern is used as a background to the Rood which still survives in the parish church and further diapers are found built into the Curfew Tower of the present building.[13] The Rood was probably part of a larger composition and it is possible that the finely carved angel's wing (pl. XXXV*b*) was part of it. The splendid owlish cat mask (pl. XXXV*c*) is part of an unusual piece of stone. It is wedge shaped and was obviously intended to be seen from below. It looks as though it was part of a string course but the top of the stone is carved with billets. Cat masks first appeared in English stone sculpture around 1140 at Old Sarum, while the types of geometric ornament shown on the previous fragments can be found in profusion, for instance on the nave doors of Durham Cathedral, 1128–30. If the angel's wing is indeed related to the Rood it is probably *c.* 1150. Judging from the fragments found at Dartford, it would seem that considerable building and decoration took place at Barking Abbey in the second quarter of the twelfth century.

The final object is a cresset lamp found at Dartford in 1948, but clearly coming from Barking because of its Romanesque design with cushion capitals (pl. XXXV*d*). Cresset stones were filled with tallow and used to provide a slow burning night-light in monasteries. The Rites of Durham describe cressets by the

choir door and in the dorter. They were made of "four square stone, finely wrought".[14] One of these stood on a column with a figure carved on each face, but most surviving cressets are very plain. At Calder there is simply a square block with sixteen cups; at Lewannick in Cornwall there is a circular block with seven cups. In comparison with these the Barking cresset is quite an elaborate example.

NOTES

[1] G. Zarnecki, *English Romanesque Sculpture* (1951), pls. 3–7.
[2] The Battle crozier is discussed more fully by T. A. Heslop in *Antiq. J.* lx (1980), 341–2.
[3] J. Beckwith, *Ivory Carvings in Early Medieval England* (1972), pp. 52–3.
[4] *Ibid.,* p. 202, catalogue no. 92.
[5] Comment by G. Zarnecki, *Antiq. J.* lx (1980), 342.
[6] For Abbots Henry and Warner, see *Battle Abbey Chronicle* (1846), p. 62.
[7] C. Miscampbell. 'Rebuilding at St. Augustine's Abbey, Canterbury,' in *Collectanea Historica: Essays in Memory of Stuart Rigold,* ed. A Detsicas (1981), pp. 63–5.
[8] I am grateful to Deborah Kahn for this suggestion. Cf. C. Dodwell, *The Canterbury School of Illumination* (1954), pl. 16a, B.L. Arundel 91 f.81v.
[9] W. Urry, 'Two notes on Guernes de Pont Sainte-Maxence: Vie de Saint Thomas', *Archaeologia Cantiana*, lxvi (1960), 94.
[10] B. Philp, 'Dartford Priory and Manor House', *Kent Archaeological Review,* 47 (1977), 160. Finds are now in Dartford Museum and the stores of Kent Archaeological Rescue Unit.
[11] V.C.H. *Kent*, ii (1926), p. 181. A. W. Clapham, 'The Priory of Dartford and the Manor House of Henry VIII', *Arch. J.* lxxxiii (1926), 67–85, esp. 70.
[12] V.C.H. *Essex* ii (1907), p. 115. A. W. Clapham, 'The Benedictine Abbey of Barking', *Trans. Essex Archaeological Society,* N.S. xii (1913), 69.
[13] G. Zarnecki, *Later English Romanesque Sculpture* (1953), pls. 65–6.
[14] T. Lees, 'Cresset stones', *Arch. J.* xxxix (1882), 390–6.

III. GOTHIC

Introduction

An Account of Medieval Figure-Sculpture in England, by E. S. Prior and A. Gardner, was published in 1912. To this day its later chapters remain the only serious attempt to explore and publish a wide range of English Gothic sculpture, drawn from the lesser as well as the greater monuments and with a proper emphasis on *disjecta membra.* It represents however a preliminary selection from an enormous body of material and the approach is that of the connoisseur, less than archaeological. English Gothic sculpture remains largely unknown and ignored, in marked contrast to the Gothic sculpture of France, Germany and Italy.

This lack of interest is hard to explain. Prior and Gardner were already able to write from a solid basis in eighteenth- and nineteenth-century antiquarian studies; many of the major buildings and more prestigious tombs had been related to documentary sources, their structures, decoration and mouldings studied by architectural historians (among whom Willis stands out as the ablest). Indeed medieval architectural history has continued to flourish in England, first through the publications of bodies like the Royal Commission on Historical Monuments, the Victoria County History and the Ancient Monuments Inspectorate and since the last war with a new generation led by John Harvey, who unearthed much new documentary information, and was followed by a younger generation, often pupils of the Courtauld Institute. Meanwhile the monumental sculpture has by and large been relegated to a footnote here and there. Admittedly Westminster Abbey has received some attention, C. J. P. Cave published numerous illustrated articles on roof bosses and Åron Andersson has said much of interest on Anglo-Scandinavian links during the Gothic period. But for some seventy years, most of the literature has been devoted to isolated topics of antiquarian interest—alabasters, brasses, misericords and occasionally tombs, though usually for their effigies; when Lawrence Stone published his Pelican History of Art volume, *Sculpture in Britain: The Middle Ages* in 1955, 3½ of the 5½ pages of his Gothic bibliography were devoted to these topics. As for English Gothic ivories, our current state of knowledge is nothing short of abysmal, but here at least there is less cause for surprise—the same state of affairs exists for French, German, Spanish, Italian, Scandinavian and indeed all Gothic ivories.

Now there are signs that the tide is turning. The papers presented to this

research seminar are enough to demonstrate a renewed interest. Indeed English Gothic sculpture, and particularly monumental sculpture, may at last be emerging from obscurity. The basic tools for its study are available: not only John Harvey's publications but the rich mine of information that was unearthed by the authors of the medieval volumes of *The History of the King's Works* and, above all, *The Buildings of England* series—a casual glance through the plates of any one of Pevsner's books will produce a surprise in the form of a virtually unknown or unpublished Gothic sculpture or monument. Now also there is Jean Bony's *The English Decorated Style*. Again, the British Archaeological Association's annual conferences have since 1975 concentrated on the history and structure of major buildings—Worcester, Ely, Durham, Wells and Glastonbury, Canterbury, Winchester, Gloucester and Tewkesbury; the four volumes of *Transactions* which have so far appeared include a number of papers on the Gothic sculpture. Another development has been the creation of the International Society for the Study of Church Monuments in 1979; two symposia have been held in London and a twice-yearly *Bulletin* is appearing, which not unnaturally tends to be British biased. Finally, Pamela Tudor-Craig has for many years been combing England for Gothic sculpture; if the Royal Academy's ambition to mount a major English Gothic exhibition in 1986 is realised, then some of the best fruits of her searches will be brought together for study for the first time.

The plates in this volume are evidence of the extraordinary beauty, interest and historical importance of much English Gothic sculpture. *Ad publicandum* . . .

NEIL STRATFORD

The Original Setting of the Apostle and Prophet Figures from St. Mary's Abbey, York

Christopher Wilson

The Early Gothic apostle and prophet figures in the Yorkshire Museum are among the best-known monuments of English medieval art. They occupy a prominent place in all the reference works, they have been made the subject of a whole series of scholarly studies, and two of them have on several occasions been included in major exhibitions.[1] As a result of this sustained interest the questions of iconography, dating and stylistic affiliation have been explored in considerable detail.[2] Much less attention has been given to the problem of identifying the original position of the sculptures within the abbey, and so it is on this aspect that the present paper will concentrate.

The seven best-preserved of the thirteen figures in the museum (pls. XXXVI, XXXVII, XXXVIIIa) were found in January 1829 in the ruins of the late thirteenth-century conventual church.[3] The discovery was made by workmen engaged in levelling the ground to make the path that still crosses the site of the south nave aisle, in the fourth and fifth bays from the east (pl. XXXIXa). The figures lay face down at a depth of six or eight feet below a ten foot-thick wall composed of architectural fragments from the abbey, notably pieces of tracery from the church.[4] According to the *Yorkshire Gazette* for 17 January 1829, the wall in question ran parallel to the south side of the nave,[5] and though its significance was not understood at the time there can be little doubt that it was the foundation of a wall built into the nave arcades when the aisles were converted into two storeys of domestic apartments in 1568–70. The converted aisles served as annexes to the state apartments formed in the claustral buildings shortly after 1539 when the abbey site and buildings came into royal hands and became known as the 'King's Manor'.[6] In 1952–6 excavations were conducted at the west end of

100

the nave, partly in order to look for more statues. These hopes were not fulfilled, but in 1955 the sleeper wall on the line of the two western bays of the north arcade was found to consist largely of tracery and other fragments from the thirteenth-century church, like the wall described in 1829.[7]

Besides the sculpture recovered from the site of the nave, the Yorkshire Museum houses six other figures or fragments of figures closely related in style. Two of these are badly weathered representations of St. James and St. John the Baptist (pl. XXXVIII*b,c*) which lay from 1736 or earlier upon the churchyard wall of St. Lawrence, Walmgate, a parish church outside the city walls to the east.[8] Between 1861 and 1869 they were acquired by the museum. Some time during the period 1840–52 a very damaged figure (pl. XXXVIII*d*) was retrieved from a bridge at Clifton over the Bur Dyke, a small stream which runs into the River Ouse some 500 m. west of the gatehouse to St. Mary's Abbey.[9] It seems likely that all three had been discovered when the ruins of the abbey church became a quarry early in the eighteenth century.[10] The lower part of a figure (pl. XL*b*), again very worn, was found recently in the Museum Gardens.[11] It shares with that from Clifton certain traits that do not recur in the other figures mentioned so far, namely slender general proportions, harshly schematised drapery between and above the feet, and the omission of any supporting block under the feet. Despite these differences, there are grounds other than provenance for accepting a St. Mary's origin. The back of the Clifton figure is shaped to fit into a corner, as are two of the figures found at the abbey in 1829 (pl. XXXVII*a, c, d*), and the Museum Gardens fragment has on its underside the remains of a raised circular area of nearly the same diameter as the shafts which emerge from behind the shoulders of six out of seven figures found in 1829.[12]

In January 1955 two standing figures and a seated Virgin and Child, all headless, were bought from a London dealer who had acquired them from a Mr Samuel Wormald of Shoreham, Sussex. At some time after 1945 Wormald had brought them from his former home, Cawood Castle in the village of Cawood, ten miles south of York. The earliest reference to them, in 1902, notes that they were found 'some years ago' on the site of a chapel in the angle between the south aisle and the chancel of Cawood church. At the time of their acquisition by the Yorkshire Museum it was claimed, on the strength of similarities in style and material, that they must have come from St. Mary's Abbey.[13] But the two standing figures are quite different from the others. Whereas the figures from St. Mary's, St. Lawrence and Clifton all have shoulders and upper arms carved completely in the round (pl. XXXVI*a*), the Cawood pieces are essentially high reliefs and lack the rear parts of the shoulders and upper arms (pl. XL*d*).[14] Moreover, the upper part of the body is in each case turned slightly to one side, in contrast to the frontal stance of all the York figures. It seems reasonable therefore to exclude the Cawood figures from the St. Mary's series. The question of their original siting must remain open, for Cawood church where they were supposedly found is a modest building unlikely to have housed large-scale sculptures. It is not impossible that they were made for the chapel of Cawood Castle, an important house of the Archbishops of York until the mid seventeenth century. Archbishop Roger of Pont-l'Evêque (1154–81) is on record as improving the residences of the see, and the style of the figures suggests a date towards the end of his life.[15] Roger should probably also be credited with the hitherto unpublished series of life-sized standing figures at York Minster (pl.XL*c*),

of which at least twenty were reused on the south buttresses of the nave (begun 1291) and the clerestory level of the west towers (*c.* 1331–9).[16] All these pieces have suffered greatly, some from weathering, others from recutting, but along with the St. Mary's and Cawood figures, two on the west front of Nun Monkton Priory, one from Holy Trinity Priory, York and three recorded on the gatehouse of Selby Abbey, they do at least bear witness to the existence in the York area of a vigorous 'school' of monumental sculpture without parallel in late twelfth-century England.[17] The Nun Monkton and Selby figures were set in niches and it is quite possible that the Cawood and York Minster statues also occupied niches. The backs of the Cawood figures are flat, but the York Minster and Nun Monkton figures are rounded. Much the most likely source for the Minster statues is the towered late twelfth-century west front demolished to build the existing Gothic nave.[18] The west front of Selby Abbey, whose stylistic links are all with York, has four niches linked by arcading, an arrangement that might well echo the lost late twelfth-century façade of York Minster.

Of the figures enumerated above only those from St. Mary's Abbey have cylindrical shafts rising out of their shoulders and heads (pls. XXXVI*a*, XL*a*). The fact that the shafts do not extend the full height of the figures makes it impossible to classify them as column-figures in the tradition inaugurated on the west fronts of St-Denis and Chartres, although the St. Mary's arrangement was used for jamb figures on numerous twelfth-century French portals outside the Ile-de-France. The shafts have always been recognised as an important clue to the identification of the original setting. As early as February 1829 the Leeds architect R.D. Chantrell wrote in a letter to the Yorkshire Philosophical Society that 'these statues were placed against the pillars of the nave, as in the church at Bruges'. Chantrell's suggestion was incorporated into the account written by the Rev. Charles Wellbeloved, Curator of Antiquities in the museum of the Yorkshire Philosophical Society (now the Yorkshire Museum).[19] The authors of the eye-witness accounts in the *Yorkshire Gazette* and *York Courant* conjectured that the figures came from an alter screen and a choir screen respectively.[20] None of these solutions is satisfactory since it is highly unlikely that an ambitious church wholly rebuilt to a unified design in the late thirteenth century would incorporate out-of-date statuary salvaged from an earlier structure. Nevertheless, all these suggestions do at least take account of the polychromy which still covered the figures at the time of their finding and which would probably not have remained so brilliant had the original location been a portal or any other part of the exterior.[21] However, once the Continental analogies for the sculptures had been recognised early in this century, the portal theory gained ground steadily, even to the point where the presence of polychromy was no longer seen as a problem.[22] In 1975 an entirely new interpretation was advanced in an article by Professor George Zarnecki and in the preface to the York inventory compiled by the Royal Commission on Historical Monuments.[23] It was proposed that the figures marked the bay divisions in the chapter house, apostles in the main chamber, precursors of Christ in the vestibule. Besides parallels with full-length figures serving as vault responds at Toulouse, Durham and Oviedo,[24] three circumstances favouring the new interpretation were mentioned: first, the nearness in date of the figures and the remaining portions of the chapter house fabric; second, the division of the chapter house proper into five bays, the ideal number for housing twelve apostle figures; third,

the suitability of the figures with angled backs for corner positions and of those with flat backs for positions below the vault springings on the long walls. It may be added that placing the figures inside the chapter house and vestibule overcomes the difficulty about the survival of their polychromy. To adduce further evidence for associating the figures with the chapter house it is necessary to consider in rather more detail the architecture of this formerly splendid building.

The main survivals from the late twelfth-century chapter house are the supports of the entrance from the cloister to the vestibule and that from the vestibule into the chapter house proper (pls. XXXIX*b*, XLII*a*). Both entrances and the vestibule survived until the early seventeenth century, together with the whole of the east, south and west claustral ranges. Around 1610, as part of a radical reorganisation of the King's Manor, all three ranges were pulled down and their site given over to garden terraces stepping down westwards towards the River Ouse.[25] Since the highest terrace covered the position of the east range total demolition was unnecessary and the medieval fabric could be left *in situ* to a maximum height of around 2 m.

The piers of the western entrance were reconstructed, mostly in coursed masonry, when the dormitory above was rebuilt from 1299. Originally each pier had a relatively small cylindrical core surrounded by no fewer than sixteen shafts *en délit*.[26] The west entrance of the parlour between the vestibule and the south transept was of the same work, and from its left jamb survives a fine though badly damaged group of crocket capitals interspersed with small multilobed leaves (pl. XLI*a*). No other foliage carving of this kind appears to have existed in the north of England, and the closest analogies are with some of the celebrated capitals in the eastern arm of Canterbury Cathedral (1174–84).[27] This link, which is shared by other capitals mentioned below, argues for a date before 1190 rather than later.[28] The main chapter house front, of the traditional form with 'windows' flanking an entrance, is treated extremely lavishly (pl. XLII*a*). Cruciform piers with provision for eight shafts *en délit* are covered with chevrons filled with foliage of very varied types, at least some of which had local antecedents.[29] The only reasonably well-preserved capital here has two pairs of converging beasts, much like those on the south-west pier of the eastern crossing at Canterbury. Many detached voussoirs from the arches of both entrances have survived (pl. XLII*b*). Their decoration is entirely abstract, for the most part elaborate varieties of chevron, and, when in position and polychromed, the effect must have been spectacular. In point of complexity, their only peer is the door of *c.* 1170 to the bishop's chapel in Durham Castle, but the simpler doorways at the west end of Selby Abbey (pl. XLII*c*) make use of many of the same varieties of chevron and may even be the work of the same masons.[30] The structure of the vestibule between the two entrances was entirely renewed when the dormitory was rebuilt at the start of the fourteenth century.[31] The vault shafts in the side walls could never have co-existed with the twelfth-century sculptures in the museum, and if one were to accept the Royal Commission's proposition that the figures of the precursors of Christ stood in the vestibule until its Decorated remodelling one would have to assume that they found another home before being consigned to the foundations of the nave in the 1560s. However, there is architectural evidence which makes it virtually certain that life-sized sculptures never adorned the vestibule. The piers and jambs of the two portals are relatively low (1.925 m).[32] and were presumably made thus in order to accommo-

date the dormitory which passed overhead. If this is correct, it follows that the supports of the original late twelfth-century vault (as well as those of its early fourteenth-century successor) rose no higher. To be incorporated into vestibule vault shafts the figures would have to stand only a few centimetres from the floor, a position unparalleled in England or on the Continent.

The main chapter house had already been destroyed, except for the foundations, when the site was exposed in 1827. The demolition was probably carried out so thoroughly because the eastern half of the site was needed for cellarage below the new west range of the King's Manor begun *c.* 1610.[33] However, there is a good deal of evidence suggesting that substantial parts of the chapter house had been pulled down as early as the 1560s.[34] This is a point of some importance for the inquiry into the location of the figures since it means that when they were requisitioned as building material the only abbey buildings which had been demolished and which were sufficiently important to have qualified for elaborate sculptural decoration were the chapter house proper and the eastern parts of the church. The chapter house was no doubt a room of considerable height, like nearly all other examples of chapter houses placed beyond the east range, and provided with a vestibule under the dormitory. The succession of a low, indirectly lit vestibule by a tall, well-lit rectangular chapter house can still be experienced at St. Werburgh's, Chester (now the Cathedral), another of the very few Benedictine houses in the North. Although the Chester chapter house is a mid thirteenth-century example of the Early English style, it is in one respect more conservative than St. Mary's Abbey for, in common with many of the grandest English Romanesque chapter houses, its vaulting is arranged in three deep compartments.[35] St. Mary's is exceptional among unaisled twelfth-century chapter houses in having five compartments of vaulting, each only half as deep as wide, and it is at least a possibility that the form of the vault reflected the desire to incorporate into its supports a full series of sculptured apostles.[36]

The Yorkshire Museum possesses a considerable number of architectural components found in the 1827–8 excavation whose style indicates that they belonged to the chapter house.[37] Most important for the present discussion are two large capitals and a fragment of another,[38] all with foliage which can be compared to examples from the vestibule and which resembles some of the latter in its dependence on Canterbury. Although quite different in format from any of the Canterbury capitals, their individual elements can almost all be paralleled there.[39] The larger of the complete capitals (pl. XLI*b*) is semicircular at the top but has rested on a deep 'pilaster' fronted and flanked by shafts *en délit.* This grouping recalls the responds of the chapter house entrance 'windows' (pl. XLII*a*) but is itself too slight to have been the respond of an arcade. Almost certainly, it was a group of vault shafts in which the wider central cylinder corresponded to the transverse rib of a vault and the other two to diagonal ribs.[40] A rib vault is by far the most likely form of covering for an ambitious late twelfth-century chapter house, and there are in fact numerous pieces of ribs in the museum and its grounds which would fit perfectly onto the capital in question if one allows for the extra area provided by an abacus slab. The rib segments are worked with three trellis-covered rolls separated by nailhead, both motifs that appear on the archivolts of the vestibule and chapter house. There are two sizes, the larger being no doubt from the transverse ribs. Some confirmation that the large capital carried ribs is provided by the small

PLATE XXXVI

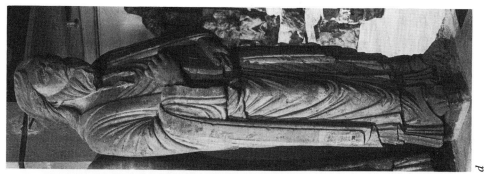

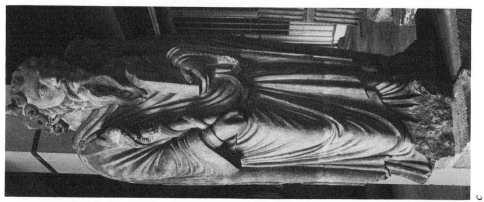

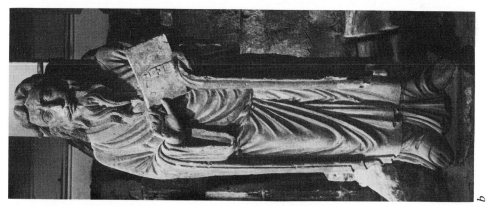

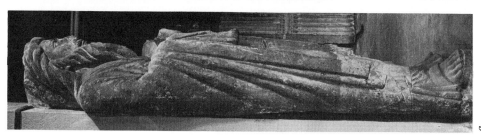

a–d. St. Mary's Abbey York: figures found in 1829 (*b,* front view of *a; c,* Moses)

a *b* *c* *d*

PLATE XXXVII

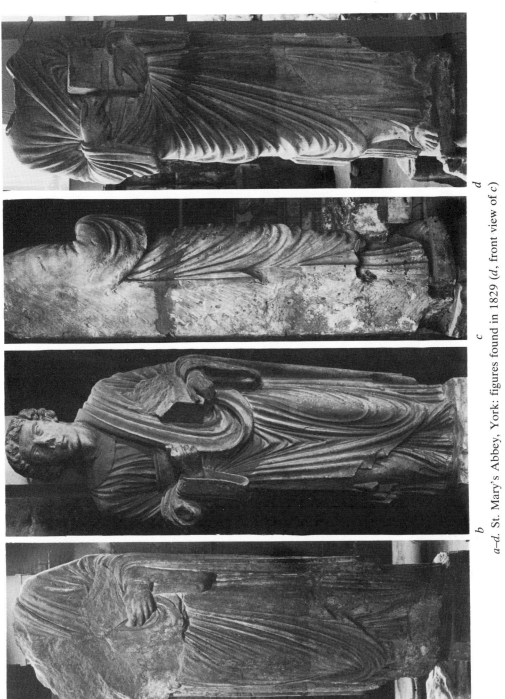

a–d. St. Mary's Abbey, York: figures found in 1829 (d, front view of c)

PLATE XXXVIII

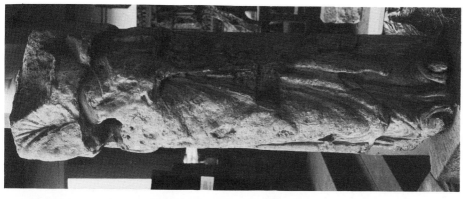

d. Figure from the Bur Dyke bridge, Clifton, York

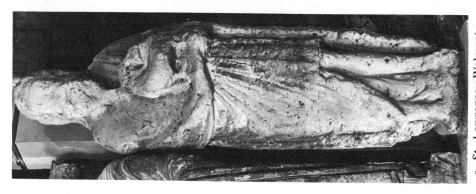

c. St. Lawrence, Walmgate, York: figure of St. John the Baptist from churchyard

b. St. Lawrence, Walmgate, York: figure of St. James from churchyard

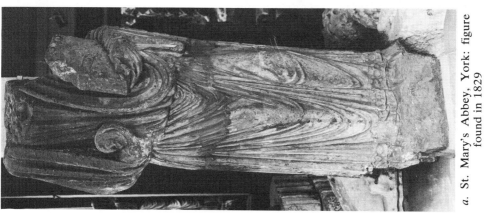

a. St. Mary's Abbey, York: figure found in 1829

PLATE XXXIX

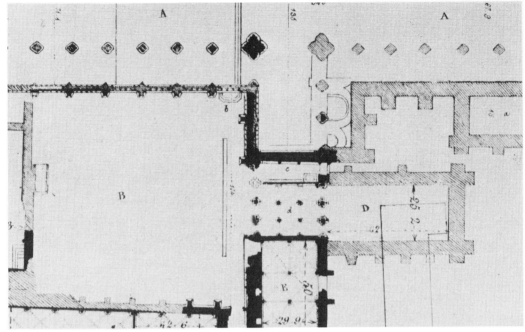

a. Plan of cloister and chapter house (after *Vetusta Monumenta*, v (1835), pl. LI)

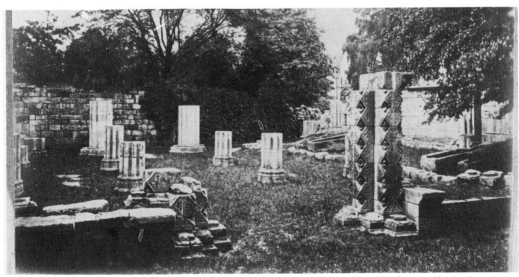

b. Nineteenth-century photograph of chapter house entrance and vestibule seen from site of chapter house proper (from Hornby scrapbook, York Minster Library)

St. Mary's Abbey, York

PLATE XL

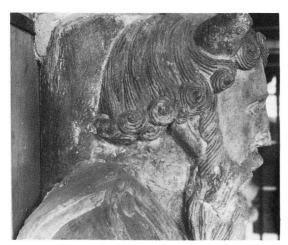

a. Detail of figure of Moses (pl. XXXVI*c*)

b. Fragment of figure found in 1970 in the Yorkshire Museum grounds

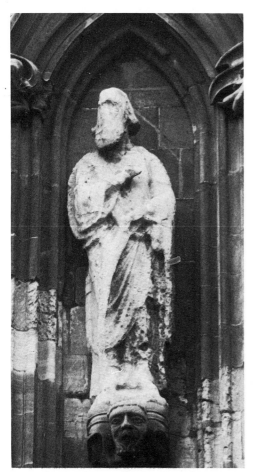

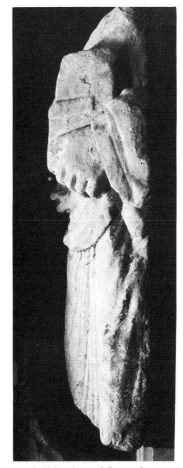

c. York Minster: figure of prophet on east face of south-west tower

d. Side view of figure from Cawood

PLATE XLI

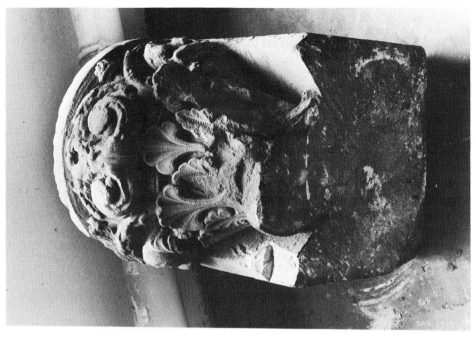

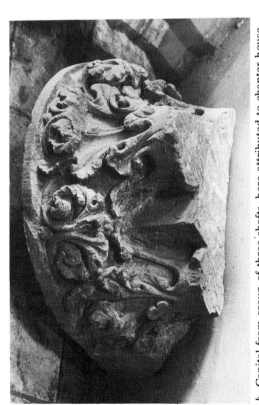

c. Capital from corner shaft here attributed to chapter house

a. Capitals from left jamb of west entrance to parlour ('c' in pl. XXXIX*a*)

b. Capital from group of three shafts, here attributed to chapter house

St. Mary's Abbey, York

PLATE XLII

b

a. North pier of chapter house entrance seen from chapter house vestibule

b. Reconstruction of chapter house entrance by R. D. Chantrell, dated 12 February 1829 (lithograph)

a

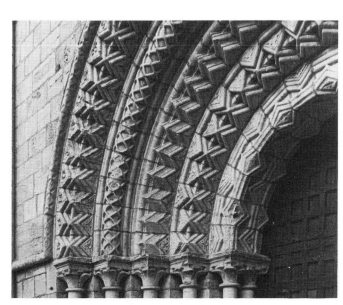

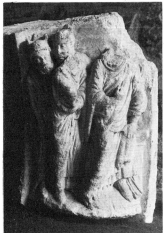

c. Detail of west door of Selby Abbey

d. Voussoir with the Magi before Herod, found in 1963 on the site of the chapter house of St. Mary's Abbey

PLATE XLIII

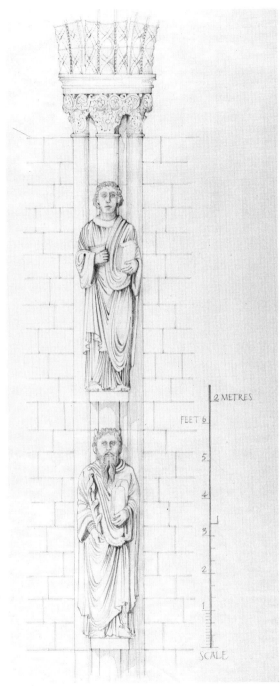

Reconstruction study showing suggested arrangement of apostle and prophet
figures in relation to chapter house vault shafts.

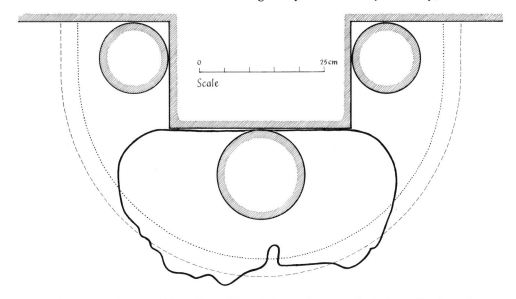

FIG. 15. St. Mary's Abbey, York. Plan of chapter house vault shafts and horizontal section at chest level through figure shown in pl. XXXVI*b* (heavy line). The dotted line indicates the upper limit of the capital. The broken line indicates the suggested upper limit of the lost abacus slab.

capital (pl. XLI*c*) which is of the same height and so presumably from the same series. It has occupied a corner position and it is difficult to see how it performed any function other than to carry a diagonal rib. Illogically, from an architectural standpoint, its shaft matched in diameter the central shaft below the large capital, and not the flanking shafts. The inconsistency can be explained if one postulates that the 18 cm. shafts under both types of capital were linked to the shafts of the same diameter which rise from all the figures whether with angled or flat backs.[41] A more approximate but none the less striking correspondence is that between the total width of all three shafts and the maximum width of the flat-backed figures (fig. 15). Seen in conjunction, the sculptural and architectural evidence indicates that the original setting was a rectangular room decorated with foliate and abstract ornament indistinguishable in style from that on the portals of the vestibule and chapter house. Since there is at present no evidence that St. Mary's Abbey possessed more than one richly decorated late twelfth-century building, the conclusion seems inescapable that all the figures adorned the chapter house.[42]

The original number of figures is of course unknown, but eleven have survived wholly or partly and it seems unlikely that only one has been lost. It is probable, therefore, that each of the twelve vault responds in the chapter house carried more than one figure, and the simplest solution would be a complete apostolic college forming an upper tier with twelve representatives of the Old Law under them (pl. XLIII).[43] The survival of figures of Moses and John the Baptist suggested to Willibald Sauerländer that there once existed a series of the forerunners of Christ, or *Christophores*, similar to those on French cathedral portals of the period *c.* 1170–1210.[44] Sauerländer did not commit himself as to the original size of the

Christophores series, although he implied that it might have been as large as the apostle series. The main obstacle to postulating twelve *Christophores* figures is the very low proportion of the surviving sculptures which conform to this iconography. Whereas the *Christophores* are now represented only by Moses and St John the Baptist, no fewer than nine figures are shown holding books, the usual attribute of apostles in twelfth-century sculpture. Of course it is not impossible that the survival rate for the apostles should be far better than for the *Christophores,* but the discrepancy seems rather too great to be fortuitous. A way out of the difficulty is to posit that the other members of the Old Testament contingent were not *Christophores* but prophets and that some of these are represented by extant book-carrying figures.[45] This leaves only the length of the beards as a possible criterion for distinguishing between prophets and apostles. Since Moses and the Baptist have very long beards and the one securely identified apostle, St. James, has a short beard, it may be suggested that all four long-bearded figures were intended for prophets and that the apostles included all or most of the four figures well preserved enough to show that they were short-bearded or cleanshaven (pls. XXXVII*b,d*, XXXVIII*a,b*). Twelfth-century artists were not at all consistent about the size of the beards they gave to prophets and apostles, but the general tendency was to show prophets wearing longer beards than apostles. An almost contemporary parallel for the firm demarcation suggested here is provided by a domed reliquary from Hochelten near Xanten which carries figures of apostles and prophets, the latter consistently more amply bearded than the former.[46] As at St. Mary's, the tonsorial distinction is made necessary by the abandonment of the usual medieval convention of equipping prophets with scrolls and apostles with books, although in this instance every figure carries a scroll rather than a book. Notwithstanding the lack of parallels for a series of book-holding prophets, the scheme proposed above has the advantage over the *Christophores* theory that it implies equal numbers of Old and New Testament figures and thus complements the architectural evidence.[47]

Whatever may have been the exact composition of the lower register in the St. Mary's chapter house, there is much to be said for thinking of the complete scheme as an amplification of a French Early Gothic portal, albeit of a type current *c.* 1150–60 rather than *c.* 1170–80. The ranging of apostles over (mostly) Old Testament personages can be seen as a rearrangement of the lintel and jamb figures of the central west portal at Chartres, and even the principal image at Chartres, the Christ in Majesty, had its counterpart at St. Mary's, at least by *c.* 1400 when the Customary of the abbey was written.[48] The York Majesty, which occupied an elevated position on the east wall of the chapter house, may not have been an original element and was not necessarily a stone sculpture, but some encouragement to think that it was both these things is provided by the Evangelist symbols from a Majesty that accompany the Old Testament figures and apostles at York Minster.[49] In any event, it is conceivable that this was the iconographical point of departure, so to speak, of the St. Mary's scheme. One of the derivatives of the west portal at Chartres, the south portal at Le Mans Cathedral, yields a suggestive parallel for the other major component of the sculptural decoration of the St. Mary's chapter house. Enclosing the tympanum showing Christ in Majesty are three archivolts carved with a very detailed Christological cycle continued down to the Marriage at Cana. It seems quite possible that seven Christological

voussoirs in the Yorkshire Museum (which include the Raising of Lazarus) were sited originally near the Majesty on the east wall. Careful measurement reveals that they came from two arches of different span, neither corresponding to any opening which has left traces in the buildings of St. Mary's. Four of the voussoirs were found in 1963 on the site of the east end of the chapter house (pl. XLII*a*), and there is a good chance that their original location was a trio of recesses or windows in the now totally demolished east wall.[50]

The 'exploded portal' iconography proposed here cannot be paralleled in any other medieval chapter house—a fact which is less discouraging than one might imagine, since the figural schemes existing or recorded in English chapter houses indicate that no consensus was ever reached about the subject matter appropriate to this type of building.[51] The only feature of the St. Mary's scheme that can be seen as reflecting earlier experiments in chapter house decoration is the incorporation of apostle figures into the vault shafts. George Zarnecki has invoked Linda Seidel's hypothetical reconstruction of the chapter house of St.-Etienne at Toulouse, in which the well-known early twelfth-century apostle reliefs in the Augustins Museum are assigned the role of vault responds. He has also mentioned the figures from the Durham Cathedral chapter house of *c.* 1133–41 which stood under capitals carrying a rib vault.[52] But neither of these parallels is close enough to suggest direct influence. St.-Etienne is remote from St. Mary's both geographically and in time, and the Durham figures differ from those at St. Mary's in their scale, in their relation to the vault supports and, most fundamentally, in their iconographic status: they are merely caryatids, not representations of particular individuals.

The quasi-architectural role of the figures within the chapter house may account for certain peculiarities in their general design. Most obviously complementary to the strong, isolated verticals of the vault shafts into which they fitted are their block-like contours and frontal stance, features criticised by Sauerländer and ascribed by him to the limited ability of the sculptors.[53] One has only to look at the York Minster figures (pl. XL*c*) to appreciate that some York carvers of the late twelfth-century were scarcely less concerned than their French contemporaries with devising vigorously asymmetrical yet balanced poses. The same comparison highlights another peculiarity of the St. Mary's series. In most cases the overall width is kept very nearly consistent by the inclusion of draperies extending from the elbows to the ankles.[54] Like the frontality of pose, this feature contributes to the general impression of immobility and would have served to reinforce the verticals of the vault shafts. The lack of such draperies on some of the broad-shouldered Minster figures imparts a skittle-like shape foreshadowing some of the jamb figures at Rheims. Earlier on it was suggested that the Minster statues were set in external niches and, if that is correct, they exemplify in one way, as the St. Mary's figures do in quite another, an abiding characteristic of English Gothic sculpture: its very limited independence from its architectural setting.

NOTES

(The research for this paper formed part of a larger investigation of the art and architecture of St. Mary's Abbey carried out at the Yorkshire Museum with the aid of a Research Award from the Leverhulme Trust Fund. The drawings were prepared by John Hutchinson.)

[1] E. S. Prior and A. Gardner, *An Account of Medieval Figure-Sculpture in England* (Cambridge, 1912), pp. 201, 213–216; A. Gardner, *A Handbook of English Medieval Sculpture* (Cambridge, 1935), pp. 106–8; R. Marcousé, *Figure Sculptures in St. Mary's Abbey, York* (York, 1951); T. S. R. Boase, *English Art 1100–1216* (Oxford, 1953), p. 241; G. Zarnecki, *Later English Romanesque Sculpture, 1140–1210* (London, 1953), pp. 48–50, 63; L. Stone, *Sculpture in Britain: the Middle Ages* (Harmondsworth, 1955), pp. 100–101; W. Sauerländer, 'Sens and York: an inquiry into the sculptures from St. Mary's Abbey in the Yorkshire Museum', *J.B.A.A.,* 3rd ser., xxii (1959), 53–69; D. Goodgal, *Figure Sculpture from St. Mary's Abbey, York,* unpublished M.A. report, Courtauld Institute of Art, University of London, 1971; R.C.H.M. *City of York,* iv: *Outside the City Walls and East of the Ouse* (London, 1975), pp. xlii–iii, 12b, 23a, 24a; M. Thurlby, *Transitional Sculpture in England,* unpublished Ph. D. thesis, University of East Anglia, 1977, pp. 129–38.

Exhibitions: *English Medieval Art,* Victoria and Albert Museum, London, 1930, No. 11; *L'Art Roman,* Barcelona, 1961, No. 606 ('St John the Evangelist'), No. 607 (Moses); *L'Europe Gothique XII^e–XIV^e siècles,* Paris, 1968, No. 25 (Moses), No. 26 ('St.John the Evangelist'); *The Year 1200,* New York, 1970, No. 30 (Moses).

[2] But see n. 8 for a new identification of one of the figures.

[3] The source invariably quoted for the excavations of 1827–8 and 1829 is C. Wellbeloved, 'Account of the ancient and present state of the Abbey of St. Mary, York, and of the discoveries made in the recent excavations conducted by the Yorkshire Philosophical Society', *Vetusta Monumenta,* v (1835), text accompanying pls. li–lx (read 5 March 1829). Not used hitherto, but often more informative than the above, are the weekly reports in the *Yorkshire Gazette,* 25 August–15 September, 6, 13, 27 October 1827, 8 November 1828, 10, 17 January 1829 and in the *York Courant,* 21 August–16 October, 30 October 1827, 12, 26 August 1828, 13, 20 January 1829.

[4] The *Yorkshire Gazette* 17 January 1829 gives the depth of the wall over the statues as six feet. Wellbeloved, *op. cit.,* 15, has 'about eight feet'. His observation that the mortar was the same as that used in the 'palace' (the King's Manor) is not helpful as he does not specify a particular part of this heterogeneous building.

[5] Wellbeloved says that the wall crossed the aisle; *ibid.* Confirmation of the accuracy of the *Yorkshire Gazette* report is provided by the plan in the Yorkshire Museum drawn in 1953 by G. F. Willmot, the excavator of the west end in the years 1952–6: the wall shown running along the site of the south arcade is ten feet (three metres) thick.

[6] A survey made near the end of Henry VIII's reign shows the east claustral range converted into the queen's lodging, the refectory into the king's hall and the west range into a chapel, hall, chambers and kitchen; P.R.O., E101/501/17. Dr H. M. Colvin kindly told me of the evidence for dating this document. For the galleries in the nave aisles see A. B. Whittingham, 'St. Mary's Abbey, York: an interpretation of its plan', *Arch. J.* cxxviii (1972), 118–46 (125–6). Despite being misled by Wellbeloved's account of the position of the wall concealing the figures, Whittingham associated it with the galleries of *c.* 1568. G. F. Willmot, who was apparently unaware of the late sixteenth-century conversion of the nave, interpreted this wall as a sleeper wall of the church begun in 1089. His results were never written up for publication but photographs in the Yorkshire Museum go far towards proving a post-Reformation date for the wall. Not only did the similar wall associated with the north arcade (exposed in 1955 and 1956) contain late thirteenth-century fragments, but the structures under the piers, which Willmot thought in 1954 were late thirteenth-century abutments to the eleventh-century sleeper wall, look in photographs like freestanding footings (cf. the late fourteenth-century eastern arm of York Minster) against which the wall is built. Willmot dug in this area partly because the 1829 excavation had been discontinued for want of funds (*Yorkshire Philosophical Society Report for 1828* (1829), 22) and partly in the hope of finding evidence for a large portal at the west end.

[7] Only late thirteenth-century fragments are recognisable in the photograph in the Yorkshire Museum which is the sole record of the make-up of this wall. The figures are therefore the only pieces predating the thirteenth-century church which are known to have been used in this way. For the excavations of 1952–6 see n. 6.

[8] The identification of the St. James figure was made by Mr Paul Barker in 1977. Below the book in the saint's left hand are the worn remains of a scrip with three scallop shells. This is the only apostle whose identity is beyond dispute: the usual identification of the beardless figure as St John the Evangelist presupposes that only apostles carried books, a reasonable assumption for stone sculpture of this period (but see p. 114 and n. 46). There is a cleanshaven Daniel (with a scroll) on

the Pórtico de la Gloria at Compostela. The figures of St. James and St. John the Baptist are shown on the wall at St Lawrence in: F. Drake, *Eboracum* (London, 1736), pl. 8 (reversed view); a sketch by Richard Gough made in 1766 purposely to supplement the information in Drake's plate, Oxford, Bodleian Library, MS Top Gen E 25, f. 193; sketches by John Carter, 1790, British Library, Add MS 29929, f. 53.

9 In the absence of any adequate record of accessions to the Yorkshire Museum in the nineteenth century, it is not possible to say exactly when the Walmgate and Clifton figures entered the collection. The Walmgate figures were being applied for in 1832 and 1838; Yorkshire Philosophical Society, Minutes of Council Meetings, 1 June 1832, 30 April 1838. They were still at St. Lawrence in 1861 but had come into the museum by 1869; C. Wellbeloved, *A Descriptive Account of the Antiquities in the Grounds and in the Museum of the Yorkshire Philosophical Society* (York, 1861), p. 52, and *ibid.*, 1869 edn., pp. 53–4. On 9 March 1840 the Council of the Y.P.S. resolved that 'application be made to the Surveyor of the Highways of the Township of Clifton for the old statue which is built into the Bridge over the Burg Dyke at Clifton . . . ' (Y.P.S. Council Minutes), and the figure was in the museum at the time of publication of the first (1852) edition of Wellbeloved, *op. cit.* (p. 36). The findspot is given there, rather unhelpfully, as 'Clifton Bridge'. The bridge in question would seem to be that shown just south of Clifton Green on the Ordnance Survey map of 1852. The site is now built over. The seventh (1881) edition of Wellbeloved's work (renamed *Handbook to the Antiquities . . .*) wrongly gives the date of accession of all three as 1838 (pp. 73, 74).

10 Drake, *op. cit.*, p. 577; additions to James Torre, *Archdeaconry of York,* York Minster Library MS L 1(8), p. 828.

11 Found by Dr Malcolm Thurlby in 1970, in the rockery opposite the south-east door of the Yorkshire Museum. The only references in print are R.C.H.M., *op. cit.*, p. xlii, 'the last figure is more fragmentary and its history is not known' and *ibid.*, p. 24a, 'Fragment of torso, similar in style and scale to the other figures; origin unknown.'

12 The diameter appears to be 17 cm., 1 cm. less than the shafts behind the better preserved figures. It has not yet been possible to examine the undersides of the other figures from St. Mary's. The Cawood figures have no circular areas in this position.

13 E. Bogg, *The Old Kingdom of Elmet and the Ainsty District* (London, 1902), pp. 232–3. Bogg's reference to 'life-sized figures in stone of the four evangelists' suggests that other figures have been lost. The Virgin and Child can be seen propped against the gatehouse of Cawood Castle in L. Ambler, *The Old Halls and Manor Houses of Yorkshire* (London, 1913), pl. XXXVII. All the unpublished information given here, as well as that for which no source is cited in R.C.H.M., *op. cit.*, p. xlii, n. 1, derives from a file in the Yorkshire Museum entitled 'St. Mary's Abbey? figures from Cawood'. The figures were traced to Cawood by a Mrs Mary Johnstone of Shoreham, Sussex, who noted that a fourth figure or fragment of a figure had sunk into the mud of a riverside garden of 'The Moorings', 8 Water Row, Cawood. The lower part of a fourteenth-century figure is still in the garden, together with fragments from the Hull Town Hall of 1862 and various medieval fragments, including a piece of keeled vault rib exactly matched by some in York Minster deriving from Archbishop Roger's choir.

14 Their shallowness at shoulder level makes it unlikely that they had incipient columns like the St. Mary's figures, but there is too much damage to be sure.

15 *The Chronicle of Robert of Torigni,* ed. R. Howlett (London, 1889), iv, p. 299. Robert came to England in 1175 and very probably gleaned his information about Archbishop Roger's residences during that visit. The influence of Mosan metalwork and a date *c.* 1180 are suggested for the Cawood figures in G. Zarnecki, 'Deux reliefs de la fin du xiie'la la cathédrale d'York', *Revue de l'Art,* xxx (1975), 17–20.

16 The location of the York Minster figures is as follows: north-west tower at clerestory level, one on the north buttress of the east side, one on the west buttress of the north side and one on the north buttress of the west side; south-west tower, at the same level, one on the south buttress of the east face; south-west corner of western crypt, seven (excluding one early fourteenth-century figure), mostly broken; Undercroft Museum, five (currently labelled 'thought to be fourteenth century'); aedicules of flying buttresses on south side of nave, six recut or renewed in 1817 (J. Browne, *The History of the Metropolitan Church of St Peter, York* (London, 1847), p. 319) and of these the easternmost one renewed entirely at some later date. The original of the recut figure on the third buttress from the east may be the very worn torso built into the terrace in the front garden of the Treasurer's House, north-east of the Minster. All the figures in the Undercroft

Museum and the western crypt were in the clustered niches to either side of the great west window, at the same level as the figures still in place.

[17] The south niche at Nun Monkton contains a scroll-holding female figure with a head that does not fit, the north niche little more than a pair of bare feet. A drawing by J. W. Walton of 1877 shows the south figure headless and the north niche empty; British Architectural Library, Drawings Collection, X14/55[2]. The figure from Holy Trinity was transferred to the Yorkshire Museum in 1981. Outriders of this York-centred group are a torso and a fragmentary head at Guisborough Priory, placed, at the time of writing, south-east of the east wall of the conventual church. Except for a short curled beard, the head resembles the 'St. John the Evangelist' in the Yorkshire Museum. For the Selby gatehouse see E. R. Tate, 'Selby Abbey and its buildings', *Report of the Yorkshire Philosphical Society for 1907* (1908), 35–47 (pl. VI).

[18] For a plan of the foundations see G. E. Aylmer and R. Cant (eds.), *A History of York Minster* (Oxford, 1977), p. 110.

[19] *Vetusta Monumenta*, v (1835), 16; summary of Chantrell's letter entered under 3 March 1829 in a volume entitled 'Y.P.S. Scientific Communications at General Meetings. Vol. I, 1822 —' in the possession of the Yorkshire Philosophical Society. Needless to say, the plan of the shafts on the figures does not match that of the thirteenth-century nave piers.

[20] *Yorkshire Gazette*, 17 January 1829; *York Courant*, 20 January 1829.

[21] The two newspaper reports referred to in n. 20 have very similar accounts of the polychromy which is mentioned in passing in *Vetusta Monumenta, loc. cit.* Thus the *York Courant:* 'The inner [?vest of] one of them was richly coloured with purple, on which were sprigs of gold. The outer vest appeared to have been covered with gold, and the face was of flesh colour. All the figures have been splendidly coloured and gilt, but not much of it is now discernible, being removed by the damp of the cement in which they were embedded . . . The beard of Moses has been richly gilt . . . When first removed . . . it was astonishing to behold the brilliancy of some parts of the gilding, which seemed as if it had just come from the artists' hands . . . '

[22] Apparently the first mention of a portal as the possible site of the prophets and apostles is in a letter by E. S. Prior dated 24 February 1907; *Report of the Yorkshire Philosophical Society for 1912* (1913), vii–viii. The only twentieth-century writers who face the problem posed by the polychromy are Marcousé (*op. cit.,* p. 5) and Whittingham (*op. cit.,* 126). Prior and Gardner (*op. cit.,* p. 216) noted the differently shaped backs and suggested that they belonged to two separate portals. None of the other writers in favour of a portal or portals as the original setting has attempted to explain the variation, which has no parallel in twelfth-century portal sculpture.

[23] See notes 1, 15.

[24] The sculptural decoration of the chapter house of St.-Etienne, Toulouse includes eight apostles and that of the Camera Santa at Oviedo all twelve, a feature not paralleled in French portals until *c.* 1200. For the Durham chapter house figures (between 1133 and 1141), which are caryatids and belong to the Romanesque tradition of atlantes, see H. W. Janson, 'The meaning of the giganti', *Il Duomo di Milano;* Acts of the International Congress held at the Museo della Scienza e della Tecnica, Milan 8–12 September, 1968 (Milan, 1969), pp. 61–76. Mr David Park kindly told me of this article. The reliefs in the Musée des Augustins, Toulouse were always accepted as coming from the portal of the early twelfth-century chapter house at St.-Etienne until this provenance was challenged in L. Seidel 'A romantic forgery: the Romanesque "Portal" of St.-Etienne in Toulouse', *Art bulletin,* i (1968), 33–42. Seidel's suggestion that the reliefs were responds of the chapter house vault is rejected in M. Durliat, *Haut-Languedoc Roman,* No. 49 in Zodiaque series *La nuit des temps* (La Pierre-qui-Vire, 1978), pp. 197–201. The sculptures are no longer displayed as a portal. The widely scattered distribution in Early Gothic art of large standing figures associated with vault shafts (north transept chapel, Notre-Dame, Etampes, *c.* 1150; Camera Santa at Oviedo, *c.* 1170; Uncastillo (Saragossa), 1179; St. Yved at Braine, east crossing piers, *c.* 1180–90; Montier-en-Der (Haute-Marne), choir, *c.* 1190; Lausanne Cathedral, west entrance hall, *c.* 1210; Magdeburg Cathedral, apse, *c.* 1225–30; ruined choir and nave of abbey of Toussaint, Angers, *c.* 1240) suggests that late twelfth-century Ile-de-France examples have been lost. Less closely comparable is the west French tradition of placing standing figures above vault shaft capitals, in some cases so that the sculptures function as the lowest voussoirs of the ribs. These are discussed at length in A. Mussat, *L'architecture gothique dans l'ouest de la France aux douzième et treizième siècles* (Paris, 1963) and L. Schreiner, *Die frühgotische Plastik Südwestfrankreichs* (Cologne and Graz, 1963).

[25] For the documentary evidence see R.C.H.M., *op. cit.,* p. 34. The terracing is indicated on a plan of

1778 (P.R.O., MP/E/344) and a grant of 1828 by which part of the St. Mary's Abbey site was leased from the Crown to the Yorkshire Philosophical Society (North Yorkshire County Council Deed 13454/10).

[26] The original plan can be deduced from the base of the destroyed pier between the parlour and the vestibule; see also n. 32. The likely source is the pair of cylindrical piers with four detached shafts in the crypt of York Minster (finished by 1166). The effect of the St. Mary's piers can be gauged to some extent from the more plainly detailed piers in the north tribune of the nave at Selby Abbey. I intend to publish a separate study of the architecture of the chapter house.

[27] Closely paralleled in most of the capitals of the Trinity Chapel at Canterbury are the stalks growing out of the lower parts of the central spines of the crockets, each of which carries a single multilobed leaf.

[28] The question of date cannot be treated in detail here, but the location of the figures in a chapter house rather than on a portal removes any necessity for dating them after the first appearance around 1200 of French portals with jamb figures showing all twelve apostles (cf. Sauerländer, *op. cit.*, 58). The flat backs of most figures recall figures on portals with splayed jambs rather than the more primitive type with stepped jambs, and this may have encouraged dating to after 1200. A date in the 1180s is accepted in Zarnecki, *op. cit.*, p. 58.

[29] Notably in a series of detached jamb fragments and voussoirs divided between the western crypt of York Minster and the Yorkshire Museum.

[30] The only work in Yorkshire which can reasonably be attributed to the St. Mary's team, including the foliage carvers, is the débris of a door from Kirk Ella near Hull; W. Wareham, 'The reconstruction of a late Romanesque doorway, Kirk Ella (Elveley) Church', *J.B.A.A.*, 3rd ser., xxiii (1968), 24–39.

[31] H. H. E. Craster and M. E. Thornton (eds.), 'The Chronicle of St. Mary's Abbey, York', *Surtees Society*, cxlviii (1933), 29, 36.

[32] This figure is the sum of the height of the south pier of the vestibule entrance plus the difference between the raised floor level here and the original level at the east end of the vestibule. The south-west pier is at its full height of *c.* 1300, as is proved by the fact that when found in 1827 the mortar on the top course retained the impressions of the late twelfth-century capitals; *Vetusta Monumenta*, v (1835), 14.

[33] R.C.H.M., *op. cit.*, p. 34, pl. 73, 'K' on ground-floor plan of King's Manor (at end of volume).

[34] This is suggested by the brick blocking wall found next to the south-west jamb of the south 'window' of the chapter house entrance; *York Courant*, 4 September 1827. A brick wall was built between the west crossing piers when the nave aisles were subdivided *c.* 1568–70. The early seventeenth-century phase of the King's Manor, which involved the demolition of the claustral ranges, made use almost exclusively of stone taken from the abbey. The chapter house is not referred to in the survey of the late 1540s mentioned in n. 6.

[35] For example, Durham, Wenlock, Bristol and St Albans. The Gloucester chapter house has three tunnel-vaulted bays but had originally an apse as well.

[36] The plan by R. H. Sharpe reproduced as pl. LI of *Vetusta Monumenta*, v (1835) is corroborated in nearly all its details by the only other plan made during the 1827–9 excavation, that by Eustachius Strickland, Trustee and Librarian of the Yorkshire Philosophical Society from 1828. Strickland's plan is in the Yorkshire Museum. It is possible that the St. Mary's chapter house was intended to rival those at the Cistercian abbeys of Kirkstall (vestibule two bays wide and two deep) and Rievaulx (five bays with apse, ambulatory and aisles).

[37] Apart from three historiated voussoirs, for which see below pp. 114–15, the most important late twelfth-century pieces found in the 1820s are foliage capitals, apparently from wall-arcading.

[38] The provenance of these capitals is not recorded but it is likely that they were among the 'several fine pieces of sculpture found, particularly capitals of columns', in the chapter house; *Yorkshire Gazette*, 13 October 1827. The two large capitals are assigned a late thirteenth-century date in R.C.H.M., *op. cit.*, p. 226, pl. 10.

[39] For example, the fragment from a large capital has small heads in the interstices above the foliage, tightly curled trios of trilobed leaves and wide 'acanthus' with central spines formed of overlapping circles (cf. Canterbury, south-west piers of east crossing and south presbytery pier immediately east of east crossing). The symmetrical pairs of scrolls directly below the abacus are flattened-out versions of the curling sprays at the ends of the large-scale crockets at Canterbury. In the corner capital the paired scrolls approximate to the rinceaux on the pier east of the north-east pier of the east crossing at Canterbury and on one of the south piers of the hemicycle at St. Leu-d'Esserent.

40 G. G. Scott placed this capital on the vault shafts of the vestibule; *Lectures on the Rise and Development of Mediaeval Architecture,* i (London, 1879), pp. 108–9, fig. 62; *The Building News,* 6 July 1877. It is, however, too large for this position, being 9 cm. deeper than the capitals on the entrances to the vestibule and the chapter house proper. Moreover, its central shaft was wider than any on the two entrances.

41 On one of the figures (pl. XXXVI*d*) the shaft is 19 cm. wide.

42 The only building of St. Mary's nearly contemporary with the chapter house is the very plainly detailed gateway to the precinct; R.C.H.M., *op. cit.,* pl. 19. Some rather poorly carved late twelfth-century double cloister capitals survive but the shafts under them have been far slimmer than those behind the life-sized figures (*ibid.,* pl. 29).

43 In stone sculpture the only near-parallel for the arrangement of figures in two registers is the Fürstenportal at Bamberg of *c.* 1235, where the relationship of the Old Law and the New Law is strikingly expressed by making apostles stand on the shoulders of prophets. There appear to be no English examples of this iconography, whose earliest known representative was the late tenth-century frescoes on the triumphal arch of S. Maria in Pallara (now S. Sebastianello al Palatino), Rome.

44 Although the oldest existing series of twelve *Christophores* is that on the central portal of the north transept at Chartres (*c.* 1210), there was probably at least one late twelfth-century cloister in France decorated with a very extended *Christophores* series. Only five typological Old Testament figures can be recognised among more than fifty recovered from the cloister of Notre-Dame-en-Vaux, Châlons-sur-Marne, but the inclusion of the rarely represented widow of Zarephath suggests that a much larger number once existed.

45 A nearly contemporary parallel for this hybrid scheme of prophets with a minority of *Christophores* is the Pórtico de la Gloria at Compostela. Here the Baptist faces St. John the Evangelist across the vestibule. The York Moses, unlike his counterpart at Compostela, shows an awareness of the *Christophores* iconography pioneered at Senlis.

46 The Hochelten reliquary, now in the Victoria and Albert Museum, is illustrated in P. Lasko, *Ars Sacra: 800–1200* (Harmondsworth, 1972), pl. 255. Christ is the only figure in the upper register with a long beard like those worn by twelve of the thirteen original prophets on the lower register. The other original prophet, Daniel, is unbearded.

47 There is of course no scarcity in medieval art of individual prophet figures holding books: within the field of Early Gothic sculpture one can point to the minority of prophets with books on the archivolts of the St. Anne portal at Notre-Dame, Paris and the west portal of Senlis. At least one of the York Minster figures is a scroll-bearing prophet (pl. XL*c*). The lack of distinguishing attributes on most of the St. Mary's figures suggests that their identification depended on inscriptions, a method that would not have been suitable had the setting been external and publicly accessible.

48 The Abbess of Stanbrook, J. B. L. Tolhurst, 'The Ordinal and Customary of the Abbey of Saint Mary, York', *Henry Bradshaw Society,* lxxiii (1936), 75.

49 For the angel and eagle see G. Zarnecki, *op. cit.* The lion and the ox are re-used above the clerestory-level window in the west side of the south-west tower.

50 The radii of the voussoirs indicates they did not form part of the portals in the east and west walls of the vestibule. I hope to publish a detailed account of the voussoirs at a future date.

51 The following list, doubtless incomplete, conveys at least an idea of the diversity of subjects:- Worcester Cathedral: mid or late twelfth-century typological scenes painted on the vault (destroyed); Oxford Cathedral: mid thirteenth-century roundels with apostles, St. Peter and censing angel painted on the vault; Westminster Abbey: mid thirteenth-century marble Annunciation group over west door, late fourteenth-century paintings in wall arcade of Last Judgment, Apocalypse and subjects from the Bestiary; Salisbury Cathedral: late thirteenth-century wall arcade spandrels carved with scenes from Genesis and Exodus; York Minster: late thirteenth-century stained glass of lives of Christ, Virgin and other saints, all save one commemorated by altars in the church; paintings on wooden vault cells of drolleries and figures shown in windows (most destroyed); paintings on wall over entrance of prelates and royalty (destroyed); thirteen empty niches immediately over entrance (presumably for statues of Christ and apostles); Canterbury Cathedral: crucifixion of *c.* 1300 painted on wall under canopy of prior's throne (destroyed); Hereford Cathedral: forty-six late fifteenth-century paintings in wall arcade of Christ and twelve apostles, 'two sisters that gave four manors', Edward the Confessor and his queen, the Earl of Pembroke, St. Winifred, St. Chad and 'other holy women' (destroyed); Lichfield Cathedral: fifteenth-century painting of Assumption on wall over entrance; Exeter Cathedral: sculptures of

minor prophets including Hosea, Amos and Jonah in niches immediately under principals of late fifteenth-century roof (destroyed). This appears to be the only parallel for the prophet series here proposed for the St. Mary's chapter house. For the sculptural decoration of the St. Albans abbey chapter house see Deborah Kahn's paper at pp. 71–89 of this volume.

At Lavaudieu, between Clermont-Ferrand and Le Puy, the east wall of the chapter house is painted with a Christ in Majesty above a row of standing apostles flanking the Virgin enthroned. Lavaudieu parallels the St. Mary's scheme not only in content but also in its derivation from church decoration, in this case apse paintings.

[52] See note 24.

[53] Sauerländer, *op. cit.,* 61, 68–9.

[54] The even width characteristic of French column figures in the tradition of the Portail Royal at Chartres is achieved by unnatural compression of the shoulders.

The Percy Tomb at Beverley Minster: the Style of the Sculpture

Nicholas Dawton

The Percy tomb at Beverley Minster is one of the most magnificent English tombs. Its rich use of sculptural ornament invests it with the opulence associated with English art at the height of the Decorated period. When its stonework was still painted and gilded it would have presented an appearance of splendour rivalled only by the most lavish productions of the period, such as the Southwell pulpitum or the Ely Lady Chapel. The statuary on the canopy is of particular importance for its high quality and good state of preservation. In the available literature, however, there is no agreement on its proper place in the history of English sculpture. Prior and Gardner attributed it to the York school, seeing it as part of an all embracing Yorkshire tradition.[1] Professor Lawrence Stone, on the other hand, strongly criticised the idea of a unified school of sculpture in Yorkshire, regarding the Percy tomb as an isolated development in a region characterized by stylistic diversity.[2]

Both views are open to criticism on different grounds. Prior and Gardner, in their attempt to discern the main developments in English Gothic sculpture, may have overlooked important divisions in early fourteenth-century sculpture in Yorkshire, allowing one to question the degree to which the Percy tomb is representative of sculpture in the county as a whole. Professor Stone, however, may have over-emphasized the heterogeneous nature of Yorkshire sculpture and obscured the continuity of tradition in the north Midland area and the north-east of England. These considerations suggest that there is a need to reappraise the problems surrounding the style of the sculpture on the Percy tomb.[3]

The Percy tomb did not escape unscathed from the alterations and restorations carried out at Beverley in the eighteenth and nineteenth centuries. The dark marble tomb chest which formerly belonged to the Percy tomb was removed in 1825[4] during the alterations which followed the decision to fit up the choir for services.[5] The appearance of the marble tomb was recorded by the antiquary Carter (pl. XLIV).[6] It fitted the Percy tomb so well that it must have been designed

for that position. The brass on the marble tomb had disappeared at an earlier date but the appearance of the indent was recorded in another drawing by Carter (pl. XLV*b*).[7]

The Percy tomb has also lost most of its painted decoration although what appear to be traces of colour are still visible on some of the figures. A considerable portion of the mantle of the angel with the scourge (pl. L*a*) is covered with irregular, straw-coloured patches, suggesting that the surface of the statues was cleaned during one of the restorations at Beverley.[8] These vestiges of polychromy testify to the originality of the statues.[9]

The sculpture on the tomb was drawn by Carter in 1790.[10] Although the tomb may have been subsequently cleaned, the condition of the main figures appears to have remained otherwise unchanged (pls. XLVI*b,c,* XLVII). Several figures are represented with broken limbs or missing attributes (pl. XLVI*a*) but none of this damage has been repaired. Christ still lacks his right forearm (pl. XLIX*a*) and the angel to his right is still deprived of both forearms (pl. L*a*).[11] The faithful manner in which Carter has represented these important breakages demonstrates the reliability of his drawings in depicting the actual condition of the sculpture in 1790.[12]

The relatively good state of preservation of the major figures at that time is remarkable considering the rough treatment meted out to so many English tombs during the sixteenth and seventeenth centuries. A drawing in Dugdale's Yorkshire Arms (pl. XLV*a*), based on a visit to Beverley in 1641, suggests that the statuary on the canopy was still extant.[13] It is possible to recognise the enthroned figure above the apex of the arch on the south face of the tomb,[14] flanked by the angels carrying the soul of the deceased in a napkin. The main gable is surmounted by statues on figured brackets although the arrangement differs from that seen in the drawing by Carter. In addition to the statues level with the apex of the arch, figures have been represented at the foot of the gable. The drawing contains other discrepancies of this nature, such as the ball-flower decoration erroneously applied to the outside of the main arch of the canopy. Small ball-flower studs, however, are found on the main arch of the vault and the artist's mistake would seem to be a case of muddled copying rather than groundless invention. The main features of the tomb can be recognised without much difficulty, even if the overall standard of accuracy is less rigorous than in Carter's drawing. The drawing in Dugdale's Yorkshire Arms may not be trustworthy with respect to the exact shape or position of the figures on the canopy but the fact that they were represented at all is strong evidence that they had survived until the eve of the Civil War.[15]

The Percy tomb brass, judging from the nature of the matrix as drawn by Carter (pl. XLV*b*), would accord with a date in the second quarter of the fourteenth century. The design of the brass canopy appears to have resembled that of the brass of John de Grofhurst at Horsmonden, Kent, dating from *c.* 1340.[16] The bold trefoil cusping of the Beverley indent recalls that of the brass of Lady Joan de Kobeham at Cobham, Kent, of *c.* 1320.[17] The arrangement of shields in rows on either side of the effigy may be compared to the design of the brass of Margarete de Camoys at Trotton, Sussex, of *c.* 1315.[18] The use of individually set letters to form the inscriptions is consistent with an earlier date for the Cobham and Trotton brasses in relation to the lost brass at Beverley. The latter had its inscription cut on a continuous brass fillet, suggesting a date not earlier than *c.* 1325.[19] The canopy of

the Percy tomb brass lacked the heaviness found in canopies after 1500[20] and must have been in existence when Leland visited Beverley in the sixteenth century. The marble tomb chest should have been in position, under the Percy tomb, at that time. This sheds considerable doubt on the attribution of the tomb to Idonea (d. 1365), wife of Henry Percy, 2nd Lord of Alnwick,[21] for Leland specified that her tomb was made of 'white alabaster'.[22] Several authors have suggested that the tomb commemorated Eleanor (d. 1328), wife of Henry Percy, 1st Lord of Alnwick.[23] This attribution relies heavily on identifying the tomb with a monument in the north choir aisle which Leland attributed to a Lady Eleanor Percy and which was mentioned previously in the will of the priest George Percy.[24] The improbable nature of this attribution was pointed out by Leach who noted that the Percy tomb is not in the north choir aisle but in the choir itself.[25] Neither of these attributions is sufficiently convincing to help with the dating of the monument.

The date of the Percy tomb cannot precede the quartering of the arms of France with those of England as this form of the royal arms occurs on the shield held by one of the knights on the tomb.[26] Edward III adopted these arms in 1340 in conjunction with his claim to the French throne.[27] The first royal seal to have the new arms was the third seal of presence, used from 21 February to 20 June 1340.[28] Although the Percy tomb should not be earlier than this, the nature of its architectural design suggests that it cannot be much later than 1340. The nodding ogee arch, surmounted by a crocketed gable and terminating in a bracket for statuary, may, as Professor Stone suggests, have been inspired by the Ely Lady Chapel,[29] begun in 1321 and substantially complete by 1345.[30] The foliage decoration of the Ely Lady Chapel provides comparisons, albeit slightly less developed, for the bulbous leaves of the Percy tomb. As a type of canopied monument, the Percy tomb derives from Court prototypes such as the tombs of Edmund Crouchback and Aymer de Valence at Westminster Abbey.[31] It represents the culmination of this form of Court design, combined with a nodding ogee arch and enlivened with blind tracery, recalling the treatment of the lateral gables of Crouchback's tomb. This type of canopy, relying for its effect on a prominent, cusped arch surmounted by a large gable, was abandoned by the tombs of Edward II at Gloucester and John of Eltham at Westminster Abbey.[32] By the standards of Court taste, the Percy tomb would no longer have been at the height of fashion after 1340. A date in the 1340s could be explained by the time lag in the spread of new trends to the North. A date after 1350, however, would seem too late for such a prestigious tomb.

The similarity between the foliage sculpture of the Percy tomb and that of the altar screen and north nave aisle at Beverley also suggests that the tomb was erected soon after 1340.[33] The long, undulating leaves of the capitals of the tomb (pl. XLVIII*a*) seem to be at the same stage of development as the foliage on the bosses of the reredos and on the capitals of the blind arcading of the north nave aisle.[34] The leaves are deeply undercut and progressively subdivided in a manner reminiscent of fronds of seaweed. Continuous ripples run along the edges and reach a crescendo in the extremities of the leaf. The foliage of the reredos and Percy tomb attains a peak of artificiality but lacks the dryness found in work after 1360, such as the bosses of the presbytery aisles at York Minster. Bilson noted that the Percy tomb was built against the screen staircase and could not have preceded it.[35] However, the similarity between the foliage carving of the tomb and that of

the altar screen and north nave aisle suggests that all these works should be close in date.

The north aisle of the nave at Beverley Minster must be contemporary with the reredos as the same sculptors worked in both areas. The musicians in the north nave aisle have the same thickset proportions, rounded head type and incisively chiselled eyes as the figure over the upper door of the screen staircase (pl. XLVIII*b*).[36] Archbishop Melton donated money to the fabric of the nave and high altar at Beverley in 1334 but this does not indicate whether work was just beginning or already under way.[37] Dr. John Harvey suggested that the reredos dates from *c.* 1324–34, although this would seem too early to account for the strong similarity between its foliage carving and that of the Percy tomb.[38] Dr. Richard K. Morris has drawn attention to the close relationship between the mouldings of the Purbeck elements of the reredos and those of the Exeter pulpitum,[39] the latter being securely dated to between 1317 and 1324.[40] Similar elaborate bases occur in several other works generally dated to the 1330s and 1340s although those of the Beverley reredos are closest to those of the Exeter pulpitum, being identical in size and design.[41]

The windows of the south nave aisle at Beverley, related to the work in the north aisle by Dr. Nicola Coldstream, have the leaf-stem design found in the great west window at York Minster and the windows of the choir at Patrington.[42] The great west window at York is dated on documentary evidence to 1338–9 or shortly before.[43] Dr. Coldstream has pointed out the close similarity between the capitals of the Patrington nave and those of the cloister at Thornton Abbey,[44] rebuilt from 1323.[45] This would suggest a date in the late 1320s or early 1330s for the Patrington nave and demonstrates the close contacts which then existed between the regions on either side of the Humber. The choir at Patrington followed the nave[46] but there is unlikely to have been any break in building activity. Dr. Coldstream has outlined the similarities between the choirs at Patrington and Hawton.[47] The foliage diaper on the wall behind Christ on the Easter sepulchre at Hawton finds very close comparisons in the leaves on the capitals of the nave arcade at Patrington. This suggests that the choir at Hawton and the nave and choir at Patrington are all very close in date and supports the 1330s dating which Dr. Coldstream proposed for the Patrington choir.[48] These considerations recommend a date in the 1330s, possibly continuing into the 1340s, for the Beverley reredos and the related work in the nave. The similarity between the foliage carving of these works at Beverley and that of the Percy tomb suggests that the latter could not have been erected much later than 1340.

The workshop which produced the Percy tomb included sculptors whose distinctive styles are found separately in a number of other monuments in the North-East. The work of the most important sculptor can be fully appreciated thanks to the survival of the statues on the canopy. The seated Christ (pl. XLIX*a*) is characterized by its upright posture. A similar straightness of attitude is found in some of the other figures. The angel on the east side of the south gable (pl. XLIX*b*) betrays little hint of a contrapposto stance and its massive proportions imbue it with a distinctive sense of solidity. The long, shaft-like folds issuing from beneath the mantle give the figure a stable, columnar appearance. The angels on the north gable (pl. L*a*) are more relaxed in attitude, with a graceful, S-shaped posture.[49] The drapery is fully modelled, with a number of prominent folds emerging from

deep hollows (pls. XLIX*a*, L*a*). This strong relief is emphasized by the decorative play of the hemline as it moves in and out of the shadow. The mantle is twisted into long scrolls of material, the edges of which are heavily undercut, revealing the inner surface of the garment. The material is pulled tightly around arms and elbows (pls. XLIX*b*, L*a*) and falls away from the body in a sheer, vertical fashion (pls. XLVII, XLIX*b*, L*a*). A number of drapery motifs are given particular prominence such as the generous, pouch-like folds of the angels and the long, conical folds falling from the knees of the seated figures. The smooth finish and the liking for finely tapering folds give the material a sleek, silky appearance (pls. XLVII, XLIX*b*). There is a consistent preference for full, regular forms with a rounded surface profile and at no point is the material allowed to fall into dainty, fluttering folds. A taste for great richness is demonstrated by the convoluted patterns of drapery seen in some of the figures. The overall effect is one of calm splendour and measured elegance.

The caryatids beneath the angels (pl. L*b*) and the subjects on the brackets on the short sides of the canopy show the same smooth finish, tightly stretched drapery and rounded surface contour found in the statuary. The former also display a vivid sense of the grotesque and an interest in realistic detail, seen especially in the characterization of the faces. The same drapery style is found in the figures on the vault bosses and in the upper cusping of the north arch.[50] Most of the cusping, however, was carved by a different sculptor. His style is distinguished from that of the statuary by its less rounded drapery treatment. The figures are wrapped in flat swathes of material which give the drapery an angular surface profile (pl. LII*a*). The heads are characterized by their bulbous foreheads, broadly arched eyebrows and flame-like hairstyles. The knights carved by this sculptor can be recognised by the way in which their mail has been represented as a series of alternating crescent incisions.[51] This master was responsible for all the cusping of the south arch and also worked on the lower cusping of the north arch.[52]

Several monuments in the north of England can be attributed to the sculptors responsible for the Percy tomb. The effigy of a lady at Alnwick, Northumberland (pl. LI*a*) shows the same measured style seen in the Percy tomb statuary. Her kerchief falls over her shoulder in soft, overlapping folds which may be compared to the flat pleats of material over the chest of Christ showing his wounds (pl. XLIX*a*). Her broad shoulders and solid build conform to the figure type of the Percy tomb statues (pl. L*a*). The Alnwick lady now lies against the wall of the south choir aisle, her head to the east. The effigy of a civilian carved from the same sandstone lies further to the east and another civilian is in the former north porch.[53] The effigies are not on their original tomb chests[54] and have evidently been moved about.[55] Dugdale does not identify them but the lady is so close in style to the Percy tomb statues that the two monuments cannot be widely separated in date.[56]

The same style is found in the effigy of Euphemia de Clavering at Staindrop, Co. Durham, as noted by Gardner.[57] The facial features and placid expressions of the two ladies are almost identical and their smoothly folded kerchiefs show the same soft treatment. The foliage carving on her ogee canopy is close in character to that on the gable over the recess in the south aisle, indicating that she has always belonged there.[58] The recess is contemporary with the remodelling of the aisle undertaken by Ralph Neville, of Neville's Cross, after he had obtained permission

to found chantries in 1343.[59] As it is stated in the licence that the chantries were to be for the souls of his parents,[60] the attribution of the effigy to Ralph's mother, Euphemia de Clavering, is likely to be correct.[61] A date of 1343 or soon after would accord well with the date already suggested for the Percy tomb.

The tomb of an ecclesiastic in the south aisle at Welwick, North Humberside, the advowson of which appertained to the provost of Beverley Minster, is also related to the Percy tomb. Poulson mentioned the Welwick tomb, believing it to be contemporary with the Percy tomb.[62] An anonymous author writing in the *Yorkshire Archaeological Journal* suggested that the same sculptor may have worked on both monuments.[63] The drapery of St. Catherine in the niche surmounting the buttress on the far left of the tomb (pl. LI*b*) hangs in long, conical folds, sharply deflected around the feet. Her cote-hardie falls over her leg in a smooth plane, articulated by fine, sharp-edged folds above and below the knee. Close comparisons for this form of drapery treatment are found in the figures in the cusping of the south arch of the Percy tomb (pl. LI*c*). The heads of the angels on the Welwick tomb (pl. LII*b*) have the rounded foreheads, strongly arched eyebrows and boldly curled hair characterizing the angels in the cusping of the Percy tomb (pl. LII*a*). The Welwick tomb would appear to have been carved by the master who executed most of the cusping of the Percy tomb.

The Welwick tomb has been given widely varying dates in the fourteenth century but its connections with the Percy tomb suggest that both monuments are close in date.[64] The design of the tomb and the style of its sculpture suggest a date of *c.* 1340. The mouldings of the jamb of the tomb recess are related to those of the jambs of the south porch and the great east window, suggesting that all these works belonged to the same building campaign (fig. 16).[65] The great east window is dated

FIG. 16. Mouldings at Welwick: A, exterior jamb of great east window; B, jamb of tomb recess; C, jamb of south porch.

by the will of Thomas de la Mare, Canon of York, proved on 20 October 1358.[66] Although the window itself is dated by the will, the jamb may have been taken over from an earlier window whose existence is implied by the terms of the gift. Unlike the south nave aisle, which is built of Tadcaster limestone, the choir is built of cobbles. This may reflect the impoverishment of the parish after the Black Death.[67] The south choir windows, however, have the convergent mouchettes of the nave aisle windows at Patrington, which are unlikely to be later than the 1330s. The choir at Welwick should have been in preparation at the same time. The pattern of the choir windows is repeated in the easternmost window of the south nave aisle, which should be given a similar date. The central reticulation unit of these windows is comparable with the tracery in the window above the tomb. The windows in the south nave aisle are contemporary with their architectural setting, suggesting that the aisle was erected in the 1330s. The tomb, however, does not course in with the wall of the aisle and would appear to have been inserted after the latter was built.[68] This suggests that the tomb is unlikely to be earlier than 1330.

The design of the Welwick tomb represents a development of ideas seen in the Easter sepulchres of Lincolnshire and Nottinghamshire. The use of foliage to cover flat areas of wall and the arrangement of ogee arches between buttresses and under a sloping cornice recall the Easter sepulchre at Hawton.[69] The Hawton choir has no fixed dates but the similarities with Patrington mentioned above seem to argue in favour of a date in the early 1330s. The blind, curvilinear tracery found on the Welwick tomb is reminiscent of that on the altar reredos at Beverley Minster, probably dating from the 1330s. The sculptor responsible for the tomb also worked on the Percy tomb which should not be earlier than 1340. These comparisons recommend a date of *c.* 1340 for the tomb at Welwick[70] and show that one of the sculptors responsible for the Percy tomb was active elsewhere in the East Riding in the years around 1340.[71]

The architectural sculpture of the Chapel of St. Michael at Beverley St. Mary's, although essentially dissimilar to the sculpture of the Percy tomb, nevertheless seems to reflect its influence to a certain extent. The heads of the angels in the north choir arcade (pl. LIIc) have the broad, furrowed brow and shock of curly hair seen in those of the angels at Beverley and Welwick (pl. LIIa,b) and may be by a local master who had been influenced by the work of the Percy tomb sculptors. Architecturally, the Chapel of St. Michael has been related to the nave and reredos at Beverley Minster. Bilson thought that the chapel was begun *c.* 1330.[73] The connections between the sculpture at Beverley St. Mary's and that at Welwick and Beverley Minster would allow for a date in the 1330s or 1340s for the chapel.

Prior and Gardner discussed the Percy tomb in relation to a wealth of sculpture in the North in such a manner as to suggest that all sculpture in Yorkshire dating from the first half of the fourteenth century was produced by a homogeneous Yorkshire school.[74] A considerable amount of evidence, however, indicates that this view is oversimplified. The problem is illustrated at Beverley by the stylistic differences separating the Percy tomb statuary from the sculpture of the reredos and north nave aisle. The latter has been regarded as earlier work by the sculptors who carved the Percy tomb.[75] However, the head of the figure above the upper door of the screen staircase (pl. XLVIIIb), with its powerful forehead and well rounded cranium, has a severity which contrasts with the more fleshy appearance of the heads of the Percy tomb statues (pl. La). The facial features of the former

PLATE XLIV

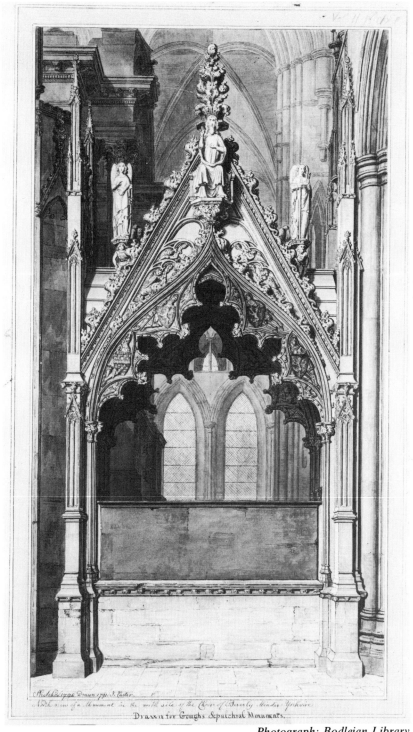

Photograph: Bodleian Library
Drawing of the Percy tomb from the north, by J. Carter, 1791
(Oxford Bodleian Library, Gough Maps 227)

PLATE XLV

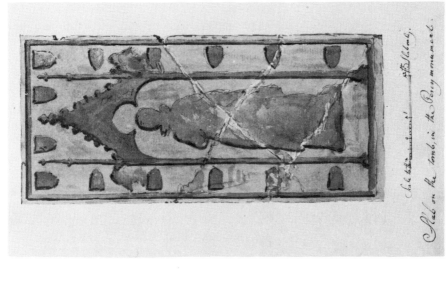

Photograph: Bodleian Library

b. Drawing of the indent on the lost tomb chest of the Percy tomb, by J. Carter, 1791 (Oxford, Bodleian Library, Gough Maps 227)

Photograph: College of Arms

a. Drawing of the Percy tomb from the south, Dugdale's Yorkshire Arms, 1667 (College of Arms RR 14.C, f. 89ᵛ)

PLATE XLVI

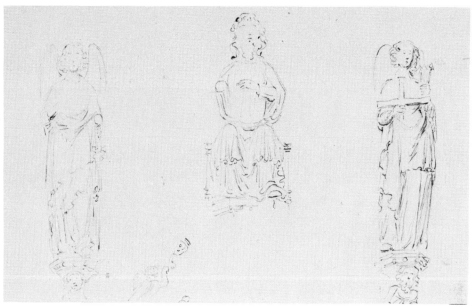

a. Figures on the north side of the Percy tomb.

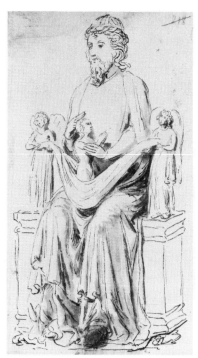

b. Seated figure on the south side
of the tomb

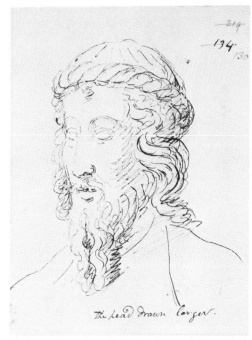

c. Enlarged drawing of head of seated figure in *b*

Drawings by J. Carter, 1790 (British Library, Add. MS. 29929, ff. 128 and 130)

Photographs: British Library

PLATE XLVII

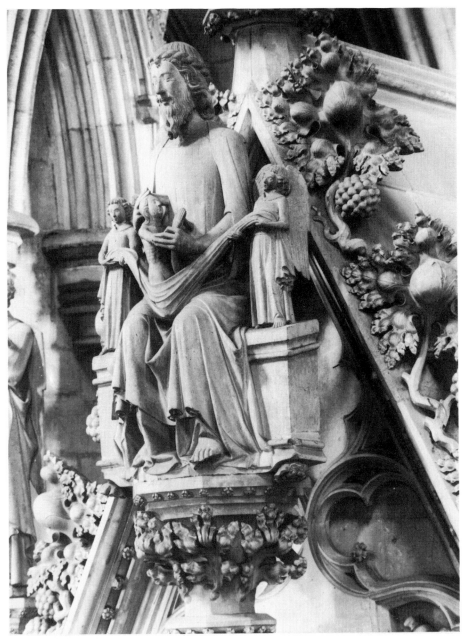

Seated figure on the south side of the Percy tomb

Photograph: Courtauld Institute

PLATE XLVIII

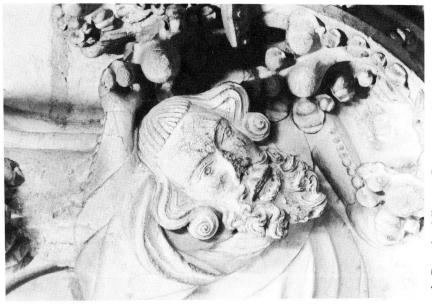

b. Beverley Minster: figure over the upper door of the screen staircase

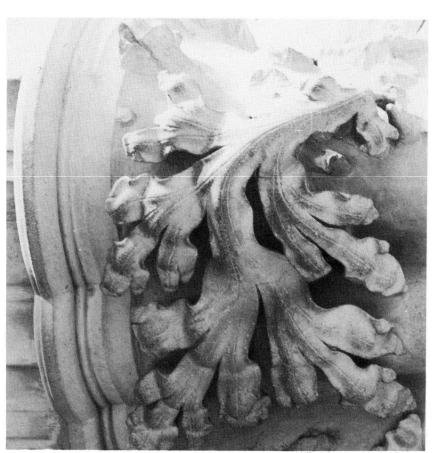

a. Capitals of the Percy tomb

Photographs: G. Hinton

PLATE XLIX

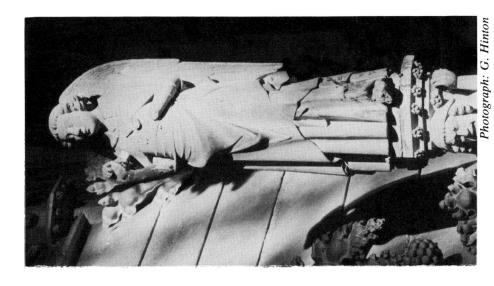

Photograph: G. Hinton

b. Angel on east side of south gable of Percy tomb

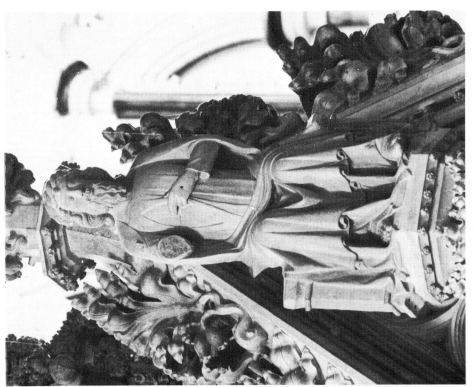

a. Christ showing his wounds, north side of Percy tomb

PLATE L

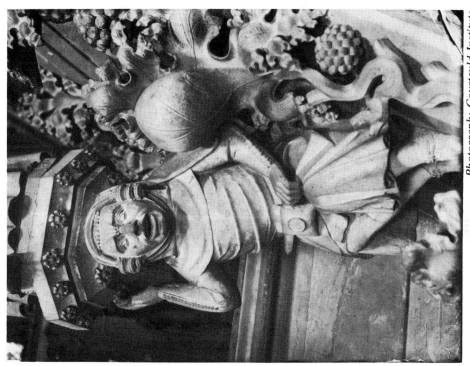

Photograph: Courtauld Institute

b. Caryatid on west side of south gable of Percy tomb (photo-
graph: F. H. Crossley; copyright: Canon M. H. Ridgway)

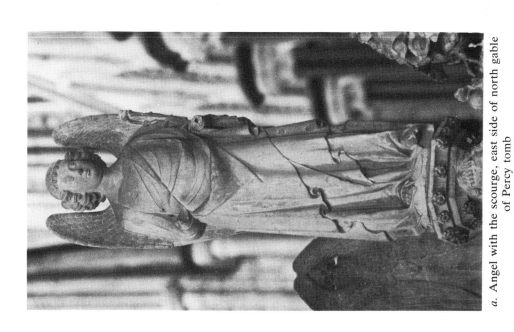

a. Angel with the scourge, east side of north gable
of Percy tomb

PLATE LI

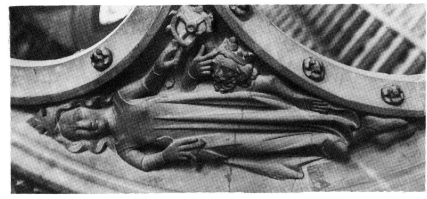

Photograph: Courtauld Institute

c. St. Catherine, inner cusping of south arch of Percy tomb (photograph: F. H. Crossley; copyright: Canon M. H. Ridgway)

b. St. Mary, Welwick: figure representing St. Catherine on the tomb of an ecclesiastic

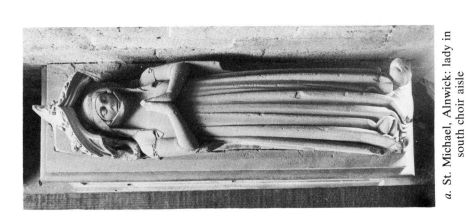

a. St. Michael, Alnwick: lady in south choir aisle

PLATE LII

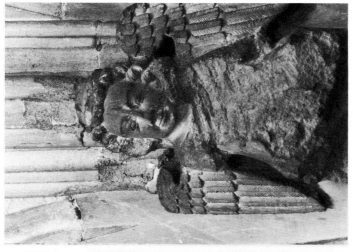

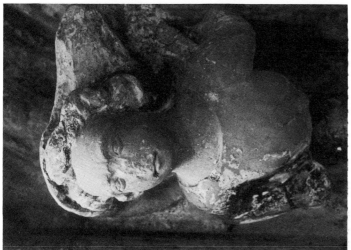

c. St. Mary, Beverley: angel in spandrel of north choir arcade

b. St. Mary, Welwick: angel on tomb

Photograph: Courtauld Institute

a. Angel in lower cusping of north arch of Percy tomb (photograph: F. H. Crossley; copyright: Canon M. H. Ridgway)

PLATE LIII

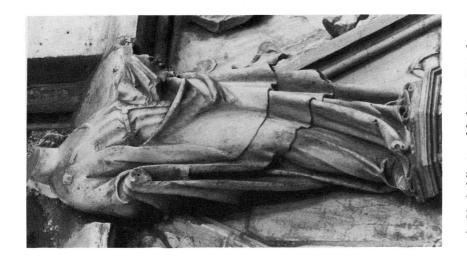

b. York Minster: Madonna over door formerly leading to Chapel of St. Mary and the Holy Angels

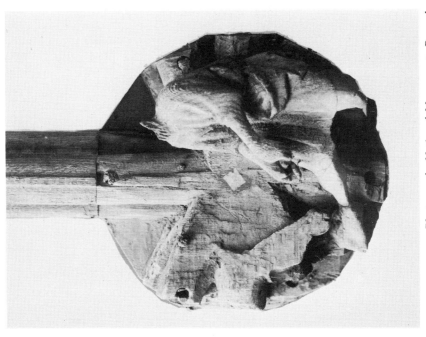

Photograph: National Monuments Record

a. Lincoln Cathedral: wooden boss in east walk of cloister

PLATE LIV

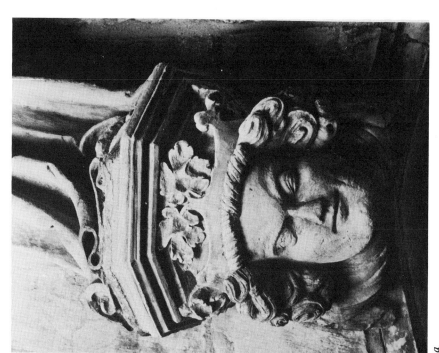

a. Head of a king, supporting the Madonna in north nave aisle

b. First capital from east, south nave aisle

York Minster

Photographs: National Monuments Record

PLATE LV

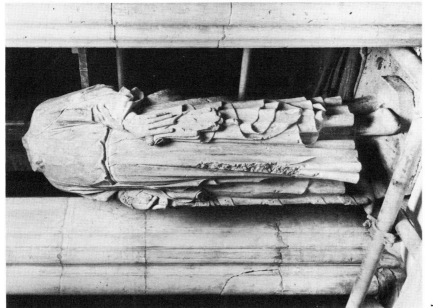

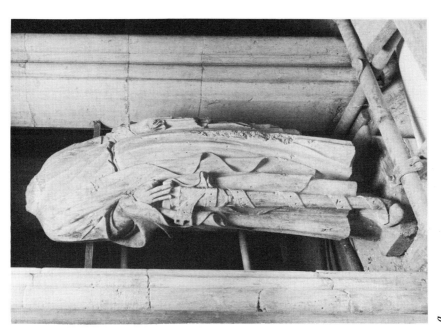

a, *b*. York Minster: statues in north triforium of nave, seventh
bay from east

Photographs: National Monuments Record

b

a

PLATE LVI

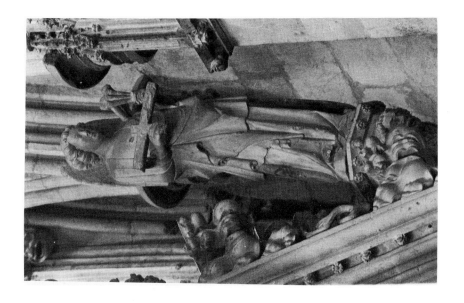

b. Angel with cross and nails, west side of north gable of Percy tomb

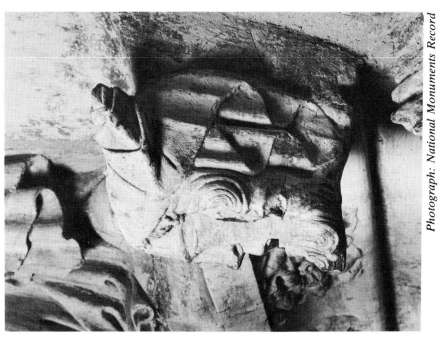

Photograph: National Monuments Record

a. York Minster: headstop on inner west wall

PLATE LVII

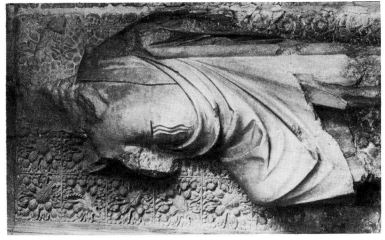

c. All Saints, Hawton: Christ on Easter sepulchre

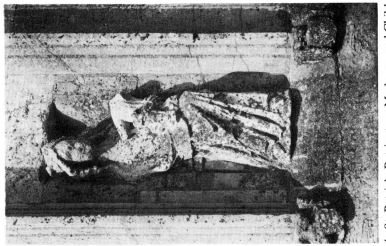

b. St. Patrick, Patrington: Madonna and Child on east front (photograph: F. H. Crossley; copyright: Canon M. H. Ridgway)

a. St. Peter, Howden: Synagogue from east wall of choir (photograph: F. H. Crossley; copyright: Canon M. H. Ridgway)

are finely engraved on the surface of the stone and have a metallic hardness and sharpness of contour which contrasts with the softer modelling of the faces of the Percy tomb angels. Although the faces of the Percy tomb caryatids and the heads on the reredos bosses show a comparable love of the grotesque,[76] the former show an interest in realism which is not found in the latter. The squat proportions and finely ribbed drapery treatment of the figures on the reredos and in the north nave aisle are likewise uncharacteristic of the sculpture on the Percy tomb.[77]

Sculpture in Yorkshire at this time would appear to have been less unified than Prior and Gardner believed and it would be wrong to characterize sculpture in the county solely by reference to the Percy tomb and the works related to it. However, this should not detract from Prior and Gardner's central argument that a continuous sculptural tradition linked the Percy tomb to the chapter house Madonna at York Minster.[78] The latter stood at the heart of the York school as defined by those authors.[79] Prior and Gardner also suggested that the York school had its origin in Lincolnshire,[80] implying that the Percy tomb sculpture belonged to a long-standing tradition in the north-east Midlands and the north-east of England.

As an outline of the overall pattern of events, Prior and Gardner's account would seem to be fundamentally sound. As further evidence of the close relationship between sculpture in Lincolnshire and Yorkshire, one may note the similarity between the figures representing the Labours of the Months on the wooden bosses of the cloister at Lincoln and the sculpture in the nave at York. The former (pl. LIII*a*) have the broad drapery treatment and low-slung, pouch-like fold found at York in the Madonna above the door in the north nave aisle, formerly leading to the Chapel of St. Mary and the Holy Angels (pl. LIII*b*). The York Madonna is dated to the second third of the fourteenth century by Professor Stone[81] and the door has been dated to the 1330s by Dr. Harvey.[82] However, the similarity between the York Madonna and the Lincoln bosses, firmly dated on documentary evidence to the 1290s,[83] suggest that the date of the former should be re-examined.

The door does not course in perfectly with the wall and gives the impression of being an afterthought, as was suggested by Dr. Harvey.[84] The miniature buttress and pinnacle on the right side of the door cut straight across the blind arcading of the aisle wall. The canopy over the head of the Madonna juts out awkwardly from the wall and the cornice behind her had to be cut away to accommodate her pronounced, backward-leaning posture. There is little evidence, however, to support Dr. Harvey's claim that the door was contemporary with the enlargement of the chapel,[85] dated by the licence granted by Archbishop Melton in 1333.[86] The bracket supporting the Madonna is flanked by two shields, one with the arms of France, the other with the three leopards of England. The arms of France Ancient are also found on a shield at the east end of the north nave arcade.[87] The presence of the arms of France, in association with the unquartered arms of England, suggests a possible connection with either Margaret, daughter of Philip III, King of France, who married Edward I in 1299, or with Isabel, daughter of Philip IV, King of France and Navarre, wife of Edward II from 1307 to 1327. The corbel head beneath the Madonna wears a crown decorated with a pitted variety of maple leaf (pl. LIV*a*) very close to that of the capitals in the aisle walls (pl. LIV*b*). The canopy above the Madonna is decorated with ball-flower, a motif also found in the gable over the centre portal of the west facade. The ogee cusping of the canopy recalls

that of the oculus of the centre portal. The tracery on the minor pinnacles of the canopy, consisting of an unencircled trefoil above twin, cusped lancets, still conforms to the late Geometric style of the nave and lower west front.

The statues representing secular figures in the nave triforium at York have much in common with the Madonna in the nave aisle and should be attributed to the same workshop.[88] The triforium figures (pl. LVa) have the leaning pose of the Madonna and their drapery shows a similar interest in bold, meandering hemlines and overlapping areas of material. The triforium figures may also be compared to the three fourteenth-century figures in the undercroft at York.[89] The drapery of both groups of statues shows a similar tendency to fall in long, vertical folds, abruptly terminated above the ankles. The mantle of the tallest undercroft figure is draped across the front of the body in a dramatic arrangement of crumpled folds. Similar passages of baggy drapery occur in the minor sculpture of the nave aisles, suggesting that the statues were carved by the workshop responsible for the sculptural decoration of the nave as a whole. However, the closest comparisons for the rippling passages of overlapping drapery of the figures on the north side of the nave (pl. LVb) are found in the sculpture of the inner west wall. The grotesques on the statue bases flanking the centre portal, the angels on either side of the centre gable and the headstops on their plinths (pl. LVIa) all possess examples of this form of drapery arrangement, suggesting that the statues are contemporary with the lower section of the inner west wall.

The foundation stone of the nave was laid in 1291[90] and a petition for a grant in 1298 stated that the nave had long since fallen.[91] The shields in the spandrels of the nave arcade date from the period 1299–1311[92] and the clerestory glass has been dated to *c*. 1310–20.[93] Dr. Harvey has associated the ball-flower on the gable above the centre portal with the presence of Hugh de Boudon about 1310.[94] The connections linking the Madonna and secular statues with the work in the nave and lower west front suggest that they were carved in the first quarter of the fourteenth century, before the appearance of the curvilinear style seen in the upper part of the west façade, dating from the 1330s.

Prior and Gardner suggested that the Percy tomb sculpture belonged to the same tradition as this work at York.[95] The validity of this view is perhaps most clearly illustrated with reference to the York nave Madonna. The generous pouch-like fold falling across the front of the figure, which is such a notable feature of the Percy tomb angels (pl. LVIb), is already found in the York Madonna (pl. LIIIb). The drapery treatment of the latter shows a liking for long, pipe-like folds and plain areas of material traversed by an incisive, meandering hemline. These characteristics are also present, albeit in a more developed form, in the Percy tomb angels (pls. La, LVIb). The drapery of the York Madonna does not have quite the same softness and fluidity as that of the Percy tomb figures and the dramatic, backward-leaning pose of the former is different from the S-shaped sway of the latter. These differences, however, can be explained by the chronological gap separating the Percy tomb from the York Madonna.

The statues from the choir at Howden, now placed in the transept and on the former choir screen in the crossing, appear to represent an intermediary stage of development.[96] Their connection with the early fourteenth-century work at York was discussed by Prior and Gardner.[97] The Howden statues, although badly weathered, are sufficiently preserved to show that in some cases the drapery was

arranged in large, pouch-like folds similar to those of the York Madonna and Percy tomb angels (pls. LIII*b*, LVI*b*, LVII*a*). The S-shaped sway, seen notably in the statue of Synagogue, would seem to represent a development beyond the style of the York Madonna towards that of the Percy tomb angels, although the Howden statues have traditionally been regarded as a half-way house between the work at York Minister and sculpture in the neighbouring region to the south.[98] At Patrington, however, the seated Madonna on the east front (pl. LVII*b*) would seem to represent a further development of the style of the Howden figures. The leaning pose and long, shaft-like folds falling from the Madonna's knee strongly recall the style of the Howden Synagogue. The bold, curly hair and long oval head of the Madonna also seem to belong to the tradition of the Howden statues[99] and have been compared to those at Beverley by Prior and Gardner.[100] The long, straight folds breaking neatly around the feet of the Madonna and the manner in which her mantle is pulled tightly around her right arm also find close comparisons in the Percy tomb statues (pl. LVI*b*). Prior and Gardner suggested that the Madonna may have come from an altar and the similarity between her head type and that of the figures on the Easter sepulchre at Patrington suggests that it is contemporary with the choir.[101] The Madonna at Patrington, the advowson of which was vested in the provost of Beverley Minster, demonstrates that a sculptor belonging to the same school as that responsible for the Percy tomb statuary was active in the East Riding in the 1330s.

The connections already mentioned between the work at Patrington and Welwick and that at Hawton demonstrate the close relationship between the Nottinghamshire and Humber areas in the second quarter of the fourteenth century. The sculpture of the Percy tomb also finds close comparisons in Nottinghamshire work. The trunk-like torso of Christ on the Easter sepulchre at Hawton has the massive proportions of the Percy tomb statues (pls. L*a*, LVII*c*). The ample drapery of the Hawton Christ has a fluidity and smoothness which closely resemble the style of the Percy tomb figures. The strong similarities between the sculpture at Hawton and that of the Percy tomb suggest that the Nottinghamshire and Humber areas were linked by a common sculptural tradition in this period.

The sculptor who carved the statuary on the Percy tomb belonged to a long and distinguished tradition in English sculpture. The course of this style can be traced back through the early fourteenth century work at Patrington, Howden and York Minster. Established at York in the first quarter of the fourteenth century, this tradition thrived in the Nottinghamshire and Humber areas in the second quarter of the century. The workshop responsible for the Percy tomb appears to have been drawn from the sculptors engaged in the work at Welwick and Patrington. The master who carved most of the Percy tomb cusping also seems to have been responsible for the work at Welwick, where the tomb and effigy in the south aisle and the Madonna over the south porch are very close in style to the minor sculpture on the Percy tomb. The statuary of the Percy tomb is particularly close in style to the Madonna on the east front at Patrington, although the poor state of preservation of the latter hinders a definite identification of hands. The effigies at Staindrop, Co. Durham, and Alnwick, Northumberland, are in the same style as the Percy tomb statuary and are further evidence of the high reputation of this workshop. At Beverley, this style is juxtaposed with a different tradition, seen in the sculptural decoration of the nave and altar reredos. The existence in Yorkshire

of sculpture unrelated to that of the Percy tomb modifies Prior and Gardner's view and creates a more varied picture of sculpture in the region. Nevertheless, the strong Yorkshire connections of the Percy tomb sculpture support Prior and Gardner's opinion that it belonged to one of the main streams of English sculpture, which flourished in the North in the first half of the fourteenth century.

NOTES

Abbreviations
J. H. Harvey, 'Architectural History from 1291 to 1558', in G. E. Aylmer and R. Cant, eds., *A History of York Minster* (Oxford, 1977)..J. H. Harvey, *York Minster*.
M. Norris, *Monumental Brasses: The Memorials* (London, 1977)M. Norris, *The Memorials*.
M. Norris, *Monumental Brasses, The Craft* (London and Boston, 1978) ...M. Norris, *The Craft*.
Journal of the Yorkshire Archaeological Association*Y.A.J.*
N. Coldstream, 'York Minster and the Decorated style in Yorkshire', *Y.A.J.* lii (1980), 89–110
............N. Coldstream, 'York Minster'.

[1] E. S. Prior and A. Gardner, *An Account of Medieval Figure-Sculpture in England* (Cambridge, 1912), pp. 329–35, 355–6, 373, 630–6.

[2] Although Professor Stone speaks of the 'York school' he contrasts the style of the chapter house Madonna at York to that of the 'Cheyne' knights, attributes one of the statues now in the Minster undercroft to London work and sees little connection between the sculpture at Beverley and earlier work in Yorkshire; L. Stone, *Sculpture in Britain, The Middle Ages*, 2nd edn. (Harmondsworth, 1972), pp. 153–4, 172, 257 n. 84.

[3] The research on which this study is based was assisted by grants from the Department of Education and Science, the Central Research Fund of the University of London, the Southdown Trust, the Nancy Balfour Trust, the Heinz and Anna Kroch Foundation, the Gilchrist Educational Trust, the Sidney Perry Foundation and the Sir Richard Stapley Educational Trust, to all of whom I am grateful. For help and advice I would like to thank N. Stratford, F.S.A., Prof. J. White, F.S.A., N. Morgan, C. Blair, F.S.A., J. A. Goodall, F.S.A., Dr. R. K. Morris, F.S.A., C. B. L. Barr, G. P. Brown and R. Emmerson.

[4] G. Oliver, *The History and Antiquities of the Town and Minster of Beverley* (London, 1829), p. 337 n. 64; G. Poulson, *Beverlac* ii (London, 1829), p. 292 n. 2.

[5] K. A. MacMahon, ed., *Beverley Corporation Minute Books, 1707–1835*, Yorkshire Archaeological Society Record Series, cxxii (London and Hull, 1958), pp. 128–34.

[6] The proportions of the tomb and canopy used for this drawing, which Carter did for Gough in 1791, are based on a drawing with measurements, made in 1790; J. Carter, *Architectural and Monumental Drawings*, v (1790), British Library, Add. MS. 29929, f. 126. The structure behind the Percy tomb, in the upper left corner of the drawing, is a part of the wooden altarpiece which was erected during the eighteenth-century restoration and removed in 1824; G. Oliver, *op. cit.,* pp. 239–42; K. A. MacMahon, *op. cit.,* p. 129; I. and E. Hall, *Historic Beverley* (1973), pp. 23–6.

[7] This drawing is based on an earlier drawing by Carter; British Library, Add. MS. 29929 f. 130. The arrangement of shields on either side of the canopy and in rows flanking the effigy is confirmed by a drawing of the Percy tomb in Torre's account of Beverley Minster (1691), York Minster Library, Peculiars etc. L1 (10), p. 167.

[8] The interior of the church was thoroughly cleaned during the restoration by Sir George Gilbert Scott, begun in 1866. *The Beverley Guardian* for 8 July 1871 noted, 'The whole south wing of the lesser transept with the north aisle and side of the choir, from the organ to the Percy Shrine, are now completed, and give some idea of the ... rich general effect we may look for when the whole of the eastern portion of the church has passed under the hands of the stone scraper'. Five years later, James Elwell of Beverley removed the paint on the sedilia and oak screens at the east end of the stalls by immersing them in a large tank containing a solution designed to soften the paint so that it could be brushed off; *Beverley Minster Magazine,* No. 119, July 1876. Neither of these sources, however, refers specifically to the cleaning of the Percy tomb at this time.

[9] Some idea of the original splendour of the painted decoration is provided by the fragments from the altar reredos on display in the south transept at Beverley.

[10] J. Carter, British Library, Add. MS. 29929, ff. 127–30.

[11] The heads of the two seated figures (pls. XLVII, XLIX*a*) contain cracks, indicating that the upper part of each was carved from a separate block. If the heads have been repaired, this would have had to have been before 1790 as they were not in need of restoration when Carter drew them (pl. XLVI*c*).

[12] Several of these breakages were 'repaired' in the drawing which Carter did for Gough (pl. XLIV), resulting in a number of inaccuracies in Gough's text; R. Gough, *Sepulchral Monuments in Great Britain,* ii, pt. 3 (London, 1796), p. 311.

[13] The shields in the cusping of the main arch have been represented but those which flanked the effigy have been omitted. If the brass had been despoiled before 1641, Dugdale's attribution of the tomb to Maud Percy could not have been based on the original inscription; *Dugdale's Yorkshire Arms* (1667), College of Arms, RR 14.C, f.89ᵛ. This attribution was refuted by R. Gough, *op. cit.,* pp. 311–12.

[14] This figure is identified as God the Father by T. S. R. Boase, *Death in the Middle Ages* (Norwich, 1972), p. 53. See also E. Panofsky, *Tomb Sculpture* (London, 1964), pp. 59–61.

[15] Evidence to suggest that the sculpture survived the Civil War is provided by Torre's drawing of the tomb; York Minster Library, Peculiars etc. L1 (10), p. 167. Although this drawing is at best no more than an approximation to the appearance of the tomb, small figures are clearly represented on the apex and brackets of the gable.

[16] M. Norris, *The Memorials,* i, pp. 21, 52; ii, p. 314, fig. 27.

[17] *Ibid.,* i, pp. 13–14; M. Norris, *The Craft,* pl. 125.

[18] M. Norris, *The Craft,* pl. 124; M. Norris, *The Memorials,* i, pp. 13–15. See also the brass ascribed to Maud de Burgh at Tewkesbury; *Portfolio of the Monumental Brass Society,* iii, pt. 2 (December 1906), pl. 6.

[19] M. Norris, *The Memorials,* i, pp. 15–16, 23. The use of a continuous brass border to carry the inscription occurs on the brass of Sir William Fitzralph at Pebmarsh, Essex, of *c.* 1325–30; *ibid.,* ii, p. 298 n. 17; M. Norris, *The Craft,* pl. 122.

[20] M. Norris, *The Memorials,* i, p. 172.

[21] The tomb was attributed to Idonea, daughter of Robert Clifford, 1st Lord Clifford, by R. Gough ed., *Camden's Britannia,* iii (London, 1789), p. 72; G. Poulson, *op. cit.,* p. 696; G. Oliver, *op. cit.,* pp. 334–5; J. Evans, *English Art 1305–1461* (Oxford, 1949), pp. 171–2.

[22] T. Hearne, ed., *The Itinerary of John Leland,* i (Oxford, 1745), p. 47.

[23] The attribution to Eleanor, daughter of the Earl of Arundel, was supported by R. Gough, *Sepulchral Monuments in Great Britain,* ii, pt. 3 (London, 1796), p. 311; W. H. Longstaffe, 'The old heraldry of the Percys', *Archaeologia Aeliana,* n.s. iv (1860), 167–71; J. Bilson, 'Beverley Minster, Part II', *Architectural Review* (1898), 257; H. Lawrance and C. V. Collier, 'Ancient heraldry in the Deanery of Harthill', *Y.A.J.* xxvi (1920–22), 98–9; F. H. Crossley, *English Church Monuments* (London, 1933), pp. 2, 5, 56; A. S. Harvey, 'A priest's tomb at Beverley Minster', *Y.A.J.* xxxviii (1952–55), 509; N. Pevsner, *The Buildings of England. Yorkshire: York and the East Riding* (Harmondsworth, 1972), p. 175.

[24] T. Hearne, *op. cit.,* p. 47; York, Borthwick Institute, Prob. Reg. 4. f. 220ᵛ.

[25] A. F. Leach, *Memorials of Beverley Minster,* ii, Surtees Society, cviii (1903), lxi. The projections on either side of the neck of the Beverley indent are hard to parallel in early fourteenth-century English brasses of ladies. See M. Norris, *The Memorials,* i, pp. 13, 20; ii, figs. 12, 19, 20, 25; M. Norris, *The Craft,* figs. 124, 125; M. Clayton, *Catalogue of Rubbings of Brasses and Incised Slabs,* Victoria and Albert Museum (London, 1968), pp. 21–2; *Portfolio of the Monumental Brass Society,* vii, pt. 4 (December 1973), pl. 19.

[26] J. Bilson, *op. cit.,* p. 257; L. Stone, *op. cit.,* pl. 133B.

[27] W. J. Petchey, *A Short Account of the Armorial Bearings of the Sovereigns of England,* Standing Conference for Local History (London, 1962), pp. 6–7.

[28] A. B. and A. Wyon, *The Great Seals of England* (1887), pp. 31–3.

[29] L. Stone, *op. cit.,* p. 172.

[30] D. J. Stewart, *On the Architectural History of Ely Cathedral* (London, 1868), pp. 136, 144; J. H. Harvey, 'The Origins of the Perpendicular Style', in E. M. Jope, ed., *Studies in Building History* (London, 1961), p. 136. The motif of an ogee arch under a gable filled with foliage decoration is found in a form similar to that of the Ely Lady Chapel in the sedilia at Tewkesbury, related to the Court style and dated to the early or mid 1330s by Dr. R. K. Morris, 'Tewkesbury Abbey: the Despencer Mausoleum', *Transactions of the Bristol and Gloucestershire Archaeological Society,* xciii (1974), pp. 149–55. The general appearance of the Percy tomb, with its prolific use of

foliage sculpture, would appear to conform to this exotic trend in Court taste.

[31] See L. L. Gee, 'Ciborium tombs in England 1290–1330,' *J.B.A.A.* cxxxii (1979), 29–41.

[32] F. H. Crossley, *op. cit.,* pp. 55–8.

[33] All references to the north nave aisle at Beverley Minster refer to the Decorated portion of the seven easternmost bays of the nave.

[34] L. Stone, *op. cit.,* pl. 131B.

[35] J. Bilson, 'Beverley Minster: some stray notes', *Y.A.J.* xxiv (1917), 221 n. 6.

[36] L. Stone, *op. cit.,* pl. 130A. The musicians in the north nave aisle were restored during the pastorate of the Rev. H. E. Nolloth (1880–1922); K. A. MacMahon, *Beverley Minster* (1975), p. 24. The left hand, right forearm and the pipes of the bagpipes of the figure illustrated by Stone have been replaced.

[37] J. Bilson, 'Beverley Minster: some stray notes', *Y.A.J.* xxiv (1917), 221 n. 6.

[38] J. H. Harvey, *The Medieval Architect* (London, 1972), p. 80.

[39] R. K. Morris, 'The development of later Gothic mouldings in England c. 1250–1400—Part II', *Architectural History,* xxii (1979), 29.

[40] H. E. Bishop and E. K. Prideaux, *The Building of the Cathedral Church of St. Peter in Exeter* (Exeter and London, 1922), pp. 62–3.

[41] R. K. Morris, *op. cit.* in n. 39, pp. 29, 43 n. 273.

[42] N. Coldstream, 'York Minster', 96, 102.

[43] See T. W. French, 'The west windows of York Minster', *Y.A.J.* xlvii (1975), 82.

[44] N. Coldstream, 'York Minster', 107.

[45] A. Clapham, 'Thornton', *Arch. J.* ciii (1946), 173; K. Major, 'The Thornton Abbey Chronicle (Bodleian Library, Tanner, MS. 166) with extracts relating to the fabric of the Abbey', *Arch. J.* ciii (1946), 175, 177–8. A considerable portion of the cloister appears to have been completed by 1331; S. E. Rigold, 'Thornton Abbey', *Arch. J.* cxxxi (1974), 376.

[46] See N. Coldstream, 'York Minster', 107.

[47] *Ibid.,* 107.

[48] *Ibid.,* 107, 110.

[49] See also J. Evans, *op. cit.,* frontispiece.

[50] This concerns the two upper blocks of the north arch. The sub-cusps of these blocks contain grotesque heads similar to those of the caryatids. The cusping of each arch was carved from four blocks, two on either side. On each side, the break comes between the two major cusps with the figures holding shields. The two lower blocks of the north arch contain work by a different sculptor.

[51] *The Illustrated Catalogue of the Heraldic Exhibition, Burlington House, 1894* (London, 1896), pls. V, VI, VIII.

[52] The same style is found in the carving on both faces of the lower block on the west side of the north arch and on the inner face of the lower block on the east side of the north arch.

[53] See C. H. Hunter Blair, 'Medieval effigies in Northumberland', *Archaeologia Aeliana,* 4th ser. vii (1930), 21, 26–7, pl. xvi, figs. 2, 3.

[54] *Northumbrian Monuments,* Newcastle upon Tyne Record Series, iv (1924), 9.

[55] The effigies were said to be under the arches of the south wall and the lady was drawn from the side which now adjoins the wall of the south aisle in W. Dugdale, *The Visitation of the County of Northumberland* (1666), College of Arms, C.41, ff. 1v, 2r.

[56] It is possible that the effigies were brought from Alnwick Priory where several members of the Percy family were buried; C. H. Hartshorne, *Feudal and Military Antiquities of Northumberland* (1858), Appendix I, pp. iii–vi. According to the Alnwick Chronicle, the first Percy lady to be buried at the Priory was Mary (d. 1362), wife of Henry, 3rd Lord of Alnwick; *ibid.,* p. vi. If she is commemorated by the Alnwick lady, the effigy may have been commissioned during her lifetime.

[57] A. Gardner, *English Medieval Sculpture* (Cambridge, 1951), p. 207. For an illustration of this effigy, see C. H. Hunter Blair, 'Medieval effigies in the County of Durham', *Archaeologia Aeliana,* 4th ser. vi (1929), pl. xviii, fig. 1.

[58] The effigy is represented in this recess, alongside the effigy of the crowned lady now at the west end of the aisle, in W. Dugdale, *The Visitation of the County Palatine of Durham* (1666), College of Arms, C.41, f.10r. Both effigies are mentioned by Leland; T. Hearne, *op. cit.,* i, p. 85.

[59] *Durham Monuments,* Newcastle upon Tyne Record Series, v (1925), 189–90.

[60] J. F. Hodgson, 'Staindrop Church', *Transactions of the Architectural and Archaeological Society of Durham and Northumberland,* iii (1890), 90 n. 23.

[61] For the attribution of this effigy, see J. F. Hodgson, 'Raby in Three Chapters, Chapter III',

Transactions of the Architectural and Archaeological Society of Durham and Northumberland, iv (1896), 91–3.

[62] G. Poulson, *The History and Antiquities of the Seignory of Holderness* (Hull and London, 1841), p. 510.

[63] Anon., 'St. Mary's Church, Welwick', *Y.A.J.* xx (1909), 140. This article was written following a meeting of the Yorkshire Archaeological Society on 3 Sept. 1908 in South Holderness, at which J. Bilson had given an address dealing at length with Welwick.

[64] The anonymous author in *Y.A.J.* suggested that the Welwick tomb was inspired by the Percy tomb and was unlikely to be earlier than 1350; *ibid.*, 140. Later writers, however, have preferred a date of *c.* 1310; E. S. Prior and A. Gardner, *op. cit.*, pp. 634–36; F. H. Crossley, *op. cit.*, pp. 56, 63, 192, 229.

[65] The mouldings of the jamb of the tomb recess are characterized by their use of a broad hollow, flanked by a roll and fillet unit set at right angles to it and partially absorbed by the hollow (fig. 16B). Very similar mouldings occur on the jamb of the south porch (fig. 16C). In this case, the sequence is framed by an outer, ogee moulding. The niche above the south porch contains a seated Madonna ringed by fiery-haired angels very similar to those on the tomb. The vaults over both the tomb and the niche are complex compositions of intersecting ribs. There can be little doubt that the porch, formerly of two storeys, is contemporary with the tomb. Mouldings very similar to those of the tomb and porch occur on the exterior jamb of the great east window. The exterior jamb of the window has the roll and hollow unit found on the jamb of the tomb, surrounded by the outer ogee moulding which occurs in a similar position on the jamb of the porch (fig 16A–C).

[66] 'Item ecclesiae de Welwik, pro renovatione magnae fenestrae cancelli ejusdem, X marcas'; *Testamenta Eboracensia*, Part I, Surtees Society, iv (London, 1836), 68.

[67] Anon., *op. cit.*, 135–9; C. Wardle and I. R. Dowse, *The Parish Church of St. Mary, Welwick* (Withernsea and Hornsea, 1981), p. 2.

[68] Anon., *op. cit.*, 139.

[69] See F. H. Crossley, *op. cit.*, p. 63, pl.; J. Evans, *op. cit.*, pl. 78.

[70] The anonymous author in *Y.A.J.* considered a number of people who might be commemorated by the tomb at Welwick; anon., *op. cit.*, 140–1. Of these, the closest in date to the probable date of the tomb was William de Beverlaco, rector of Welwick 1317–27 and probably still alive in 1335.

[71] During the course of the excavation carried out in the 1890s at Watton Priory, about eight miles north of Beverley, fragments of a sumptuous canopied tomb were discovered on the site of the north wall of the presbytery. These included the remains of a military effigy and an ogee canopy described as of the same character and workmanship as the Percy tomb. The fragments were deposited in the parish church at Watton but their present whereabouts are unknown. See W. H. St. John Hope, 'Watton Priory, Yorkshire', *Transactions of the East Riding Antiquarian Society*, viii (1900), 81–2.

[72] Coldstream, 'York Minster', 110.

[73] J. Bilson, 'St. Mary's Church, Beverley', *Y.A.J.* xxv (1920), 384.

[74] E. S. Prior and A. Gardner, *op. cit.*, pp. 329–35, 355–6, 373, 630–6.

[75] L. Stone, *op. cit.*, p. 172.

[76] *Ibid.*, pls. 131A, 133A.

[77] The sculpture at Beverley Minster has been compared in an all-embracing way to the work of the 'realist' master in the octagon and screen wall at Trondheim, begun after the fire of 1328; G. Fischer, *Domkirken i Trondheim* (1965), i, pp. 375, 378–86; ii, pp. 582–3. The style of the Trondheim figures, however, with its taut drapery and realistic characterization, has more in common with that of the Percy tomb caryatids than with that of the musicians in the north nave aisle at Beverley.

[78] E. S. Prior and A. Gardner, *op. cit.*, pp. 333–5. See L. Stone, *op. cit.*, pl. 116A.

[79] E. S. Prior and A. Gardner, *op. cit.*, pp. 328–32, 631.

[80] *Ibid.*, p. 328.

[81] L. Stone, *op. cit.*, p. 257 n. 84.

[82] J. H. Harvey, *York Minster*, p. 181.

[83] A. F. Kendrick, *The Cathedral Church of Lincoln* (London, 1898), p. 30; *The Book of John de Schalby, Canon of Lincoln 1299–1333*, Lincoln Minster Pamphlets No. 2 (1966), p. 15.

[84] J. H. Harvey, *York Minster*, p. 181.

85 *Ibid.,* p. 181.

86 A. Hamilton Thompson, 'The Chapel of St. Mary and the Holy Angels, otherwise known as St. Sepulchre's Chapel at York', *Y.A.J.* xxxvi (1944), 67 n. 6.

87 D. J. Hawke, *The Medieval Heraldry of York Minster* (Menston, 1971), pp. 23, 81.

88 When Carter visited York in 1790, he noted that there were two figures standing in the triforium on the south side of the nave, and that several other figures lay in the hollow of the vaulting; British Library, Add. MS. 29929, f.80. The latter would appear to have comprised the three other figures now in the triforium, in the seventh bay from the east on the south side, and in the fifth and seventh bays from the east on the north side, as well as the three fourteenth-century figures now in the undercroft; see below n. 89. As all the statues in the triforium are secured in the same manner, by a brace which dies into the stonework, these braces are no guarantee that the figures were originally intended for their present locations.

89 One of these figures, described as one of two or three headless statues from the nave, then in the Minster Library, was illustrated by E. S. Prior and A. Gardner, *op. cit.,* p. 332, fig. 368. The two larger figures were attached by cramps identical to those of the figures now in the nave triforium. There are marks in the stonework of the triforium for braces to support two more statues. These marks correspond in height to the cramp (94 cm. from base of figure) or marks for a cramp (97 cm.) in the backs of the undercroft figures, showing that the figure with the sword was at one time put up in the seventh bay from the west, on the south side of the nave, and the other figure in the corresponding bay to the north. The two figures were probably amongst those which were mentioned by Browne as having been taken down from the triforium and left in the charge of the masons; J. Browne, *The History of the Metropolitan Church of St. Peter, York* (London, 1847), p. 138 n. 1.

90 J. Raine, ed., *The Historians of the Church of York and its Archbishops,* ii, Rolls Series (London, 1886), pp. 409–10.

91 R. Willis, *op. cit.,* p. 28 n.d.

92 D. J. Hawke, *op. cit.,* pp. 15 ff.

93 D. O'Connor, 'The stained and painted glass', in G. E. Aylmer and R. Cant, eds., *A History of York Minster* (Oxford, 1977), pp. 342–6.

94 J. H. Harvey, *York Minster,* pp. 156–7, 190.

95 E. S. Prior and A. Gardner, *op. cit.,* pp. 333, 335.

96 Gent, in his picturesque description of the choir some thirty-seven years after the roof had fallen in, mentioned a number of statues then in situ, some of which can be identified with some of the figures now in the crossing and transept; T. Gent, *The Ancient and Modern History of the Loyal Town of Rippon* (York, 1733), p. 57. The statue to the north of the entrance formerly leading to the south choir aisle can be identified as St. Cuthbert holding the head of St. Oswald, which Gent included with a number of bishops constituting the image work of the east window. The statue of *Synagogue* (pl. LVII*a*), now in the crossing, can be identified with the figure on the east front which Gent believed to represent Justice. The figures of St. Peter and St. Paul, also in the crossing, were said by Gent to have belonged to the south part of what then remained of the lofty, roofless walls.

97 E. S. Prior and A. Gardner, *op. cit.,* p. 335.

98 *Ibid.,* pp. 334, 335, figs. 371, 373. The Howden choir has no fixed dates. Dr. Coldstream has proposed a date of *c.* 1315–35; N. Coldstream 'York Minster', 110. Bilson, however, thought that work could have begun slightly earlier, around 1310; J. Bilson, 'Howden Church: some notes on its architectural history', *Y.A.J.* xxii (1913), 162. The tracery of the windows of the south choir aisle was more advanced than that of the windows of the nave aisles at York Minster, begun in 1291. The tracery in the heads of the gables on the east front at Howden gives no indication of having attained the rich, curvilinear stage seen in the upper part of the west facade at York, dating from the 1330s. Much of the work on the Howden choir would seem to date from the second and third decades of the fourteenth century.

99 This is especially noticeable in the case of the angel now placed to the north of the entrance to the former north aisle.

100 E. S. Prior and A. Gardner, *op. cit.,* p. 356.

101 N. Pevsner, *The Buildings of England. Yorkshire: York and the East Riding* (Harmondsworth, 1972), pl. 38.

A Group of Masons in Early Fourteenth-Century Lincolnshire: Research in Progress

Veronica Sekules

It has long been recognized that many of the fourteenth-century churches in Lincolnshire and Nottinghamshire are the product of a local school of masons. The main group lies in a belt to the south of Lincoln and to the west of Boston and the Fens. I would like to air here some of the very basic questions and problems which arise when one is dealing with a local school and to see if it is possible to be more precise about its operations. For instance, who decides what the buildings should look like and what they should contain. Is it a patron or rector, mason or architect? Are the churches built by a single body of masons travelling from one to the next or was the bulk of the cutting and carving done at the quarry with only the assembly necessary on site ? Unfortunately, none of this information is available from documents. It is, however, possible to make a few deductions from a careful examination of the buildings themselves and also from information about benefactors and incumbents.

This study is concerned only with the sculpture, not entirely without justification, as apart from the fact that it is of very high quality, these buildings are on the whole distinctive for their accretions of decorative detail rather than for any architectural innovations. For example, the plan of the church of St Andrew at Heckington, probably finished by c1330,[1] is nothing remarkable for a church in this area. Its striking feature is the extent and lavishness of the decorative detail, particularly of the exterior (pl. LVIIIa,b). However, in essence, the architectural vocabulary differs very little from the exterior of the Angel Choir at Lincoln some sixty or seventy years earlier (pl. LIXa). Both have an elaborate tablement, large traceried windows, buttresses embellished with gabled and crocketed niches for

151

statues and decorated parapets with jutting figure corbels beneath. There is a difference in scale, of course and, owing to the discrepancy in date, the treatment of the detail is somewhat different.

That Heckington parish church should be using the vocabulary of decorative enrichment fitting for a cathedral is not suprising when one learns that the rector from 1308 to 1349, the man who built the chancel,[2] was Richard de Potesgrave, a wealthy chancery clerk and chaplain to Edward II. The principal lay benefactors were cousins to the king: Henry de Beaumont, Earl of Buchan, and his sister Isabel, grandchildren of the Emperor of Constantinople and like Potesgrave, in fact much more so, wealthy and influential. Obviously Potesgrave and the Beaumonts were prepared to pay for the very best. The interior of Potesgrave's chancel is no less lavishly decorated than the exterior of the church. With its tomb (pl. LIX*b*), sacristy and Easter sepulchre (pl. LX*a,b*) on the north side and double piscina (pl. LXI*a*) and triple sedilia (pl. LXI*b*) on the south the scene was set for some very special liturgical practice[3] which would in itself have been a raison d'être for the chancel rebuilding. It is clear in this case that the form and the content of this church were determined by its benefactors, who must have exerted a considerable influence over the masons who built it.

To return to the question of the masons and the transmission of the 'workshop' style we must examine other buildings in the area. St. Denys church at Sleaford, near Heckington, was given new aisles in the early fourteenth century which extended to the west to encase the thirteenth-century tower (pl. LXII*a*). The idea was evidently to revamp a jaded west front and the result is a pretty, in detail superb, but in total unhappy, conglomeration of many of the features used at Heckington: elaborate tablement, traceried windows, gabled niches, pinnacles— here used as tabernacles for statues and wave parapets. The same vocabulary is in use but it is as if any permutation from the stock of decorative features could be assembled to achieve a generally luxurious effect. The basic Heckington format was also used at Newark (Notts.) for the south aisle (pl. LXII*b*), in course of erection in the early 1320s. The variations in the design are very slight and many of the details, for instance the corbel types (pl. LXII*c*), correspond exactly. This is also the case at Anwick (pl. LXIII*a,b*), Ewerby (pl. LXIV*a,b*), Silk Willoughby and Donington, all parish churches in Lincolnshire with towers in the Heckington style.

The sculptural details on each of these buildings are repeated to such a formula as to make it impossible to determine whether there was any scope for individual invention. Perhaps any competent mason, given the right set of drawings, could reproduce any feature required, or perhaps each mason had a speciality which was entirely his responsibility. It becomes apparent from an examination of some of the elaborate set piece interior works, such as the Easter sepulchre and sedilia at Heckington and others related to it, that one cannot indeed marry a particular sculptor to a particular monument to a particular style, to the extent that one can assume that he both executed and designed it.

The Easter sepulchre and sedilia at Heckington (pls. LX*a*, LXI*b*) have a similar buttress and base mouldings but otherwise differ in important respects such as details of arches, figure and foliage style, depth and complexity of carving. In short they are by different sculptors. They undoubtedly belong together as part of the same programme and are of the same date.[4] The two pieces appear to be made of

PLATE LVIII

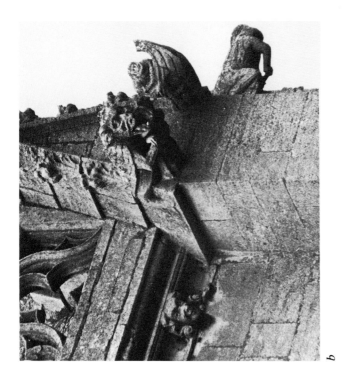

a. St. Andrew, Heckington

b. Detail of corbels

b

a

PLATE LIX

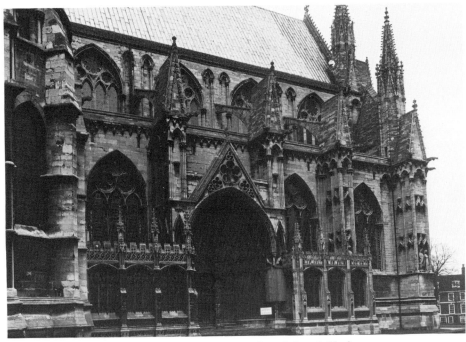

a. Lincoln Cathedral: exterior of Angel Choir

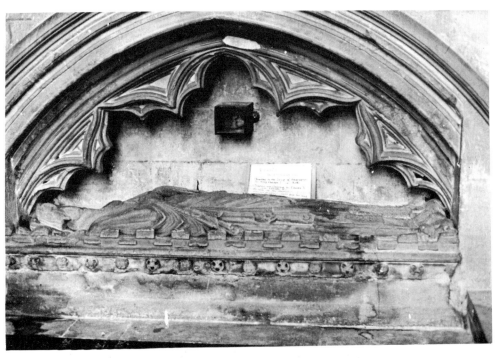

b. St. Andrew, Heckington: Potesgrave tomb

PLATE LX

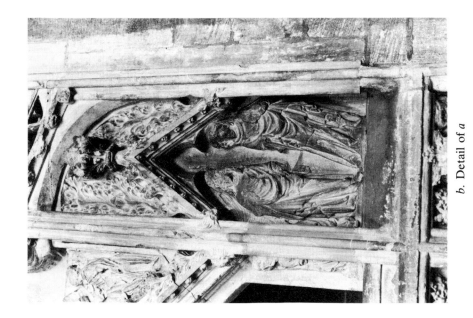

b. Detail of a

a. St. Andrew, Heckington: Easter sepulchre

PLATE LXI

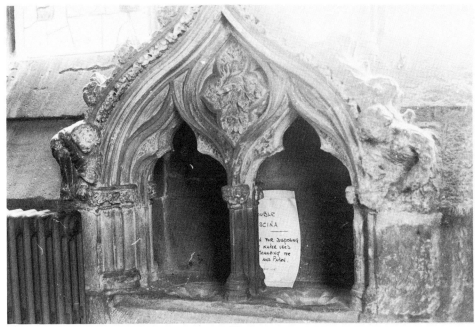

a. Piscina

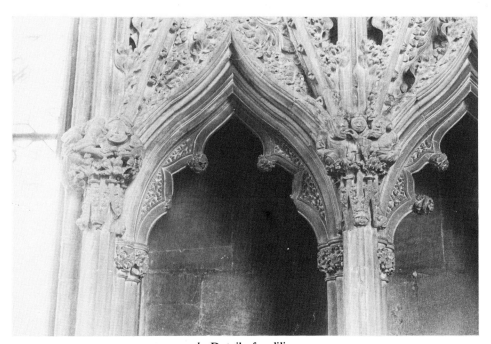

b. Detail of sedilia

St. Andrew, Heckington

PLATE LXII

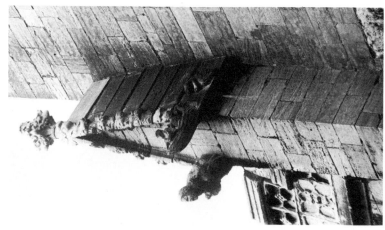

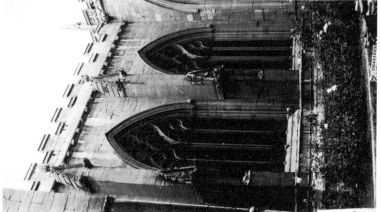

c. Detail of corbels in b

b. St. Mary Magdalen, Newark:
south aisle

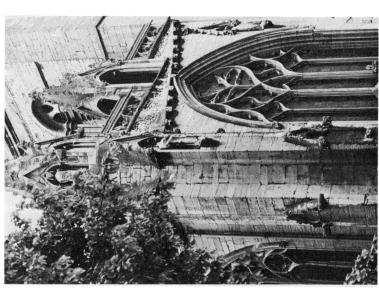

a. St. Denys, Sleaford: detail of north-west corner

PLATE LXIII

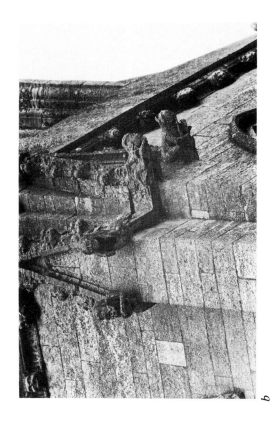

b

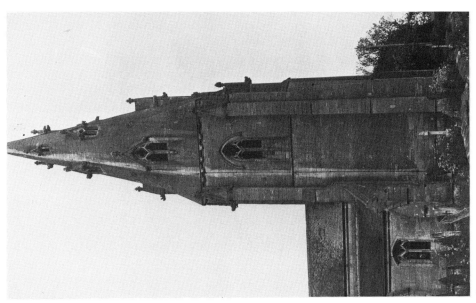

a

a. View of tower

b. Tower corbels

St. Edith, Anwick

PLATE LXIV

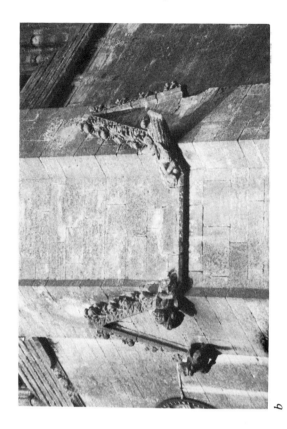

b

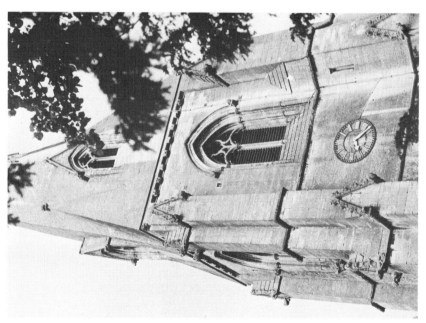

a

a. View of tower

b. Tower corbels

St. Andrew, Ewerby

PLATE LXV

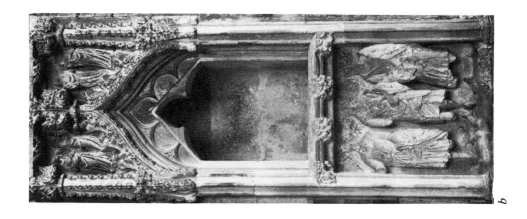

a. Exterior view of chancel

b. Easter sepulchre

St. Peter, Navenby

PLATE LXVI

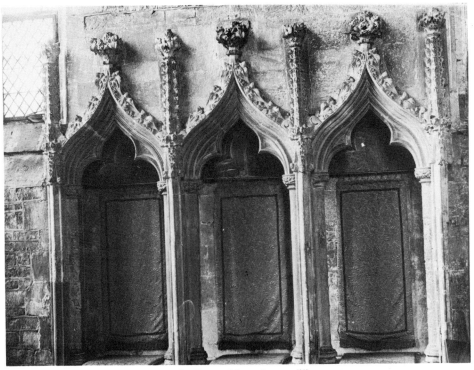

a. St. Peter, Navenby: sedilia

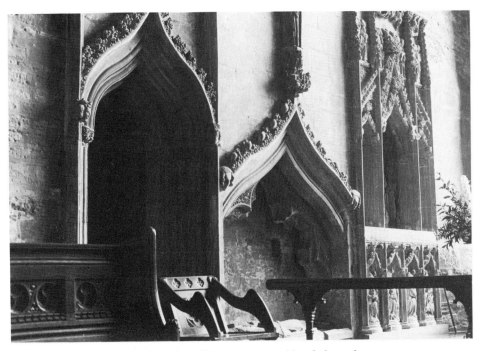

b. All Saints, Hawton: north side of chancel

PLATE LXVII

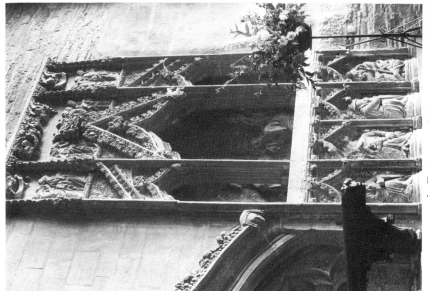

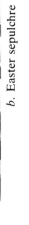

b. Easter sepulchre

a. Sedilia and piscina

All Saints, Hawton

different stone but both have been coursed in so carefully with the surrounding squared stone dressing and window mouldings that they must have been measured and carved on site and not despatched in kit form from the quarries.

The exterior of the early fourteenth-century chancel at Navenby (pl. LXV*a*) is much plainer than Heckington. Inside, however, it has exactly the same range of chancel fittings: tomb, sacristy,[5] Easter sepulchre, piscina with double drain, and triple sedilia. It is possibly a little earlier than Heckington, commissioned by another royal clerk and chaplain, William de Herlaston, who was rector from 1325 to 1329.[6] The design of each of the fittings at Navenby is quite different from each of the Heckington ones, being some what smaller and less elaborate. Nevertheless, the Easter sepulchre (pl. LXV*b*) and sedilia (pl. LXVI*a*) are without doubt by the same sculptor who made the Heckington Easter sepulchre.

So far we have two large pieces of sculpture made for the same church at the same time by different sculptors, one of whom made two pieces of sculpture in a nearby church. At Hawton (Notts.), however, we have another permutation which may throw an interesting light on the way in which the sculptors worked. The church has an early fourteenth-century chancel[7] unembellished on the exterior but with the same elaborate range of interior fittings as the other two churches (pls. LXVI*b*, LXVII*a,b*). The resemblance between the fittings at Hawton and Heckington is strikingly close and it is immediately obvious that the designs are almost identical. It is equally obvious from a closer inspection that Hawton is altogether more sophisticated. The carving of the sedilia (pl. LXVII*a*) is more assured, more detailed and in deeper relief than that at Heckington and it is clearly the work of a different mason. Similarly the Easter sepulchre at Hawton is iconographically more complex, for instance it includes *Noli me tangere* and Ascension scenes. Overall the style of carving is bolder and fuller and this extends to the interpretaion of certain elements of the design. The soldiers at Hawton sit on semicircular projecting podia beneath nodding ogee arches instead of on a recessed straight plinth beneath plain cusped arches (pl. LXVII*b*). The difference in treatment of the wave mouldings in the middle register is also interesting. At Heckington, the wave mouldings act as pseudo-buttresses 'supporting' the main niche head (pl. LX*b*). At Hawton, the wave mouldings remain as a decorative feature but no longer make sense as pseudo-architecture as they are leaning against the pinnacles above the arch.

Thus at Hawton we have another group of sculptors reinterpreting the designs used before at Heckington. It is clearly a member of the same group rather than a straight copy as many of the architectural details—mouldings, capitals and window tracery designs—are repetitions of those used at Heckington and elsewhere. The sculptors were not necessarily responsible for the original concept but it seems are in every case, even with the major pieces, compiling designs from stock. The important thing was that the sculptors should work collectively interpreting the fashionable style as appropriate for each commision.

I have hinted that with these buildings it is not necessary to envisage an architect in the sense of a person who works out an overall design, but perhaps that the benefactors fulfilled that role. Certainly this is demonstrable in the case of Heckington which is the most lavish and complete of the buildings. There are no structural innovations, it is rather the permutations of standard decorative fea-

tures with which these buildings are frequently embellished which gives them their special character.

If it is indeed the case that this particularly distinctive style could be reproduced by any competent mason, then it follows that any 'workshop' was as good as the designs at its disposal, and although the masons may belong to the locality, the designs may not or vice versa. This is perhaps an obvious conclusion, but it serves as a warning that, although one can learn a great deal from making stylistic comparisons, one needs to exercise extreme caution before jumping to any conclusions, particularly when comparing two pieces of sculpture which superficially look alike.

NOTES

[1] The argument for the dating of Heckington is lengthy, but, briefly, the church was probably rebuilt in the period between 1307, the date at which Richard de Potesgrave succeeded to the rectory, and *c*. 1330. In 1328, Potesgrave had licence to found a chantry at the altar of St. Nicholas and this probably represents the near completion of the fabric.

[2] According to a former inscription in the east window of the chancel noted in 1603–5 by Francis Thynne (B.L. Add. MSS. 36295 f. 40) and in 1675 by Gervase Holles (B.L. Harley 6829, f. 254).

[3] According to most surviving records (many published by Alfred Heales in *Archaeologia,* xlii (1869), 263–308), Easter sepulchres were temporary wooden structures erected over the Easter period on the north side of the chancel. Permanent stone monuments with Easter iconography appear in Lincolnshire in the late thirteenth century and in my view are related to *Heilige Gräbe* in Germany and the Low Countries; their sudden appearance in England is perhaps connected with rising interest in the feast of Corpus Christi.

[4] They were dated 20 years apart by Lawrence Stone, *Sculpture in Britain, The Middle Ages* (Pelican History of Art), p. 169.

[5] Only the doorway and the lower courses of masonry of the existing sacristy are fourteenth-century.

[6] In 1325, William de Herlaston succeeded to the rectory of Navenby. He was one of the leading clerks in the chancery under Edward II and would certainly have known his colleague, Richard de Potesgrave, whose church, some 10 miles away, would have been almost complete. Navenby was one of his first ecclesiastical appointments and in 1325 he was immediately granted some lands there which may have meant that he was about to build. In 1330, he left to become a canon of Llandaff and the tomb at Navenby, which is in a different style from the rest, is likely to be that of his successor, John de Fenton, who died in 1332.

[7] The chancel fittings at Hawton were dated *c*. 1330 by the Revd. F. H. Burnside (*Trans. Thoroton Soc.* xxix (1925), 184 f.). Although his dating is likely to be roughly correct, he bases his argument on unsatisfactory evidence.

Fourteenth-CenturyCorbel Heads in the Bishop's House, Ely

Nicola Coldstream, F.S.A.

The two guest halls of the medieval convent of Ely survive, albeit altered, to the south of the cloister. The so-called Great Hall is now the Bishop's house. It was originally a first-floor hall on an undercroft, built in the thirteenth century and enlarged in the first half of the fourteenth, before being converted to a dwelling house, probably in the seventeenth century.[1] Its wooden roof dates from the fourteenth-century alteration, which was probably made during the great period of rebuilding at Ely in the 1320s–1330s. The arched principals were supported on figured stone corbels, once 12ft. 6in. from the floor, but now, thanks to the insertion of an extra floor, barely 6in. above the skirting boards. Of the twelve original corbels five are still in place, the central group of four, and a fifth to the north-east.[2]

The corbels are in the form of crouching human figures, all facing towards the central axis of the hall. The main group is arranged so that they all face inwards to an imaginary centre, while the fifth looks away from them to another centre, so we can imagine three groups arranged in fours, looking to three centres (fig. 17). They are all under battlemented abacuses 16in. square, and the depth of the figures is approximately 11in. They are carved in a soft stone, possibly clunch, and are covered in a white slip, which is chipped in places to reveal paint beneath. Although there has been some damage and a little restoration, they are on the whole very well preserved.

The two figures on the south side are a soldier and a man with a flying cloak (pl. LXVIIIa,b). The soldier carries a round shield, perhaps to show that he is a pagan, and he wears a hooded jerkin, with a purse on a belt over his right hip. The face of the cloaked man has been badly cut, but he shares with the soldier the frown lines on the forehead, although his beard, crinkly hair and the tubular folds of his cloak are in marked contrast. On the north side there is a very well preserved man in a

165

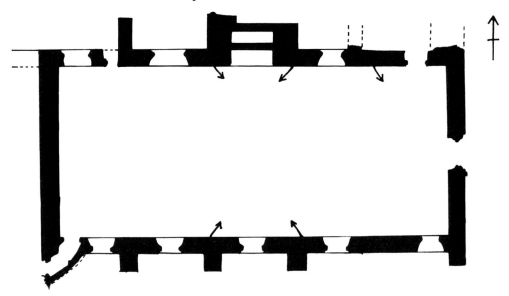

FIG. 17. Bishop's House, Ely. Plan to show position of corbels and directions they face.

cloak and cap (pl. LXIX*a*). His expression is calmer than that of the cloaked man opposite him, and his dress includes a row of six buttons down his front. Next to him, and opposite the soldier, is a bearded man with long flowing hair (pls. LXIX*b* and LXX*a*). He has a belt across his stomach and his cloak goes over his knee. The fifth corbel, the outlier to the main group (pl. LXX*b*), is extremely stout, with a satisfied expression. He has a beard and very neatly cut hair, with a bald patch, which is probably not a tonsure, as he is in secular dress with, again, a row of buttons down his front. His ears are large and close to his head, and he crouches with his hands on his knees. His left hand now has a hole cut through it, but is not possible to say when this was done.

The carving of these five faces is extraordinarily vivid: the last in particular has been given a face and expression so specific as to suggest the possibility that they were made from live models. That they were intended as portraits in the modern sense is unlikely, and in any case not susceptible of proof. Nothing can be said about what, if anything, they represented. We do not know if they were all different, if there were originally two each of six 'types', or if there were any women. They may represent characters in a well-known story, but with seven of the original twelve missing, it is not useful to speculate.

For the period between *c.* 1250 and *c.* 1350 the question of studies made from the life can be divorced from that of portraiture. Representations of real persons for commemorative purposes, such as the effigy of Eleanor of Castile,[3] or with iconic connotations, such as the statue of Louis IX at Mainneville (pl. LXXI*a*),[4] were not made from life studies. The Mainneville figure was made forty years after Louis IX's death, but both figures were deliberately idealised beyond the point at which any portrait at any period tends to be idealised, and they are typical of their time. At Naumburg cathedral, however, the figures of secular benefactors in the

PLATE LXVIII

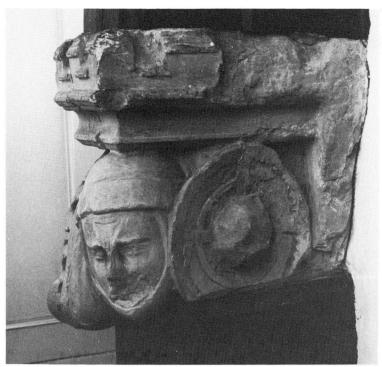

a. South-east corbel (now in vestry)

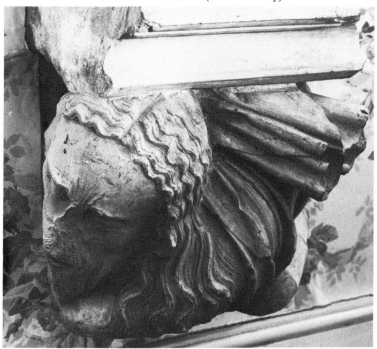

b. South-west corbel (now in sitting-room)
Bishop's House, Ely
Photographs: N. Stratford

PLATE LXIX

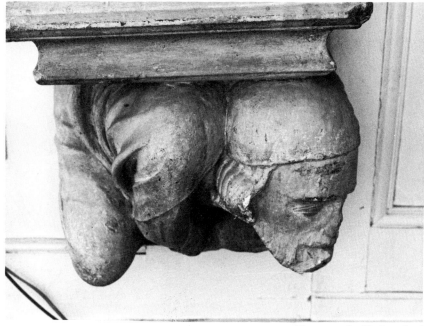

Photograph: N. Stratford

a. North-west corbel (now in bedroom)

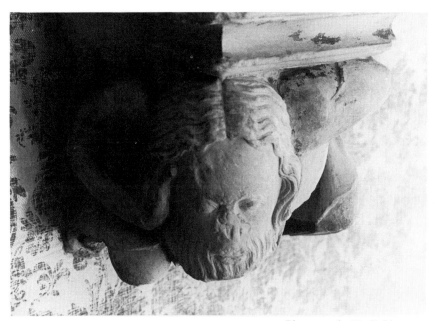

Photograph: N. Coldstream

b. North middle corbel (now on staircase)

Bishop's House, Ely

PLATE LXX

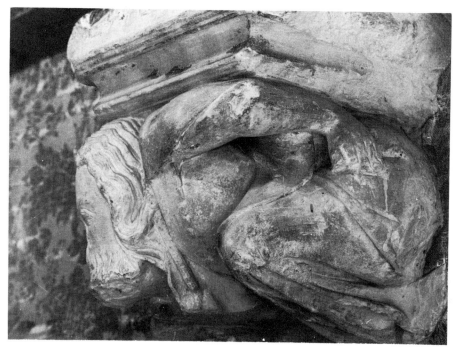

Photograph: N. Stratford

a. North middle corbel

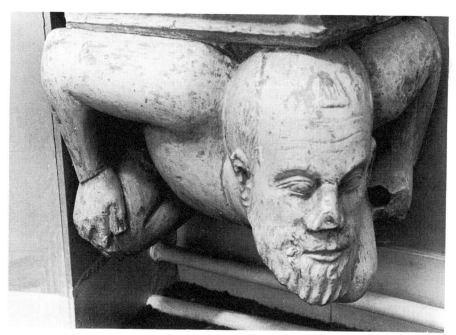

Photograph: N. Coldstream

b. North-east corbel (now in bathroom)

Bishop's House, Ely

PLATE LXXI

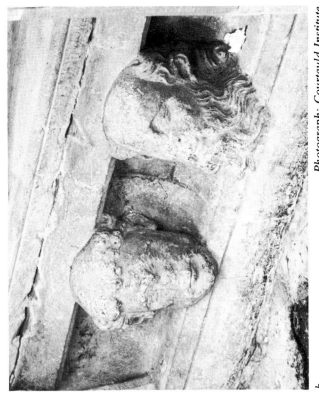

Photograph: Courtauld Institute

a. Mainneville, Eure, France: statue of Louis IX

b. Wells: detail of tomb of William de Marchia

Photograph: N. Coldstream

PLATE LXXII

a

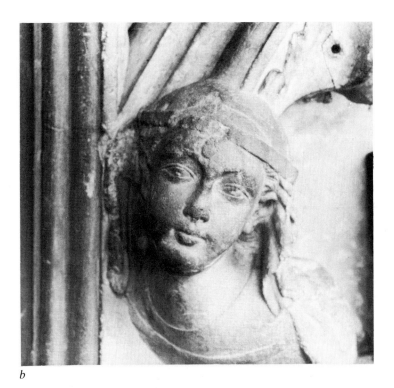

b

a,b. St. Augustine, Bristol: heads on Berkeley tomb, south choir aisle

Photographs: N. Coldstream

PLATE LXXIII

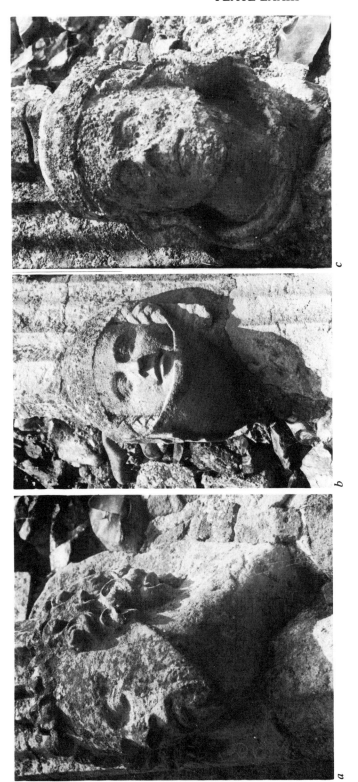

a,b,c. Wingfield Suffolk: label-stops

Photographs: A. T. Heslop

PLATE LXXIV

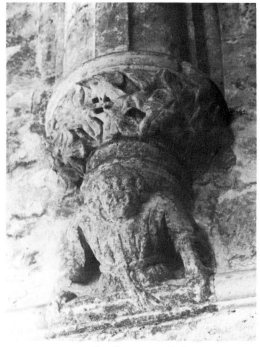

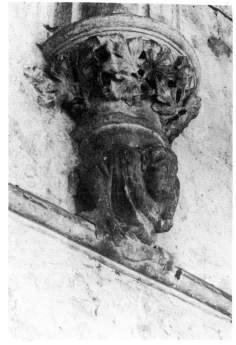

a. South-west corbel

b. North-east corbel

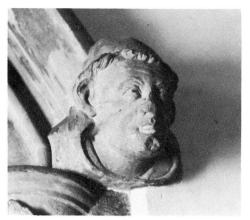

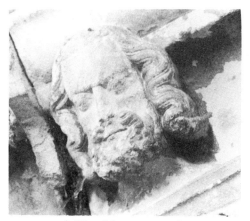

c. Label-stop on east door

d. Head in east cornice

a,b,c. Mayfield, Sussex: hall of archbishop's palace
d. Ely: Lady Chapel

Photographs: N. Coldstream

west choir were certainly modelled on living people, but not on the long-dead people whom the statues represent.[5] In other words, there seems to have been an interest in carving from the life, but not necessarily in making a recognisable likeness in the case of a specific person. The sculpture did not have to resemble the person portrayed, but it could be taken from the life. The interest in nature, also manifest in depictions of plants and birds, is, with human representation, separate from individual portraiture in the modern sense.

The Ely corbels are not in the class of commemorative or iconic sculpture, but are genre figures, part of the vast mass of small, decorative heads on weepers, label-stops and keystones as well as corbels. Here there was greater freedom to depict characters apparently drawn from life, but to distinguish such faces can be hazardous, as carved heads around 1300 could be anything from idealised to grotesque, with all shades of naturalism in between. The tradition of using heads for decorative purposes goes back in France to Reims and Amiens,[6] and interest in the human face is apparent from the second quarter of the thirteenth century at Salisbury, with Clarendon, Westminster and Lincoln slightly later.[7] German interest in naturalism, in addition to the figures at Naumburg, should not be overlooked. By the first quarter of the fourteenth century most parts of England were producing carved heads, but many of them were made to a formula. The facial expressions of the heads on the Marchia tomb at Wells (pl. LXXIb,) are reasonably specific, but on the Berkeley tombs at Bristol (pl. LXXIIa,b) or at Wingfield, Suffolk (pl. LXXIIIa,b,c) we find the same face reproduced with different hairstyles or headdresses. Even there, however, we should not exclude the possibility that the original face was modelled from the life. In the hands of a not very competent sculptor the face could become stereotyped, as it did in parts of St. Augustine's. Bristol and the bosses at Exeter.[8] Although it is possible that the carved heads in the Octagon at Ely come into the category of stock face types used in large programmes,[9] the corbels in the Bishop's house probably cannot be so classed. There are no faces or groups of faces anywhere resembling them, and even allowing for the destruction of many sources of parallels, they remain outside the mainstream of decorative head carving.

Examples of figured stone corbels supporting a wooden roof are hard to find. Few survive in secular halls and none in vernacular architecture. The majority of royal houses were ephemeral, timber-framed buildings and, of the more permanent residences at Woodstock, Guildford and Clarendon, nothing remains of the roof structure. Two buildings in the ambience of the court do, however, have wooden roofs supported on figured corbels: the Battel hall at Leeds, Kent, and Caerphilly castle.[10] In neither of these is there any emphasis on realism, and there are only tantalising hints of specific royal taste for it: the Clarendon label-stop, the Westminster triforium figures.[11] That Edward I may have shared his father's taste for realism in small things is suggested by the stubbly chin found by Miss Pauline Plummer on one of the weepers of the Crouchback tomb. It cannot, however, be shown that portrait-corbels supported roofs in the king's houses, but it remains possible that the impetus came from the court. The wooden full-length figures at Penshurst, if authentic, may have had parallels elsewhere.[12]

The institution which built for permanence was the church, and there are two parallels for Ely in the great halls of the archbishops of Canterbury at Charing, Kent, and Mayfield, Sussex.[13] Although Mayfield was restored by G. E. Street on

its conversion for use as a chapel, the battered corbels supporting the great stone roof arches were allowed to survive (pl. LXXIV*a,b*). They differ in pose and proportion from the Ely figures, but that their destroyed faces could have been portraits is suggested by the surviving label-stop on the south-east door of the hall (pl. LXXIV*c*). The extant figure at Charing, almost obliterated, has a pose similar to one at Mayfield. The halls may date from *c.* 1300 rather than later.[14]

The corbel heads at Ely were almost certainly carved by the sculptors of the Lady Chapel, although it has to be emphasised that this assertion is almost impossible to prove. In the Bishop's house there are sculptures with heads, and bodies in tight clothes with few folds; in the Lady Chapel the carved figures are dressed in flowing garments and their heads, with two of three exceptions, have been destroyed. This makes comparison difficult. It is unlikely, however, that there were two groups of sculptors of this quality working at Ely at the same time, and while comparisons are difficult they are not impossible. The head in the east cornice of the Lady Chapel (pl. LXXIV*d*) is of a more conventional type, but draperies, where they can be compared, are similar. The heads in the Octagon, allegedly identifiable portraits, are of greatly inferior quality, either because they are by different hands or because the stone was unfamiliar.

Professor Erlande-Brandenburg remarked that the late fourteenth-century portraits of France, for instance the painting of Jean le Bon or the statue of Charles V, possibly from the Louvre, were made with the confidence born of a long tradition.[15] He suggested that this tradition should be sought not in tomb effigies, which had been made from death masks in the first half of the fourteenth century, but from representations of living kings made from the life. These he traced to the early fourteenth century, arguing that the Mainneville figure does not represent Louis IX, as assumed, but is a likeness taken of Philip the Fair. It seems clear that his identification is incorrect, and the statue is a representation (not a life-study) of Louis IX;[16] but his argument may have some truth in it. The late fourteenth-century formal portraits may have been developed from the small informal portraits which had been about for over a century, of which the corbels at Ely are very fine examples.

NOTES

[1] T. D. Atkinson, *An Architectural History of the Benedictine Monastery of St. Etheldreda at Ely* (Cambridge, 1933), i, pp. 80, 82, 85, pl. xxii; ii, plans, sheet ix.

[2] For their kindness, hospitality and help I would like to thank the Right Reverend the Bishop of Ely and Mrs Walker, and Sister Mary Paul, Convent of the Holy Child Jesus, Mayfield. I am grateful to Mr Neil Stratford for drawing my attention to these sculptures and allowing me to reproduce his photographs. Dr Eric Mercer and Miss Sarah Pearson gave me some useful help. A more detailed study of these corbels is in preparation.

[3] L. Stone, *Sculpture in Britain: the Middle Ages,* 2nd ed. (Harmondsworth, 1972), pls. 108, 109A.

[4] G. S. Wright, 'The tomb of St. Louis', *Journal of the Warburg and Courtauld Institutes,* xxxiv (1971), 65–82.

[5] H. Küas, *Die Naumburger Werkstatt* (Berlin, 1937), pls. 82–105.

[6] W. Sauerländer, *Gothic Sculpture in France, 1140–1270* (London, 1971), p. 486, pls. 170, 171, 257.

[7] S. Whittingham, *A Thirteenth Century Portrait Gallery at Salisbury Cathedral* (1970); Stone, *op. cit.,* pls. 91A and B, 92; Courtauld Institute Illustration Archive, i, Part 7, *Lincoln, Angel Choir,* 1/7/89–96.

[8] E. K. Prideaux and G. R. Holt Shafto, 'Bosses and corbels of Exeter Cathedral', *Devon and Cornwall Notes and Queries,* vi, 2 (1910), plates passim.

[9] R. Hausherr, 'Zu Auftrag, Programm und Büstenzyklus des Prager Domchors', *Zeitschrift für Kunstgeschichte,* xxxiv, I (1971), 32–5.

[10] I am grateful to Dr. R. K. Morris for drawing my attention to these examples.

[11] Stone, *op. cit.,* pls. 91, 92.

[12] M. Wood, *The English Medieval House* (London, 1965), p. 308.

[13] P. K. Kipps, 'The Palace of the Archbishops of Canterbury at Charing, Kent', *Arch. J.* xc (1933), 78–97. Wood, *op. cit.,* p. 308, pl. 24.

[14] S. E. Rigold, 'Two Kentish hospitals re-examined: St. Mary, Ospringe and SS. Stephen and Thomas, New Romney', *Archaeologia Cantiana,* lxxix (1964), 46–7, discusses a corbel head (reproduced as pl. IIB) at Ospringe, with eyes carved in the same unusual technique as the Mayfield label-stop, and argues for a date near 1300. The window tracery at Charing and Mayfield need not be later than *c.* 1310.

[15] A. Erlande-Brandenburg, 'Le tombeau de Saint Louis', *Bulletin Monumental,* cxxvi (1968), 7–36. For the Charles V statue, see now *Les Fastes du Gothique, le Siècle de Charles V* (Paris, 1981), cat. no. 68, pp. 119–21.

[16] Above, n. 4.

IV. ADDITIONAL MATERIAL

Recent Studies in the Pre-Conquest Sculpture of Northumbria

James Lang, F.S.A.

The shadow of W. G. Collingwood will always fall across modern scholars who work on the pre-Conquest carvings of Northern England, not only because of his synthesis of the subject in his 1927 book, where he laid down a chronology for the monuments based upon stylistic criteria, but also on account of his groundwork in cataloguing the surviving pieces in the northern counties. More than fifty years on, those entries still provide the core for much of the emerging *Corpus of Anglo-Saxon Sculpture* to be published for the British Academy under the editorship of Professor Rosemary Cramp. Collingwood's survey was based upon personal examination of all the extant pieces, which he drew; it is a measure of the developments in the field that the new survey is being undertaken by a team adopting a standard approach, and that an archive and photographic record of many hundreds of stones is being assembled in Durham. Fieldwork for this project over the last ten years has led to the discovery of a considerable number of new carvings, often within the fabric of pre-Reformation churches, and excavation of major ecclesiastical sites, such as Jarrow and York Minster, has added to the corpus as well as on occasion providing, at last, a stratified context to assist in dating the sculptures.

In his preface to *Northumbrian Crosses of the Pre-Norman Age*, Collingwood declared his intention of placing 'the examples in series', acknowledging that 'to do this convincingly a corpus of the whole body of known fragments would be required'. In some areas the extant pieces are now almost twice as numerous as in Collingwood's time, and the increase in quantity of Northumbrian sculptures has

had two important effects on critical approaches to the material. First, many of the key pieces selected by Collingwood, Brøndsted and Kendrick for their stylistic sequences can now be seen to be derivatives or even provincial echoes of fashionable sculpture current in artistic centres such as influential monasteries or thriving commercial towns. The centrality of the Middleton crosses, for example, or the animal ornament of the Pickhill hogback and the Clifford Street slab from York, have been challenged (Lang 1973; Lang 1978a) so that their former crucial position in the development of tenth-century styles is less firm than it was. This particular change is largely due to the discovery of the pre-Conquest cemetery under York Minster, excavated by Derek Phillips in the late 1960s. This site yielded a huge crop of stratified tombstones, only some of which have seen publication (Pattison 1973); the authoritative account will appear in the forthcoming excavation report from the York Minster Archaeological Office. It was not only the sheer bulk of the sculptural finds beneath the Minster which shifted the accepted sequences, as Collingwood would have acknowledged; the quality of the carving revealed an expertise which had hitherto never been associated with late pre-Conquest sculptors, and the influence of this accomplished Metropolitan School upon the monuments in the ridings has become clear. Such excellence springs to the defence of scholars who are often accused of regarding their sculptures as artefacts (which indeed they are) rather than art objects.

The second effect of the sudden increase in extant pieces is to fill certain gaps, either in the chronological series or in the typology of monuments and artefacts. The York Minster cemetery, for example, has at last yielded a number of early Anglian monuments, so the balance of Anglian and Anglo-Scandinavian sculpture in York has now shifted. Similarly, Rosemary Cramp's excavations at Jarrow have brought to light a unique example of a genre little explored until recently: the decorative stone lectern (pl. LXXVa, fig. 18), now in the Bede Monastery Museum at Jarrow Hall, has led to a re-examination of carvings which do not easily conform to what we know of funerary memorials of the period. Miss Gwenda Adcock, in her unpublished thesis on interlace (Adcock 1974), has suggested that the Anglian fragment from Kirkby Moorside might also be reconstructed as stone furniture, and it is possible to assemble quite a large group of stone chair fragments from monastic sites in the North. The 'frith stools' of Hexham and Beverley are well known, but now a composite chair made up of flat slabs, sometimes with zoomorphic terminals and decorated edges, has emerged. The animal head at Lastingham (pl. LXXVc) was identified some time ago by Rosemary Cramp as a chair terminal of the type illustrated in David's throne in the Durham Cassiodorus and the seats of the Evangelists, Mark and Luke, in the St. Chad Gospels at Lichfield. The discovery in a barn wall of the tapering side slab of this chair has confirmed this identification (pl. LXXVd) and another, with the same slim lines and distinctive shape of one vertical and one inclined edge, has been found at Bamburgh opposite Lindisfarne (pl. LXXVb). An early date for the Hexham chair, bringing it into the late seventh century has been postulated by Rosemary Cramp (1974, 123–4), so that all the examples of stone furniture so far recognised in Northumbria are to be attributed to the earliest phases of stone carving. Only the neglected lamp-holder in the Yorkshire Museum at York offers a clue to the existence of this genre in the later period (Collingwood 1909, 200 and 203) and Richard Hall's discovery on his Coppergate site of fragments of crudely incised

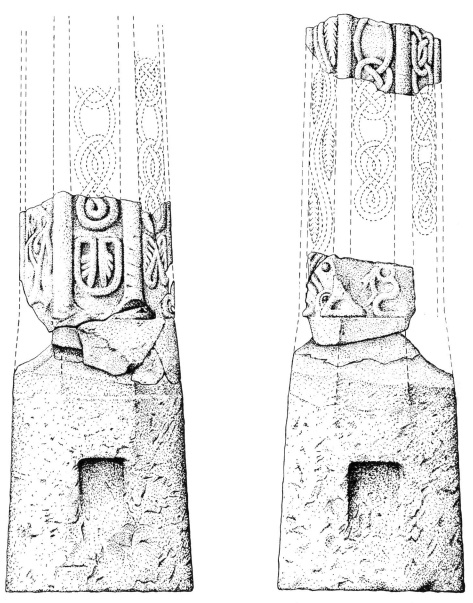

FIG. 18. Reconstruction of the Jarrow lectern (copyright R. J. Cramp).

lamp-holders in stone suggests that we should not always be searching in purely ecclesiastical contexts for carvings of this kind.

The chronology of Northumbrian sculpture established by Collingwood and Brøndsted, as we have seen, laid out the pieces in stylistic sequence from the classical, often architectural, carvings at Hexham to the degenerate eleventh-century monuments of rustic character produced on the eve of the Conquest. The phases of this stylistic development have to be determined on purely typological grounds and by comparative method in considering the ornament, since, as David Wilson has pointed out in his Collingwood Symposium lecture (Wilson 1978), there are very few fixed points for dating reliably at this period. Hardly any are 'signed', and few carry inscriptions, those that do being susceptible to wrangling over linguistic and epigraphic detail. The phases put forward fifty years ago do seem on reflection to be a trifle arbitrary, the stylistic shifts taking place at regular twenty-five year intervals. The Viking incursion is the only historical event which is related to a significant change in taste in animal ornament, though this has recently been reconsidered in the light of the continuing tradition of Anglian zoomorphic design during the Anglo-Scandinavian period (Lang 1978a; 1978b). A new approach to establishing a chronology on the lines of Collingwood's pattern was undertaken by Rosemary Cramp in her paper on 'The Anglian tradition in the ninth century' (Cramp 1978b), where the principles of dating were scrutin-ised before a new set of phases was presented for an acknowledgedly 'theoretical chronology'. The attribution of any date range in actual figures is a brave act, and no doubt future modifications to the sequence will be made, but where Professor Cramp's pattern differs from those of Brøndsted and Collingwood is first in the acceptance of regional characteristics in the sculpture groups, and secondly in relating the stylistic periods more closely to the cultural and historical contexts.

In the same volume, Richard Bailey has played the sceptic in his contribution on the chronology of the Anglo-Scandinavian sculpture of Northumbria (Bailey 1978). Even the comparatively narrow dating range possible for pieces like the Durham Cathedral cross-heads is open to doubt, to say nothing of the problems posed by their conservatism, and for more difficult cases the arguments will continue to rely upon comparative stylistic method and supporting evidence from historical sources and other media. The debate on the date of the Aycliffe shafts, for example, is likely to proceed on these lines (Morris 1978; Cramp 1980). Christopher Morris, in the Collingwood tradition, pleads for a consideration of the links that an important monument has with 'the total corpus of pre-Norman stones' from the site itself and 'related centres in the same area, before finally settling for its date'. And it is noticeable that the majority of studies produced during the last ten years concentrate on local groups rather than attempt the grand view of the total scene. The model for this approach was Rosemary Cramp's critique of the Otley crosses (Cramp 1971) which both examined the stylistic development at Otley itself and related the crosses to Northumbrian and Mercian parallels. This study was followed by others adopting the same approach: the Aycliffe article by Christopher Morris we have already cited, the 'bound dragon' group in Ryedale (Lang 1973), the Viking Age stones from York (Pattison 1973), and the corpus of early carvings from Hexham (Cramp 1974). A recent reviewer of *Anglo-Saxon and Viking Age Sculpture and its Context* complained that the subject is becoming one 'only for the initiate' because it demands a mighty degree

PLATE LXXV

c

d

c,d. Lastingham, N. Yorks: chair-arm
fragments

b. Bamburgh, Northumberland: chair-arm

*Photographs: a,b, T. Middlemass (copyright: R. J. Cramp);
c,d, J. T. Lang*

a. Jarrow: stone lectern

PLATE LXXVI

c. Brompton

b. Sockburn

The Allertonshire atelier

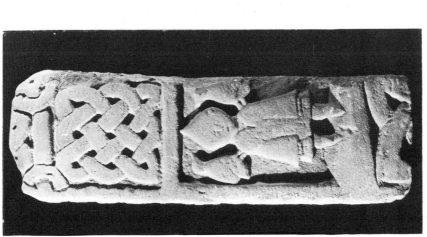

a. Kirkleavington

Photographs: a,b, T. Middlemass (copyright: R. J. Cramp); c, C. D. Morris

PLATE LXXVII

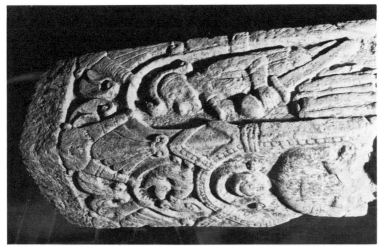

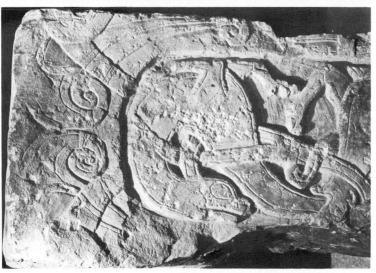

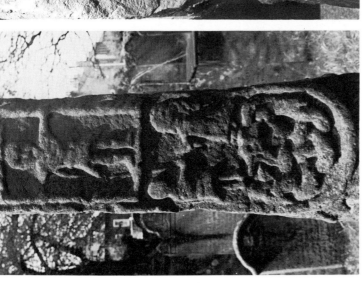

a. The Gosforth Cross, Cumberland: detail of the Crucifixion by the Gosforth Master

b. Detail of shaft from Newgate, York, showing tooling and construction lines

c. The Nunburnholme Cross, E. Yorks., showing the work of two sculptors

Photographs: a,b, J. T. Lang (b, courtesy of Yorkshire Museum); c, M. Firby

PLATE LXXVIII

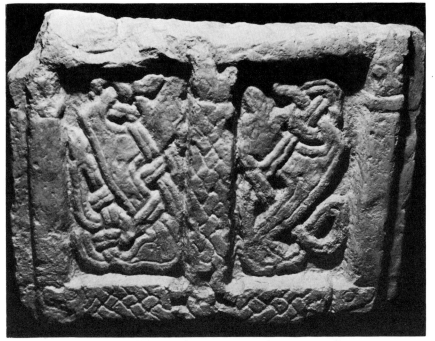

a. Grave-slab fragment from Clifford Street, York

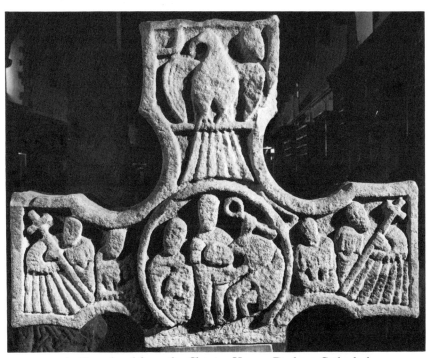

b. Cross-head from the Chapter House, Durham Cathedral

Photographs: a, J. T. Lang (by courtesy of the Yorkshire Museum);
b, T. Middlemass (copyright, R. J. Cramp)

of familiarity with particular monuments. If, however, we are to understand the nature of what is a very eclectic art form, the only way of determining local influences and local chronologies is to scrutinise as closely as possible local groupings.

This is not to determine local 'schools'. The notion of a school differs widely in commentaries on the complete range of medieval sculpture and the Corpus team tends to eschew regional labels for the groupings. Sexton, writing of Irish sculpture over thirty years ago, adopted the attitude which seems the most cautious and the most realistic.

> . . . the various local 'schools' represent not the development of a traditional style in a locality, but the work of different master sculptors, the work of each of whom is to be found, for the most part, in a definite region as might be well expected. We must think of sculptors, possibly sculptor families, who were responsible for the carvings in a definite region.
> (E. H. L. Sexton, *Irish Figure Sculptures* (1946), p. 22)

Critical studies have therefore recently tended to depart from classification of monuments on broad art historical grounds and from attribution to a particular style which would in turn imply a date range. Instead, studies of local groups have concentrated on cutting techniques, methods of laying out the decorative scheme, and the dimensions of particular motifs. What might appear as an obsession with measurements and fine detail has in fact provided the material evidence for the ateliers, or even the particular hands which produced the monuments. The basis for the recognition of a local school or workshop can too easily rest on a subjective reaction to similarities between carvings which happen to survive in a restricted locality. Cutting techniques, on the other hand, are particular and measurable, even idiosyncratic in some cases, so that sculptures which share these features can be grouped dispassionately and with more assurance. Sometimes apparently dissimilar **monuments** turn out to be from a single workshop, despite radical differences in their ornament and form: the Masham round shaft, for example, is by the same hand as the Cundall/Aldborough squared shaft, the one arcaded, the other panelled (Lang, forthcoming).

Undoubtedly the most important development in this field is Richard Bailey's discovery that templates were used in the drawing up of the carved decoration (Bailey 1978 and 1980). He has shown that three of the Durham cross-heads which share the same iconography were produced by this method (pl. LXXVIII*b*). Whilst figural scenes result on the finished carving, it is clear that the template shapes were pure curves which could be used, as they were in Allertonshire in North Yorkshire, for the drawing of a variety of figural motifs. The Allertonshire group is the most convincing in terms of providing evidence of a workshop. The template curves correspond at three sculpture sites, and tricks of cutting, lay-out habits and choice of stone unite several shafts, all of them within a circle of about ten miles across (pl. LXXVI*a,b,c*).

In Yorkshire it has so far been possible to isolate the work of at least four ateliers: in Allertonshire, Ryedale, Wensleydale and York itself. The Ryedale workshop, which includes the well known Middleton crosses, covered much the same range of distribution as the Allertonshire one and used local stone, but at Gainford on the River Tees a fragment of a grave-slab obviously comes from the

York template series, suggesting that some sculptors served a much larger area. Perhaps the thorough geological survey necessary for the *Corpus* will reveal further connections of this kind, though it is notoriously difficult to locate the particular quarries for the monuments even within a limited area.

The examination of tooling and profiles in the cutting has also led one step beyond the atelier to the hand of a particular sculptor. Unlike Gautr in the Isle of Man, the sculptors' names are unknown, though their sculptural techniques amount to a kind of signature. The first identification was made by Miss Gwenda Adcock in her work on the interlace patterns of Northumbrian sculpture (Adcock 1974 and 1978) where she indicated that many knotwork designs were identical in size and disposition, especially with regard to the hole-points around which the interlacing strands were wrapped. This suggested the use of a single template, if not the work of a single sculptor. Then attention was turned to the Gosforth Cross in Cumberland (Bailey and Lang 1974) which possesses motifs and modes of cutting in relief which are also found on one of the hogbacks, the Fishing Stone and a cross-head at the same site; the quality of this carving led the authors to refer to the sculptor as 'the Gosforth Master' (pl. LXXVII*a*). Current studies of the Newgate shaft in York, the rejected fragment found by Richard Hall at Coppergate and the Clifford Street slab are beginning to suggest that all three are by a single hand. The task is lightened here by the carver's preference for fine grained limestone which retains the toolmarks and lay-out lines extremely well, even to the extent of revealing the use of a gouge, perhaps like that which emerged from Coppergate (Hall 1980, 18). We may expect the 'Newgate Master' to take his place alongside the template users of the other York atelier before long (pls. LXXVII*b* and LXXVIII*a*).

The effect of this change of emphasis is to inhibit confident dating rather than to promote it. Works from a particular atelier are now being bunched together instead of spread evenly across a steadily evolving chronology. There is no way of telling whether or not the ateliers were operating concurrently, or what the duration of a particular workshop's activity was, or how long a template was kept in use. What does emerge is a development which consists of very productive bursts in some areas, and it is possible that all these local floruits of sculpture might have occurred within a short space of time with long periods of artistic sterility between them. This would be as true for the Anglian period as it might be for the Viking Age, but for the later phase there is a curious piece of evidence which supports such a theory. Throughout Northumbrian sculpture there is no example of late Viking styles (Mammen or Ringerike), apart from the solitary, atypical piece at Otley. It is probable that most Anglo-Scandinavian carvings were therefore produced in the first half of the tenth century or, at the most generous estimate, between Halfdan's consolidation of his conquest of York about 876 and the death of Eric Bloodaxe in 954. The same limited time scale may also operate for much pre-Viking sculpture in the ninth century, when one suspects sculptors in the Ripon area were particularly active for only a short time, or even in the earliest period when the foundation of new monasteries along the east coast may have provided an impetus which ran out of steam quite quickly. The new reluctance to date the carvings, then, simply reflects the archaeologist's cautious requirements of fixed points and material evidence. It is interesting to compare different approaches in two papers on the Nunburnholme cross in the East Riding (Pattison

1973; Lang 1977), whose complexity results from more than one sculptor having worked on the shaft (pl. LXXVII*c*).

The Nunburnholme cross presents additional problems in the interpretation of some of its iconography, and since 1970 there has been a steady trickle of articles on a subject that attracts the popular interest as easily as it does the informed sceptic's distrust. Christian iconography, having the authority of canonical requirements behind it, tends to be handled less speculatively than the pagan or heroic. Dr Elizabeth Coatsworth's work on the iconography of the Crucifixion in sculpture has illuminated our understanding of panels at Bothal, Hexham, Alnmouth and Aycliffe (Coatsworth 1973, 1974, 1977 and 1978) and the complexities of the scenes on the Durham cross-heads are considered in the Collingwood Symposium volume (Coatsworth 1978) (pl. LXXVIII*b*). Rosemary Cramp has drawn together a number of representations of the Evangelists' symbols in Northumbria by way of exploring the connections between monastic centres in the region (Cramp 1978a), warning us at the same time of the danger of inferring wide influences from few and scattered examples. The same caution might apply to the wilder explorations of ostensibly pagan iconography seen on a few Viking Age monuments at Sockburn and Lowther (Lang 1972) and of heroic scenes involving Sigurd and Weland in Yorkshire and Lancashire (Lang 1976; Bailey 1980). Whilst these monuments can be stylistically dated to the tenth century and therefore indicate a pagan or at least a secular preference in the Middle Viking Period in Northumbria, it is not true to say (Smyth 1981, 273 ff.) that this small group of carvings represents a very considerable pagan presence in the Viking colonies of the north of England. This class of sculpture is represented by an exceedingly low percentage of the total corpus of Anglo-Scandinavian carvings, and often the heroic depictions are presented alongside Christian iconography, suggesting that the two traditions were compatible. The Sigurd cross at Kirkby Hill, for instance, carries a Crucifixion, and the Weland references at Leeds form part of a theologically subtle programme of mixed heroic and Christian motifs. Sometimes, however, the Christian interpretation of motifs on funerary sculpture seems a little too esoteric for its rustic sculptors: the 'hart and hound' device is common throughout the North on late pre-Conquest stones and Richard Bailey's treatment of the Dacre example presupposes a patron who not only had access to a comprehensive library but who also perversely eschewed traditional symbols of Christian redemption (Bailey 1977). His acknowledgement of the Germanic tradition, and of Celtic influences on the Cumbrian carving, leads us to firmer ground.

Finally, it is Richard Bailey's book on the Viking Age sculpture of Northumbria that has brought the subject enthusiastically to a general readership (Bailey 1980). It crystallises much recent work on the pre-Conquest sculpture of the region and refers to many stones that were unknown to Collingwood. It differs from Collingwood's great book in not being concerned with establishing the definitive chronology for Northumbrian sculpture, yet, along with the work reviewed in this paper, it owes a great debt to Collingwood, who ended his own survey with the words:

> They have to consider the examples, and all the examples. They have to conceive them in series and connexion. They have to remember the conditions of the stone-cutter's craft, the human circumstances which make it necessary to take that craft on its own terms . . .

BIBLIOGRAPHY

Adcock, G. (1974): *A Study of the Types of Interlace of Northumbrian Sculpture,* M Phil. thesis of Durham University, unpublished.

Adcock, G. (1978): 'The theory of interlace and interlace types in Anglian sculpture', in ed. Lang (1978), 33–45.

Bailey, R. N. (1972) 'Another lyre', *Antiquity,* xlvi, 145–6.

Bailey, R. N. (1974): *The Sculpture of Cumberland, Westmorland and Lancashire North of the Sands in the Viking Period,* Ph.D. thesis of Durham University, unpublished.

Bailey, R. N. (1977): 'The meaning of the Viking Age shaft at Dacre', *Trans. Cumberland & Westmorland A. and A. Soc.,* 2nd S., lxxvii, 61–74.

Bailey, R. N. (1978): 'The chronology of Viking Age sculpture in Northumbria', in ed. Lang (1978), 173–203.

Bailey, R. N. (1980): *Viking Age Sculpture in Northern England.*

Bailey, R. N. and Lang, J. T. (1975): 'The date of the Gosforth sculptures', *Antiquity,* xlix, 290–3.

Carragain, E. O. (1978): 'Liturgical innovations associated with Pope Sergius and the iconography of the Ruthwell and Bewcastle crosses', in ed. Farrell (1978) (B.A.R. 46), 131–47.

Coatsworth, E. (1973): 'Two representations of the Crucifixion on late pre-Conquest carved stones from Bothal, Northumberland', *Arch. Ael.,* 5th S., i, 234–6.

Coatsworth, E., (1974a): 'An un-noticed sculpture fragment in Durham Cathedral Library', *Trans. Arch. & Arch. Soc. Durham and Northumberland,* N.S. iii, 109–10.

Coatsworth, E. (1974b): 'Two examples of the Crucifixion at Hexham', in ed. Kirby (1974), 180–4.

Coatsworth E. (1977): 'The Crucifixion on the Alnmouth Cross', *Arch. Ael.,* 5th S., v, 198–201.

Coatsworth, E., (1978): 'The four cross-heads from the Chapter House, Durham', in ed. Lang (1978), 85–96.

Collingwood, W. G. (1909): 'Anglian and Anglo-Danish Sculpture at York', *Yorks. Arch. J.* xx, 149–213.

Collingwood, W. G. (1927): *Northumbrian Crosses of the Pre-Norman Age.*

Cramp, R. J. (1971): 'The position of the Otley crosses in English sculpture of the eighth to ninth centuries', *Kolloquium über spätantike und frühmittelalterliche Skulptur,* Mainz, 55–63.

Cramp, R. J. (1972): 'Tradition and innovation in English stone sculpture of the tenth to eleventh centuries', *ibid.,* 139–48.

Cramp, R. J. (1974): 'Early Northumbrian Sculpture at Hexham', in ed. Kirby (1974), 115–40.

Cramp, R. J. (1977): 'Mediterranean elements in the early medieval sculpture of England', 9th Congress, U.I.S.P.P., Nice.

Cramp, R. J. (1978a): 'The Evangelist symbols and their parallels in Anglo-Saxon sculpture', *Bede and Anglo-Saxon England* (ed. R. T. Farrell) (B.A.R. 46), 118–30.

Cramp, R. J. (1978b): 'The Anglian tradition in the ninth century', in ed. Lang (1978), 1–32.

Cramp, R. J. (1980): 'The pre-Conquest sculptural tradition in Durham', *Medieval Art and Architecture at Durham Cathedral* (Trans. Brit. Arch. Assoc.), 1–10.

Cramp, R. J. (forthcoming): *The Viking Image* (U.S.A.).

Cramp, R. J. and Lang, J. T. (1977): *A Century of Anglo-Saxon Sculpture*

ed. Farrell, R. T. (1978): *Bede and Anglo-Saxon England* (B.A.R. 46).

Farrell, R. T. (1978): 'The archer and associated figures on the Ruthwell Cross', in ed. Farrell (1978), 96–117.

Hall, R. A. (1975): 'St Mary Castlegate', *Interim* 3/1, 18–28.

Hall, R. A. (1978): 'Coppergate', *Interim* 5/2, 2 and 25.

Hall, R. A. (1980): 'Coppergate', *Interim* 7/2, 15–21.

Hope-Taylor, B. (1971): *Under York Minster.*

Howlett, D. R. (1974): 'Two panels on the Ruthwell Cross' *J. Warburg and Courtauld Inst.* xxxvii, 333–6.

ed. Kirby, D. P. (1974): *St. Wilfrid at Hexham.*

Lang, J. T. (1972): 'Illustrative carving of the Viking period at Sockburn on Tees', *Arch. Ael.,* 4th S., l, 235–48.

Lang, J. T. (1973): 'Some late pre-Conquest crosses in Ryedale; a reappraisal', *J.B.A.A.* 3rd S., xxxvi, 16–25.

Lang, J. T. (1976): 'Sigurd and Weland in pre-Conquest carving from Northern England', *Yorks. Arch. J.* xlviii, 83–94.

Lang, J. T. (1977): 'The sculptors of the Nunburnholme Cross', *Arch. J.* cxxxiii, 75–94.

Lang, J. T. (1978a): 'Continuity and innovation in Anglo-Scandinavian sculpture', in ed. Lang (1978), 145–72.

Lang, J. T. (1978b): 'Anglo-Scandinavian sculpture in Yorkshire', *Viking Age York and the North* (ed. R. A. Hall) (C.B.A. Research Report no. 27), 11–20.

ed. Lang, J. T. (1978): *Anglo-Saxon and Viking Age Sculpture and its Context* (B.A.R. 49)

Lang, J. T. and Morris, C. D. (1978): 'Recent finds of pre-Norman sculpture from Gilling West, N. Yorkshire', *Med. Arch.* xxii, 127–30.

Morris, C. D. (1973): 'An Anglo-Saxon grave-slab from Hurworth, Co. Durham', *Arch. Ael.,* 5th S., i, 236–40.

Morris, C. D. (1974): 'Two early grave-markers from Billingham', *Arch. Ael.,* 5th S., ii, 49–56.

Morris, C. D. (1976): 'Pre-Conquest sculpture of the Tees Valley', *Med. Arch.* xx, 140–6.

Morris, C. D. (1978): 'Aycliffe and its pre-Norman sculpture', in ed. Lang (1978), 97–133.

Pattison, I. R. (1973): 'The Nunburnholme Cross and Anglo-Danish sculpture in York', *Archaeologia,* civ, 209–34.

Smyth, A. P. (1981): *Scandinavian York and Dublin,* ii.

Wilson, D. M. (1978): 'The dating of Viking art in England', in ed. Lang (1978), 135–44.

Wilson, D. M. and Klindt-Jensen, O. (1980): *Viking Art,* 2nd edition.

Two Twelfth-Century Voussoir Stones from Sopwell House, St. Albans

Eileen Roberts, F.S.A.

Two wedge-shaped stones, carved with medallions containing a lion and stylized foliage (pl. LXXIX), were discovered about 1965 at the Sopwell House Hotel, St. Albans, Hertfordshire. The site (TL 156 053) is located about a mile and a quarter south-east of St. Albans Abbey. The sculptures were found during building operations, in an unstratified position, just outside the front door of the hotel, and are now in the collection of the Verulamium Museum.[1]

The stones were probably components of one of the ornamental arched orders of an Anglo-Norman arch or doorway of considerable size. They fit together to form a fifteen-degree segment of a circle. The arch they describe, plus their measurements, indicate that twenty-two such stones would comprise a semi-circle about 7 ft. 5¾ in. in diameter (fig. 19). The entrance to the south porch of Malmesbury Abbey, Wiltshire, measures c. 7 ft. 6 in. across its internal opening, and has eight enriched orders.[2]

Each stone has two long, plane surfaces meeting at ninety degrees, which would have been embedded in the thickness of a wall. The soffit face is regularly tooled, measuring 4¾ in. wide.[3] A rebate ¾ in. deep separates the soffit from the rounded, sculptured surface. The relief is higher on the right side than on the left, so that the carving would present itself effectively to those passing through the arch.

Although the voussoirs are of Totternhoe stone, an easily-carved freestone of poor weathering quality,[4] yet the carving is preserved quite fresh and crisp, as from an interior or otherwise protected location. The lion's face is partly broken away, while the surfaces of the tail, tassel and one paw are missing. The textures of the body and mane are especially clear and the foliage is mainly intact.

A considerable amount of pigment is present on the voussoir stones, blue on the background inside the medallions, and pink on the background outside, in the spandrels. The pigments will be discussed in a separate report.[5]

PLATE LXXIX

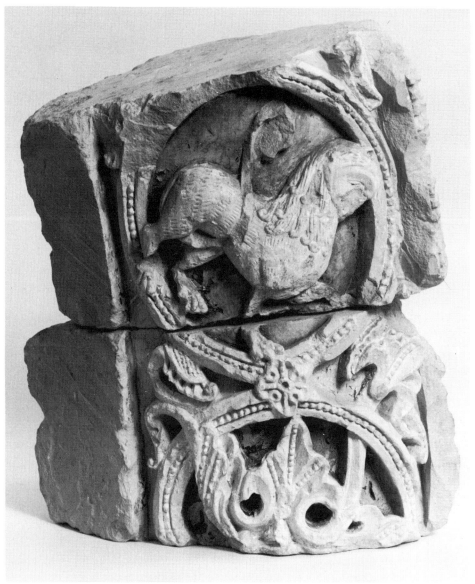

Photograph: Verulamium Museum

Voussoir stones found at Sopwell House, St. Albans

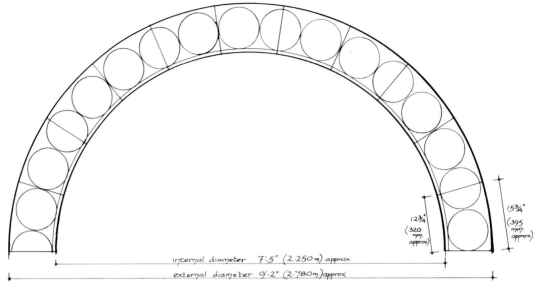

internal diameter 7'·5" (2·250m) approx
external diameter 9'-2" (2·780m) approx

12¾" (320 mm. approx)
15¾" (395 mm. approx)

FIG. 19. Reconstruction of Norman arch.

Possible context

At St. Albans, two parish churches, St. Michael and St. Stephen, contain twelfth-century work;[6] Sopwell Priory and St. Julian's Hospital were both founded in that same century.[7] St. Albans Abbey, however, is the dominant Romanesque monument of the area, and the quality of the voussoir stones points unmistakably to it. In fact, the scale of the lost archway suggests adornment, not of the lost conventual buildings, but of the Abbey church exterior itself.

Possible locations must now be considered. The Anglo-Norman west front of the Abbey, terminating the nave then ten bays long, was probably completed by the time of the dedication on 28 December 1116.[8] The original west doorways, presumably three in number, were doubtless in the severe style of the rest of the building. Enrichment, if any, would have been a later application, although there is no record of this being done. The voussoir stones are unweathered, yet a porch or narthex is not in the Anglo-Norman tradition. This seems to rule out the west front as a possible location. The west front of Paul de Caen's church was demolished from 1197,[9] when the nave was lengthened westwards.

The voussoir stones might have adorned a processional doorway, opening from the nave into the cloister.[10] We do not know if the church dedicated in 1116 had a western processional door: when the nave was lengthened by Abbot John de Cella, 1195–1214, a doorway was placed in bay 12 of the south aisle, opening to the west of the outer parlour.[11] Furthermore, bays 4 to 8 of the Norman south aisle were destroyed by the fall of masonry of 1323 and rebuilt in the Decorated style.[12] No doorway to the cloister was placed in bay 7 during this build, as would be expected.

It is certain, however, that an Anglo-Norman processional door opened into the east walk of the cloister from the south transept, just as at Ely,[13] and at Christ-

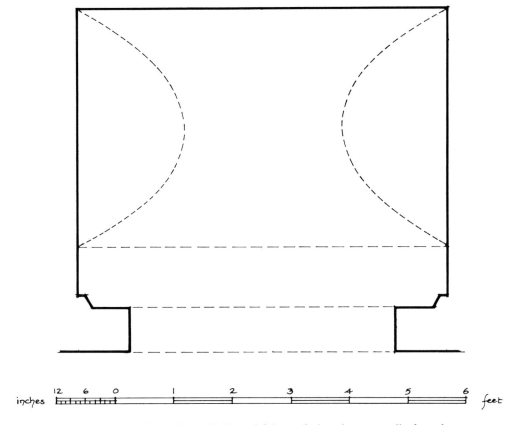

FIG. 20. St. Albans Abbey: plan of lobby of (blocked) door in west wall of south transept.

church, Canterbury. At St. Albans, it survives internally as a walk-in cupboard, with the external access blocked.[14] The inner arch is a plain one, with simple imposts, and measures 4 ft. 6 in. across. It widens into a rectangular lobby, about 6 ft. 3½ in. across, with intersecting tunnel vaulting (fig. 20). "The masonry, though early, hardly looks as old as the wall in which it is set", wrote William Page and Sir Charles Peers in 1908.[15] We know that Abbot Robert de Gorham, 1151–1166, rebuilt the east walk of Abbot Paul's cloister,[16] and a richly embellished doorway could well have been part of this scheme. The scale of the doorway is consonant with that of the conjectured arch. Although twelfth-century cloisters were usually open arcades on a dwarf wall under a lean-to roof, such an arrangement would protect from weathering any delicate carving high on an archway. This seems a likely position for the doorway.

John Moote, while still Prior (before 1396), again rebuilt the cloister on the east and south sides with studies and a library, inserting, apparently, the 'Abbot's Door' in bay 1 of the south choir aisle.[17] The Anglo-Norman processional doorway could have been dismantled externally and blocked at this time.[18] Other Romanesque work which John destroyed was incorporated as rubble into his rebuilding projects.[19] One other doorway certainly demolished at this time and

re-used as building rubble, was reassembled and set, with additions, into the south transept almost a century ago.[20]

One should mention in this context the doorway of the chapter house as Robert de Gorham rebuilt it. On the plan revealed by the recent excavation (fig. 14), the aperture measured about 8 ft. across.[21] Neither the scale nor the sheltered position rules out the possibility that the voussoir stones adorned this doorway, but whether or not the sculptural style conformed is another question.

Description of the sculpture

The medallion chain, inspired no doubt by Byzantine textiles, was a popular Anglo-Norman motive.[22] Examples occur widely in the sculpture of the period, from Kilpeck to Ely, from Barfreston to Durham. Circular links are the most popular units, but vesicas, lozenges and inverted hearts are also used. The Sopwell voussoirs are exceptional in the use of oval fields (pl. LXXIX), 7¾ in. across and 9¼ in. down, outside measurements.

On the upper stone the medallion is almost complete; on the lower, only half survives. The medallions are not disposed radially, with one unit to a single stone; instead, four stones would be required to accommodate three complete frames. A perfect, semi-circular arch to this scale would contain 16½ frames, 8 frames with figures and 8½ with foliage or *vice versa* (fig. 19).

The moulding of the medallion frames consists of a fillet-chamfer-fillet-roll-fillet-chamfer-fillet, a refined moulding in this small scale. The roll consists of a row of beads. To emphasise the continuity of the chain motive, a continuous beaded fillet on a larger scale followed the outer circumference of the sculptured order (pl. LXXIX, extreme right).

The medallions are linked together by rosettes of cruciform shape. There is a large double boss in the centre, a smaller boss in each angle, triplets of beading in the middle of each petal, and a continuous roll around the whole motive. Linking rosettes are common on Byzantine textiles,[23] and they also appear carved on the side portals of the west door at Vézelay, a monastery visited by the St. Albans abbot, Robert de Gorham, on a return journey from Rome.[24]

The figure of a lion occupies the upper medallion. With its easy, moving stance, overlapping the frame, it was probably inspired either by the Bestiary or by the zodiac symbol for the month of July. The face is fully frontal, revealing the sweeping brow. If this face, now lost, had been a human one, we would have a rare example of a Romanesque sphinx.[25]

The curly mane is represented by two tiers of striated S-hooks, terminating in tight coils. The body, thick, muscular and sturdy, is carved in high relief. The pelt is textured in rows of short, parallel lines, a device appearing on mosaics at San Clemente, Rome.[26] The tail, long in proportion to the body, is held aloft. It is damaged, but it was probably not beaded, nor the tassel floriated. The ankles are slender and each heavy paw has three spatula-shaped, prominently-jointed toes. The treatment achieves a balance between the lightness and energy of the Anglo-Saxon style, and the pattern-making tendency of the Normans.

The lower medallion was filled with foliage scrolls, flowing over and under the medallion frames to occupy the spandrels on either side. The leaves are clear and

distinct, with lines of beading on stems and foliage. They fall within the popular Acanthus Style, which was characterized by thick foliage, modelled on designs of the Winchester School.[27]

Four separate leaf motives survive, three of which are well preserved. Inside the lower frame is a palmette with five lobes, of which three have beaded frames. A large concentric boss marks their point of confluence, and the two lowest lobes curl downwards towards the stem.

Left of the medallion, overlapping the frame and pierced by it in the Anglo-Saxon manner, is a folded leaf in profile. Five semi-circular lobes are shown, and the tip of the leaf continues beyond the frame as a long, curling hook of a particular kind. This leaf has two beaded veins, and it resembles a slice from a certain decorative band of foliage in the *Bible of Bury St. Edmunds*.[28]

Left of the linking rosette is an oval leaf with an S-curved stem. It has a 'cap', entirely covered with beading, and edged with a very narrow roll. On the lower edge of the leaf are scallops, each deeply hollowed out, while the tip of the leaf is curled into a tight ball.

Summarizing the leaf style, one notes that individual leaves have more than one vein, and that the leaf surfaces between these veins rise to form sharp ridges.[29] Some leaves have scalloped borders, while others are edged in a roll.

Little stylistic affinity exists between the Sopwell voussoir stones and the series of Anglo-Norman capitals from twelfth-century conventual buildings, all now lost,[30] which are mounted in the south transept of the Abbey church and the slype. Abundant parallels, however, can be found among the fifty-three manuscripts surviving from the extensive library held by St. Albans in the twelfth century.[31] Numerous examples of cruciform rosettes, palmettes, hooked and profile leaves, as well as concentric bosses and beading, can be found in the *St. Albans Psalter,* in Bede, *Super Cantica* and in St. Anselm's *Prayers and Meditations*.[32] These manuscripts all have associations with the Alexis Master.[33]

Even more parallels can be found in that group of St. Albans manuscripts noted by Otto Pächt to form 'a bridge between the St. Albans School and the mid-twelfth-century Canterbury style'.[34] These include Josephus' *De Bello Judaico* in the British Library, the *Opera* of St. Ambrose and the detached St. Albans *Kalendarium*, both in the Bodleian.[35] Further affinities can be found in other manuscripts, not belonging to St. Albans, but reflecting the Alexis Master's influence: these include the *Eadwine Psalter*, the *Great Lambeth Bible* and the associated *Avesnes leaf*.[36]

The date of the sculpture

Four kinds of evidence assist in dating the Sopwell voussoirs. First, the depth of the relief and the mature style of carving reflect the Byzantine influences so important in England from the second quarter of the the twelfth century.[37]

Secondly, is the use of oval fields upon a rounded order. Round frames were carved on flat orders from *c.* 1140 at Ely, and continued as late as 1160 at Alne in Yorkshire. Circular frames on rounded orders appear at Fishlake, Yorkshire, 1160–70. At Barfreston, Kent, round frames on a rounded order and vesicas on a flat order, *c.* 1180, are combined on one doorway. Vesicas on rounded orders are found at Malmesbury, 1160–70 and at Glastonbury, *c.* 1210.[38] The Sopwell

voussoirs, logically, should be earlier than Malmesbury, as the sculptural fields are well-rounded ovals, not slender vesicas.

Thirdly, there is the similarity of the carved motives, foliage and otherwise, to those which adorn twelfth-century manuscripts in the libraries of St. Albans and of other houses influenced by St. Albans. These illuminations range in date from 1120 to 1150. Manuscript models could obviously be contemporary works or earlier ones; books once illuminated exerted a lasting influence, and the sketch-books from which they drew continued in use in the scriptorium.

Finally, there are the documentary references to appropriate works at St. Albans Abbey. Robert de Gorham, abbot from 1151 to 1166, rebuilt the east walk of the cloister. A richly adorned processional doorway on the west wall of the south transept could have been part of this programme. Considering all these factors, a date is suggested for the sculptures early in the rule of Abbot Robert, after 1151.

Conclusion

St. Albans Abbey, which enjoyed a high reputation in the twelfth century, was a recognised leader in several fields of artistic endeavour, in metalwork, embroidery and miniature painting as well as in architecture.[39] The Sopwell voussoir stones afford a glimpse of the lost magnificence of St. Albans monastery and suggest that its sculptures possessed a distinction comparable to that of other arts being practised at St. Albans at that time.

NOTES

[1] Such a find is by no means unique in the area. "Some sculptured fragments . . . have been disinterred from a meadow at Sopwell, and are now preserved by the care of the owner of Oaklands". I. C. and C. A. Buckler, *The Abbey Church of St. Alban* (1847), p. 163.

[2] Harold Brakspear, 'Malmesbury Abbey', *Archaeologia*, lxiv (1913), 417f. and plan facing p. 436.

[3] J. Neale, *The Abbey Church of St. Alban* (1877), p. 36 comments on the tooling of stones in St. Albans Abbey.

[4] A. R. Warnes, *Building Stones: their Properties, Decay and Preservation* (1926), pp. 59f.; E. Roberts, 'Totternhoe Stone and flint in Hertfordshire churches', *Med. Arch.* xviii (1974), 68.

[5] A sample of the pigment is with the Department of the Environment's Ancient Monuments Laboratory. As the analysis report is not available at the time of writing, it is hoped to publish it at a later date.

[6] *Gesta Abbatum Monasterii Sancti Albani a Thoma Walsingham, regnante Ricardo Secundo, eiusdem ecclesiae Praecentore, compilata* (1867), i, p. 22; Harold M. and Joan Taylor, *Anglo-Saxon Architecture*, ii (1965), pp. 528ff.

[7] V.C.H. *Herts.* iv (1914), pp. 422 and 464.

[8] *Gesta Abbatum* (op. cit. in n. 6), i, p. 71; William Page, 'On some recent discoveries in the Abbey Church of St. Alban', *Archaeologia*, lvi (1897), plan facing p. 1 and p. 3; L. F. R. Williams, *History of the Abbey of St. Alban* (1917), p. 48, n. 2.

[9] *Gesta Abbatum*, i, p. 218.

[10] Francis Bond, *English Church Architecture* (1913), ii, pp. 702ff.

[11] V.C.H. *Herts.*, ii (1908), p. 504 and plan facing p. 484.

[12] *Gesta Abbatum*, ii, p. 129.

[13] G. Zarnecki, *The Early Sculpture of Ely Cathedral* (1958), p. 17, pl. 17 and frontispiece, marked 'V'.

[14] G. H. Cook, *Portrait of S. Albans Cathedral* (1951), p. 11, lower left hand side of picture. Buckler, *op. cit.*, p. 134.

[15] V.C.H. *Herts.*, ii (1908), p. 501.

16 *Gesta Abbatum*, i, p. 179; V.C.H. *Herts.*, ii (1908), p. 507, n. 156.

17 R.C.H.M., *Inventory of Hertfordshire* (1911), p. 182; V.C.H. *Herts.*, ii (1908), 502; Cook, *op. cit.*, pl. 45.

18 *Gesta Abbatum*, iii, p. 441; V.C.H. *Herts.*, ii (1908), p. 507.

19 M. Biddle, *St. Albans Abbey Chapter House Excavations 1978* (1979), p. 13. Noted earlier by James Neale, *op. cit.*, p. 4 and by Sir Edmund Beckett, *St. Alban's Cathedral and its Restoration*, (1885), p. 69.

20 Cook, *op. cit.*, pl. 26.

21 M. Biddle and B. Kjølbye-Biddle, 'England's premier abbey: the medieval chapter house of St. Albans Abbey and its excavation in 1978', *Hertfordshire's Past*, xi (1981), 3–27 and esp. 13, fig. 7E.

22 Eric C. Millar, *English Illuminated Manuscripts from the Xth to the XIIIth century* (1926), p. 26.

23 Cyril G. E. Bunt, *Byzantine Fabrics* (1967), *passim*.

24 Arthur Gardner, *Medieval Sculpture in France* (1931), p. 111; R. B. C. Huygens, ed., *Monumenta Vizeliacensia* (1976), p. 506.

25 Heinz Demisch, *Die Sphinx: Geschichte ihrer Darstellung von den Anfängen bis zur Gegenwart* (1977), pl. 328.

26 G. Zarnecki, *Art of the Medieval World* (1975), fig. 246. A link existed between San Clemente, Rome and St. Albans in the cult of St. Alexis: O. Pächt, 'The chanson of St. Alexis', in O. Pächt, C. R. Dodwell and F. Wormald, *The St. Albans Psalter (Albani Psalter)* (1960), pp. 134ff. Note the same textural effect on a bear in the *Bury Bible*, f. 220r, shown by C. M. Kauffmann in 'The Bury Bible', *Journal of the Warburg and Courtauld Institutes*, xxix (1966), pl. 25b.

27 T. S. R. Boase, *English Art, 1100–1216* (1953), pp. 38f.

28 C. M. Kauffmann, *Romanesque Manuscripts 1066–1190* (1975), pl. 149, middle band (Cambridge, Corpus Christi College, MS. 2).

29 W. R. Lethaby, *Westminster Abbey Re-examined* (1925), p. 25, fig. 20, shows a capital with similar, ridged leaf surfaces, dated 1120–30.

30 The 1978 excavation of the St. Albans Abbey Chapter House revealed that the south wall of the slype was internally twelfth-century work (Biddle, *op. cit.* (1979), p. 12). This sole surviving portion of the Romanesque domestic range has recently been demolished.

31 N. R. Ker (ed.), *Medieval Libraries of Great Britain: a List of Surviving Books*, Royal Historical Society Handbook, No. 4 (1941), pp. 164–8.

32 For the St. Albans Psalter (Hildesheim Cathedral Library) see Kauffmann, *op. cit.*, no. 29, pp. 68–70. Mr. Christopher Hohler protests against the nomenclature *St. Albans* Psalter since, he writes, 'its Calendar is wrong for St. Albans, its distribution of the Psalter is wrong for St. Albans, its litany is wrong for St. Albans' (*Études d'Art Médiéval Offertes à Louis Grodecki* (1981), p. 100, n. 6). For Bede, *Super Cantica* (Cambridge, King's College, MS. 19), see Kauffmann, *op. cit.*, p. 46 and fig. 40 and Pächt, *op. cit.*, p. 166. For Anselm (Verdun, Bibl. Mun., MS. 70) see Kauffmann, *op. cit.*, no. 31, p. 71 and Pächt, *op. cit.*, p. 165.

33 Pächt, *op. cit.*, pp. 147ff.

34 *Ibid.*, p. 158, n. 3.

35 For Josephus (B.L. Royal MS. 13 D. vi, vii) see Kauffmann, *op. cit.*, no. 32, pp. 71f. and Pächt, *op. cit.*, p. 168. For the Anselm (Oxford, Bodleian MS. 752) see *ibid.*, p. 168; For the detached *Kalendarium* (Oxford, Bodleian MS. Auct. D. 2.6) see Kauffmann, *op. cit.*, no. 71, p. 101.

36 For the *Eadwine Psalter* (Cambridge, Trinity College MS. R.17.1) see *ibid.*, no. 68, pp. 96f. and Pächt, *op. cit.*, pp. 169f. For the *Great Lambeth Bible* (Lambeth MS. 3) see Kauffmann, *op. cit.*, no. 70, pp. 99f. For the *Avesnes Leaf* (Avesnes, Soc. Arch.) see *ibid.*, p. 100 and C. R. Dodwell, *The Great Lambeth Bible* (1959), pl. 7.

37 G. Zarnecki, *Later English Romanesque Sculpture* (1953), p. 32.

38 G. Zarnecki, *English Romanesque Sculpture* (1951), pl. 78 and *op. cit.* (1953), pls. 81, 83, 87, 96 and 130.

39 For St. Albans' status generally, see, David Knowles and J. K. S. St. Joseph, *Monastic Sites from the Air* (1952), p. 6. For the Anglo-Norman architecture, see Geoffrey Webb, *Architecture in Britain: the Middle Ages*, (2nd edn., 1965), p. 28. For the metalwork, see C. C. Oman, 'The Shrine of Alban: two illustrations', *The Burlington Magazine*, lxiii (1933), 237. For needlework, see G. A. I., pp. 83–87 and 127. For minature painting see Margaret Rickert, *Painting in Britain: the Middle Ages* (1965), p. 89.

The Herefordshire School: Recent Discoveries

Richard K. Morris, F.S.A.
(University of Warwick)

All Saints, Billesley, near Stratford-on-Avon (Warwickshire), is a small aisleless church maintained by the Redundant Churches Fund. Most of its features belong to a remodelling of *c.* 1692 (V.C.H. *Warks.* iii (1945), p. 61), including the vestry adjoining the nave to the south, but recent archaeological investigation has confirmed that the nave is substantially medieval. In November, 1980, in the course of treatment to remedy decayed timberwork, Mr. Thurston of Bedford Timber Preservation noticed signs of carving in the wall behind a skirting board which he had removed from the west jamb of the arch between the vestry and the nave. With the help of the architect, Lyndon Cave of the Ancient Monuments Society, he stripped the plaster from the lower part of the jamb, to reveal a finely preserved carving, immediately identifiable as belonging to the Herefordshire School of sculpture of the mid twelfth century (pl. LXXX).

The carving is on a single block of oolitic limestone, probably from the north Cotswolds, slightly broken at the edges—maximum width, 41¾ in. (106 cm.); maximum height, 18 in. (45.7 cm.); thickness, 6½ in. (16.5 cm.). It had been re-used on its side as part of the seventeenth-century arch into the vestry, but it is fairly certain that originally it was a semi-circular tympanum, about 45 in. (114 cm.) wide, and 22½ in. (57 cm.) in radius. Represented on it are a dove (top left), a trousered figure typical of the Herefordshire School (centre), a large biped with scaly body (probably winged) and thick tail (top right), and a scaly serpent (bottom right), all set into a dense forest of acanthus interlace. No important carving appears to be missing from the tympanum, except the head of the biped.

In style, the tympanum is so close to the carvings on the font at Eardisley in western Herefordshire, dated *c.* 1150 by Professor Zarnecki, that they must be by the same hand. The theme of the trousered figure wrestling with foliage tendrils recurs there, and particularly close is the treatment of the sleeves, creating the effect of shoulder-pieces and elbow-pieces. The comparison with Eardisley

PLATE LXXX

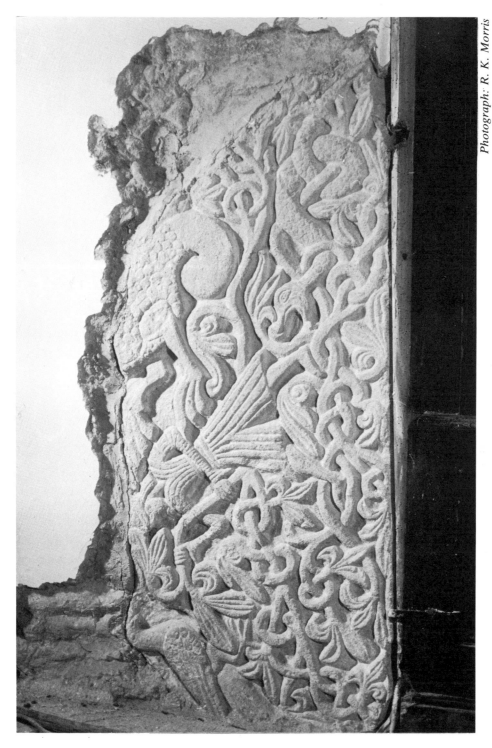

Photograph: R. K. Morris

All Saints Billesley, Warks.: re-used tympanum in west jamb of vestry arch (copyright: History of Art Department, University of Warwick)

PLATE LXXXI

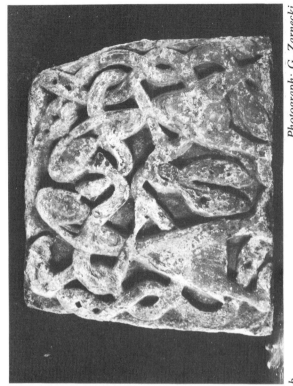

Photograph: G. Zarnecki

a. All Saints, Billesley, Warks.: fragment of Harrowing of Hell from blocked door in west wall of vestry (copyright: History of Art Department, University of Warwick)

b. Williams Bros. shop, Monmouth: Herefordshire School panel (copyright: Courtauld Institute)

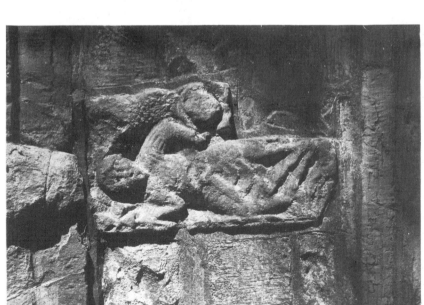

Photograph: R. K. Morris

a

b

extends to the other known piece of sculpture at Billesley, on the exterior of the vestry, which depicts the Harrowing of Hell (pl. LXXXI*a*)—very similar to the Harrowing scene on the font. Though this carving is very weathered, it is possible to make out in good light that the sleeve of Christ is treated in the same individual way as those of the figures on the tympanum and font.

The Billesley Harrowing is of oolitic limestone, presumably the same stone as that of the tympanum, and its maximum dimensions are approximately 21½ in. (54.6 cm.) high by 12¼ in. (31 cm.) wide. It has been cut down from a larger piece, probably another tympanum, and reset at an unknown date (after 1692) in the blocked west door of the vestry. It is possible that more of this tympanum may be discovered shortly, for another dressed block of oolitic limestone has been found directly above the trousered figure piece in the west jamb of the vestry, but lying horizontally so that any sculptured face is buried in the wall; however, as it is the same thickness as the trousered figure tympanum, there is every likelihood that it too is carved. Fortunately, an opportunity to investigate this possibility will be afforded, for the Redundant Churches Fund has agreed to the removal shortly of both carved tympana pieces from their respective locations, and their eventual resetting in a more suitable position in the church for better preservation and presentation.

Since the discoveries at Billesley, Professor Zarnecki has pointed out to this writer the existence of a previously unknown Herefordshire School panel in Monmouth, and has kindly allowed it to be published here for the first time (pl. LXXXI*b*). Unfortunately, its surface is very damaged, and most of the detail is lost; but the pose of the paired figures, apparently trousered and with caps and long hair, set amongst interlacing tendrils, is very reminiscent of the same figures on the Eardisley font. The piece is built into the Williams Bros. shop in Monmouth, and is reported to measure 18¾ in. (47.6 cm.) by 19 in. (48.2 cm.).

A more extensive publication of all the above carvings is planned by this writer at a future date, once investigations at Billesley have been completed.

Carved Stonework from Norton Priory, Cheshire

J. Patrick Greene

Introduction

Norton Priory was founded near Runcorn in Cheshire by the third baron of Halton, William fitz William, in 1134. Following a trial excavation by F. H. Thompson in 1970, excavation on a large scale was organised by Runcorn Development Corporation in 1971 and each succeeding year, directed by the writer (Greene 1972, 1974, 1980). Little was known about Norton Priory before excavation commenced, with the exception of the west range undercroft (discussed by Thompson, 1967). The undercroft contains a fine late twelfth-century Romanesque doorway, incorporated in a Victorian porch added to the undercroft in 1868 (the doorway is illustrated by a measured drawing in Crossley 1938, facing page 79; photographs in Thompson 1967, plate XIA; Pevsner and Hubbard 1971, plate 8 etc.).

The other important survival of the medieval period that Hugh Thompson was able to discuss and illustrate in his 1967 paper was the remarkable statue of St. Christopher carrying the Infant Christ, which has been dated to *c.* 1380–90 (Thompson 1967, 67 and plate XII).

Ten seasons of excavation and research have expanded knowledge of Norton Priory considerably. In spite of systematic post-Dissolution demolition and robbing of the monastic buildings, a substantial amount of carved and decorated stonework has come to light.

Twelfth century

Of particular interest amongst the objects associated with the primary buildings at Norton are two beak-head voussoirs (pl. LXXXIV*b*). One was found embedded in foundations that had been dug as part of a modification to the chapter house, so it is likely that the entrance to the chapter house from the cloister was originally

PLATE LXXXII

b. Sandstone head of canon

Norton Priory Cheshire: sculpture from mid thirteenth-
century cloister arcade

Photographs: Brian Williams

a. Sandstone head of woman

PLATE LXXXIII

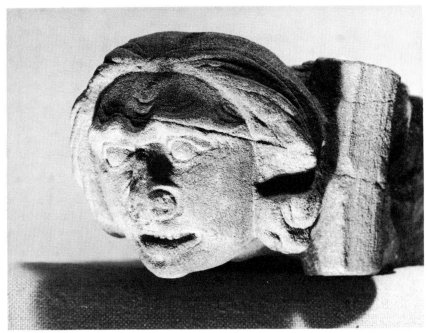

a. Sandstone head

b. Stiff leaf foliage

Norton Priory, Cheshire: sculpture from mid thirteenth-century cloister arcade

Photographs: Brian Williams

PLATE LXXXIV

b. Twelfth-century beak-head voussoir

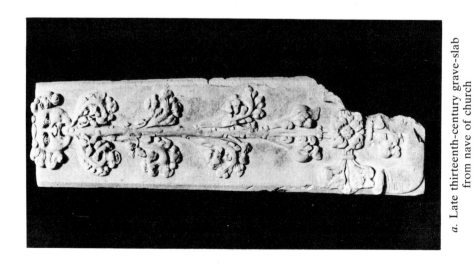

a. Late thirteenth-century grave-slab
from nave of church

Norton Priory, Cheshire

through a doorway embellished with beak-heads. The other beak-head was found near the original west door of the church, which may also therefore have had beak-head decoration. Beak-heads, although common east of the Pennines, are rare in the north-west—only one other place in Cheshire (Bruera) and one in Lancashire (Overton) have them (Henry and Zarnecki, 1958, fig. 8, p. 21).

Late twelfth century

Towards the end of the twelfth century, Norton Priory underwent a major rebuilding, apparently to permit an expansion in the number of canons. The south and west ranges were totally rebuilt, the cloister was expanded, the church extended to the east and west, a new chapter house was built, and the rere-dorter was doubled in size. Conservation work within the west range undercroft in 1974 revealed, quite unexpectedly, a superb survival of this period of expansion. The slype linking the cloister with the outer courtyard had been lined with a brick barrel vault in the eighteenth century. Removal of the brickwork revealed decorated blank arcading lining both sides. The arcading is round headed, with attached capitals and bases but free-standing shafts. The capitals show a great variety of forms, including volute, waterleaf, incurved-cone, and 'arum lily' types. The bases are of two types—one with water-holding torus mouldings, the other a simple chamfer, decorated in some cases with chevrons. The moulding of the arcade arches is different on each side of the two bays—two filleted profiles, one keeled, one bearing dog-tooth projections. The passage vault was pointed, with diagonal and transverse ribs (the crown is now missing).

Thirteenth century

Many fragments of a mid thirteenth-century cloister arcade, used as rubble when the cloister walk was rebuilt in the early sixteenth century, were recovered during its excavation. The arcade consisted of trefoil arches supported by triple shafts. The mouldings are deeply undercut, and the spandrels are embellished with relief figures. Those found include two women's heads (pl. LXXXII*a*), two heads of canons (pl. LXXXII*b*), a grotesque head (pl. LXXXIII*a*), various animals such as a monkey-headed serpent, and an otter-like beast. Other spandrels are adorned with stiff-leaf foliage (pl. LXXXIII*b*). From the same context came part of a seated figure (possibly Christ in Majesty), and some fragments of panels with relief figures, which presumably were set into the cloister walk walls. The Whalley Abbey annals recorded that in 1236 'the church and cloister of Norton are burnt'. It is likely that the trefoil arcade was erected as part of the process of repair. To the latter part of the century belongs a remarkable grave slab found in the nave; it depicts a tree of life issuing from the mouth of a semi-grotesque face (pl. LXXXIV*a*).

Fourteenth and fifteenth centuries

In about 1300 a large chapel was erected at the east end of the church, possibly to house the 'holy cross of Norton'. Window tracery from the robber trench of its

north wall demonstrates that it was of unusual design, with crocketed and cusped triangular canopies within the tracery. This can be paralleled in, for example, the east window of Merton College Chapel, Oxford.

Norton Priory was raised to the status of a Mitred Abbey in 1391 (Greene 1979). It is tempting to associate the St. Christopher statue with the elevation— was the opportunity taken to adopt a second patron saint at that time? The elevation certainly resulted in expansion of the abbot's accommodation with an apparently fifteenth-century tower house added to the west side of the west range. Conservation of the west range undercroft revealed the springing of a ribbed vault of the basement of the tower house. The springing was supported by a corbel in the form of an angel with outstretched wings.

Conclusion

The programme of work at Norton has resulted in the discovery of a substantial body of carved stonework, ranging in date from the twelfth to the fifteenth century. The collection has a particular interest in view of the relative paucity of decorated medieval stonework in the north-west. The quality of workmanship is generally of a high order—testimony to the substantial endowments that Norton received from local benefactor families.

BIBLIOGRAPHY

Crossley, F. H. 1938: 'Cheshire churches in the twelfth century', *Chester Arch. J.* xxxii, 73–97.
Greene, J. P. 1972, 1974, 1980: 'Norton Priory', *Current Archaeology*, 31, March 1972, 216–20; 43, March 1974, 246–50; and 70, January 1980, 343–9.
—— 1979: 'The elevation of Norton Priory, Cheshire, to the status of Mitred Abbey', *Trans. Hist. Soc. Lancashire and Cheshire*, cxxviii, 97–112.
Henry, F. and Zarnecki, G. 1958: 'Romanesque arches decorated with human and animal heads', *J.B.A.A.,* 3rd ser., xxi, 1–34.
Pevsner, N. and Hubbard, E. 1971: *Cheshire* (The Buildings of England).
Thompson, F. H. 1967: 'Norton Priory, near Runcorn, Cheshire', *Arch. J.* lxxiii, 62–8.

Glastonbury and Two Gothic Ivories in the United States

Neil Stratford, F.S.A.

In 1910 Bligh Bond excavated the undercroft of the refectory at Glastonbury, uncovering as he did so a number of fragments which appeared to have fallen from the room above and which he believed to have formed part of a screen across the east end of the refectory.[1] Whether some or all of these fragments, which he unfortunately failed to list, do indeed come from a screen remains to be seen when the Glastonbury sculpture has been properly inventoried and studied;[2] perhaps a monumental ensemble with figures in niches of the type of the Christchurch reredos would have been appropriate against the east wall of the refectory?[3] Be that as it may, some of the 1910 fragments are visible in a photograph published by Bligh Bond, who described them as "portions of three or four figures of seated ecclesiastics in full canonical dress".[4] Two of these can be identified from the photograph with fragmentary sculptures in the Abbey Museum (pl. LXXXVa,b), undoubtedly niche or wall sculptures for polygonal socles.[5] Although their original function is not certain and the building they adorned has been destroyed, they can be dated with some confidence within the first half of the fourteenth century.[6] But this confidence is based on a study of the mouldings of the seats of the two figures (fig. 21), rather than on any stylistic comparison with other stone sculpture in England; for in the present very imperfect state of knowledge about English Gothic sculpture, these Glastonbury figures seem isolated.[7]

Given that almost no Gothic ivories can be either localised or dated anywhere in Europe (the 'Grandisson ivories', divided between the British Museum and the Louvre, are virtually unique in this respect), the two Glastonbury figures assume a special importance. For the style of their drapery, its disposition even in many of the smallest details, the depth of their cutting and the pose of the figures is closely similar to that of two famous elephant ivory statuettes in the United States, one at Yale (pl. LXXXVIa),[8] the other in New York (pl. LXXXVIb).[9] These two ivory Virgins have with remarkable persistence been attributed to England and dated c.

PLATE LXXXV

b

a

a,b. Abbey Museum, Glastonbury: limestone figures

PLATE LXXXVI

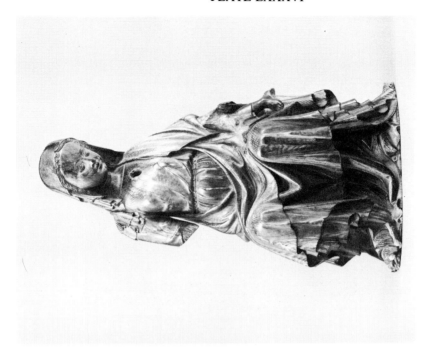

b. Metropolitan Museum of Art, New York (Cloisters Collection): ivory Virgin

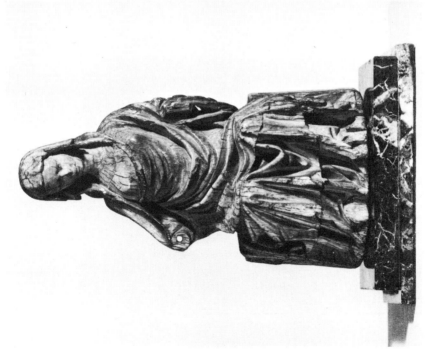

a. Yale University Art Gallery (Maitland F. Griggs Fund): ivory Virgin

PLATE LXXXVII

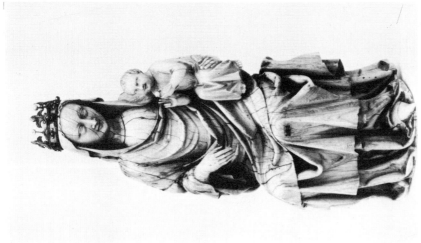

b. State Hermitage Museum, Leningrad: ivory Virgin and Child

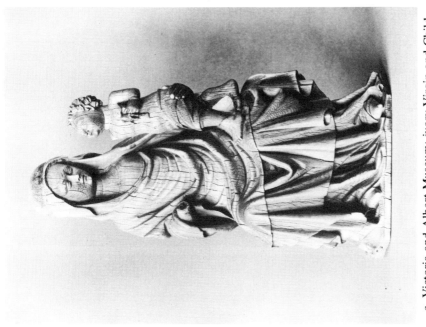

a. Victoria and Albert Museum: ivory Virgin and Child

PLATE LXXXVIII

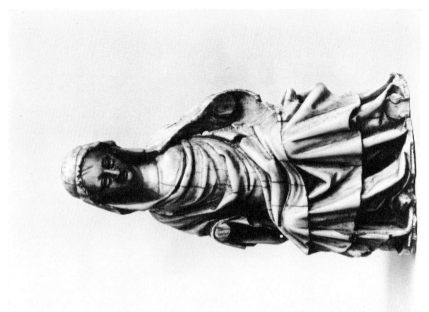

b. Musée du Louvre, Paris: ivory Virgin

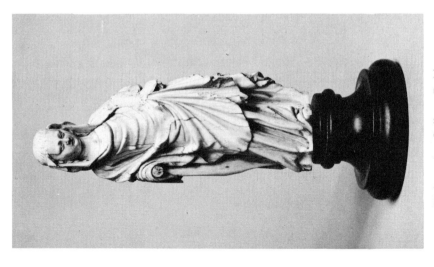

a. Walters Art Gallery, Baltimore: ivory Virgin

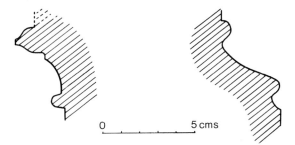

FIG. 21. Glastonbury: *left*, top moulding, and *right*, bottom
moulding of seats of sculptured fragments in Abbey Museum.

1300, but their attribution has never been accompanied by any very substantial
stylistic comparisons.[10] Indeed there are major stylistic differences between the
two pieces. The Yale statuette is carved with deeply cut draperies and modelled
with a vigour which is in marked contrast to the quiet, inward-looking dignity of its
pose. The New York Virgin is lyrical, less monumental, perhaps later in date.
Nevertheless both have common features with the Glastonbury fragments. This
Glastonbury link provides proof positive that the two ivories are English, in the
sense that their sculptors were probably English or at least worked in England or
could have received their training in an English milieu, or a combination of any
three of these virtues. A *caveat* however: the Glastonbury fragments are them-
selves difficult to relate to other English sculpture. For the time being, it would be
dangerous to consider them as specifically 'West Country', rather than say, 'Lon-
don'.

It may well be that the Yale and New York Virgins belong to a larger group,
which includes a beautiful Virgin and Child in the Victoria and Albert Museum
(pl. LXXXVIIa);[11] this ivory probably dates from the third quarter of the four-
teenth century. If the head is discounted as modern, a statuette in Leningrad (pl.
LXXXVIIb) is very close in style to the London Madonna.[12] Can these two ivories
perhaps be considered as French? In which case they are examples of how centres
like Paris were ready to absorb artistic ideas from areas such as England and
northern France in the second and third quarters of the fourteenth century, a
phenomenon which has long been recognised by historians of the manuscript
illumination of the period. A few wood sculptures in Sweden[13] could also be
related to the group and there are other ivories in Baltimore (pl. LXXXVIIIa)[14]
and the Louvre (pl. LXXXVIIIb),[15] which are by one and the same sculptor, who
was apparently a later product of the workshop of the Master of the Victoria and
Albert Madonna. It should also be noted that the particular configuration of deep
drapery folds in the skirt of the seated figures can still be found *c.* 1400, in French
Court circles (?).[16] But to introduce other works of art is to stray further from the
Glastonbury comparison, which it is the purpose of this note to stress. For if any
progress is to be made in grouping, dating and localising the vast *corpus* of
surviving Gothic ivories, a start must be made through precise comparison with
works of art in other media, for instance with the localised and dated manuscripts
and with monumental sculpture. Only in this way can the ground rules of attribu-
tion be changed. At present 'English' applied to a Gothic ivory invariably implies a

judgement of quality; 'Paris' is taken as the High Gothic norm, as indeed it may occasionally have been, whilst certain deviations in style, for instance a tendency to dislocation of the smooth parabolas of the drapery or a marked pathos or ferocity of expression are taken as signs of an essentially English provincialism. One has only to look at the great achievements of fourteenth-century England in the realms of architecture and sculpture to realise how false such criteria must be.

Taking manuscript painting and monumental sculpture, Madame Danielle Gaborit-Chopin has recently succeeded in refining for certain groups of ivories the old classifications, attributions and datings of Koechlin.[17] As English Gothic sculpture becomes better known and published, further light will no doubt be thrown on the ivory carvings of the period. Study of the English account rolls should also prove highly revealing.[18]

Acknowledgments

I would like to thank the following: Mr. W. J. Wedlake for his identification of the Glastonbury sculptures in the photograph of 1910–11; Dr. Richard Morris, Department of the History of Art, University of Warwick, for advice about fourteenth-century mouldings; Dr. William Wixom, Chairman, Department of Medieval Art, The Metropolitan Museum and The Cloisters, New York, and Mr. Paul Williamson, Assistant Keeper, Department of Sculpture, Victoria and Albert Museum, for providing the photographs published as pls. LXXXVI*b* and LXXXVII*a*; Mr. Nicholas Dawton for photographing the Glastonbury fragments for me and providing pl. LXXXV*a*. Above all to Madame Danielle Gaborit-Chopin, Conservateur au Département des Objets d'Art du Louvre, to Dr. Charles Little, Curator in the Department of Medieval Art of The Metropolitan Museum, and to Mr. Richard Randall, Director of The Walters Art Gallery, this short note is addressed as a 'gleaning', following our happy and instructive meetings during 1978–79, when we studied together the collections of Gothic ivories in Baltimore, New York, London and Paris.

NOTES

1. F. Bligh Bond, 'Glastonbury Abbey. Fourth report (1910–11) on the discoveries made during the excavations', *Proc. Somerset Arch. and Nat. Hist. Soc.* lvii, pt. II (1912), 74–85.
2. Mr. Warwick Rodwell has now been charged by The Trustees of Glastonbury Abbey with listing the Glastonbury collections for a new *lapidarium*; they have no system of numbering and no records are known to survive.
3. Compare the big Majesty relief of *c.* 1230–40 on the east wall of the refectory at Worcester, which was reused in the fourteenth century as part of a larger composition with niches; see N. Pevsner, *Worcestershire* (The Buildings of England, 1968), pl. 20. For the Christchurch reredos, see A. Gardner, *English Medieval Sculpture* (revised edn., 1951), fig. 436.
4. Bligh Bond, *op. cit.,* esp. p. 80 and photograph opp. p. 74.
5. Both are headless figures, carved in the local yellow Doulting limestone. They are seated on cushions. Their seats are plain, with simple mouldings, partly damaged, at top and bottom—see fig. 21. The backs of the figures and seats were never intended to be seen; there is a large hole for a metal attachment in the centre of the back of each seat: 1 (pl. LXXXV*a*)—H. 55 cm., W. of seat 32 cm., D of block 23.5 cm. 2 (pl. LXXXV*b*)—H. 43 cm., W. of seat 38 cm., D. of block 25 cm.

Although damaged, it is clear that both figures rested on polygonal bases or socles with a three-sided projecting top. Both figures are vested in full ecclesiastical dress as for mass, with alb, stole, dalmatic and chasuble; the ends of a maniple are visible against the throne (pl. LXXXV*a*, right).

[6] Bligh Bond (*op. cit.*, p. 81) implied that the refectory undercroft was of the period of the *aula*, begun by Abbot Fromond (1303–22), whereas it seems to have been of late twelfth-century date. Again, on p. 80, fig. 1, he illustrated a detail of a stone cornice with five-petalled roses, which he believed to have had projecting brackets on which the figures could have rested. Two sections of this "cornice" are exhibited in the Abbey Museum; they are clearly of the Perpendicular period, probably fifteenth-century. I have been unable to trace the evidence for the suggestion that they had projecting brackets, but in any case they cannot be contemporary with the two seated figures. As to the other elements mentioned by Bligh Bond as found in this area, none can now be identified with certainty, although there are a few Museum fragments of fourteenth-century blank tracery, which may also come from the 1910–11 excavations.

[7] The mouldings of the seats are very damaged and it is therefore difficult to take an accurate profile. However their general profile is clear. According to Richard Morris, the base may be compared, among West Country examples, to the bases of the retrochoir east piers at Wells (*c.* 1310–20?) and to the arcade bases of the Wells chancel (*c.* 1326–40?), whilst the type continues in use at, for example, Ottery St. Mary; see R. K. Morris, 'The development of later Gothic mouldings in England *c.* 1250–1400—Part II,' *Architectural History*, xxii (1979), 28–9 and fig. 17K. As for the capital with the roll-and-fillet moulding, it is very close to the capitals of the chancel arcade at Wells; and see also R. Morris, *op. cit.*, p. 23 and list for Variety (5) on p. 25. Dr. Morris's conclusion in the course of our correspondence may be quoted: "So Dec., *c.* 1325, give or take 10–15 years each way, looks very plausible".

[8] Yale University Art Gallery (Maitland F. Griggs Fund, 1956, 17.5). H. 17.7 cm., ex-Mathias Comor.

[9] New York, the Cloisters Collection (1979.402). H. 27.3 cm., ex- G. J. Demotte, New York; a Dublin collection. First exhibited Detroit Institute of Arts, *Catalogue of a Loan Exhibition of French Gothic Art* (1928), No. 69, where it is claimed that the ivory was "offered to Jean de Dormans at the time he was made Bishop of Lisieux in 1359".

[10] For the Yale ivory, see recently P. Verdier in Catalogue, *Art and the Courts. France and England from 1259 to 1328* (Ottawa 1972), No. 69 (England, *c.* 1300); D. Porter, *Ivory Carving in Later Medieval England, 1200–1400* (Ph.D. thesis, State University of New York at Binghamton, 1974—published University Microfilms International, Ann Arbor, Michigan), No. 32 and pp. 96ff. (English, *c.* 1300); L. D. Tabak in Catalogue, *Transformations of the Court Style. Gothic Art in Europe 1270 to 1330* (Museum of Art, Rhode Island School of Design, Providence, Rhode Island, 1977), No. 21 (England, *c.* 1300); D. Gaborit-Chopin, *Ivoires du Moyen Age* (Fribourg, 1978), pp. 159, 210 (no. 245) (Angleterre, début du XIVe s. (?)). The statuette has normally been considered part of a Coronation group but Tabak suggested plausibly that it may be a Virgin Annunciate. For the Cloisters Virgin, see Porter, *op. cit.*, No. 33 and pp. 96ff. (English, *c.* 1325); W. D. Wixom, in *Notable Acquisitions 1979–80* (The Metropolitan Museum of Art, New York, 1980), pp. 22–3 (English (London?), *c.* 1300).

[11] V. & A. 201–1867. Elephant ivory, seated Virgin and Child with bird, Virgin's hands lost, top of head cut for separate metal crown. H. 20.4 cm. Often published as English, but R. Koechlin, *Les Ivoires Gothiques Français* (Paris, 1924), No. 703, followed by M. H. Longhurst, *Catalogue of Carvings in Ivory, Part II* (Victoria and Albert Museum, 1929), p. 31, believed it to be "French, end of the fourteenth century". D. Gaborit-Chopin (*op. cit.*, p. 159) returns to the English attribution, with an advanced fourteenth-century date. As to another seated Virgin and Child in the V. & A. 204–1867, ill. Longhurst, *op. cit.*, pl. XXIX, its authenticity has been doubted (see J. Leeuwenberg, 'Early nineteenth-century Gothic ivories', *Aachener Kunstblätter*, xxxix (1969), 121, fig. 19), perhaps correctly, though Leeuwenberg goes further to claim the big V. & A. ivory (pl. LXXXVII*a*) as another fake; this is out of the question.

[12] State Hermitage Museum, ø 35. Koechlin (*op. cit.*, No. 704) agrees that the group in Leningrad, formerly in the Basilewsky collection, is virtually identical to the big V. & A. Virgin. I have not seen the Leningrad ivory, and am grateful to Mr. V. Suslov, Vice-Director of the Hermitage Museum for permission to publish it.

[13] See A. Andersson, *Medieval Wooden Sculpture in Sweden* (Stockholm/Uppsala), vol. ii (1966) and v (1964), particularly ii, figs. 54, 56a–b, 60; v, pls. 92–93, 96–97. Most of these sculptures are

placed by Andersson in the circle of the Bunge master, active in Gotland in the first quarter of the fourteenth century, though his style persisted until the middle of the century.

14 Baltimore, Walters Art Gallery 71.237. Elephant ivory, standing figure of the Virgin Mary, the left arm recut where the Christ Child has been broken off, top of head cut to receive separate metal crown now lost. H. 15.5 cm. See R. H. Randall, Jr., *Medieval Ivories in the Walters Art Gallery* (Baltimore, 1969), No. 20 (French (Paris), second half of the fourteenth century). The ivory was bought in 1914 (Gruel, Paris).

15 Louvre OA. 10004: Elephant ivory, seated Virgin, hand and Christ Child (?) lost, top of head cut for separate metal crown. H. 10.5 cm. See *Les Arts,* lix (novembre, 1906), ill. p. 31: ex-Claudius Côte. The statuette is said to come from the Cluniac nunnery of Marcigny (Saône-et-Loire), whose treasures were dispersed in November, 1793 (see J.-B. Derost, *Les Chroniques de Marcigny* (Mâcon, 1949), pp. 128–9). I know of two other fourteenth-century works of art in the United States, which are reputedly from Marcigny, a marble group of The Trinity in Portland, Oregon (Catalogue, *Art and the Courts, op. cit.,* in n. 10, No. 63) and a seated ivory Virgin and Child in Baltimore (71.286), ex-Claudius Côte. See however *Les Arts, loc. cit. sup.* ill. p. 32, where the Baltimore group is not given a Burgundian provenance.

16 *e.g.* the Burgos Cathedral jet and ivory Virgin and Child, ill. D. Gaborit-Chopin, *op. cit.,* No. 11; the monumental ivory Virgin and Child, ill. O. M. Dalton, *Catalogue of the Ivory Carvings of the Christian Era . . . of the British Museum* (London, 1909), No. 330, pl. LXXIV.

17 To give only two examples, see D. Gaborit-Chopin, *op. cit.,* pp. 143–5 (for a comparison of certain ivories of the so-called "group of the Soissons diptych" with the St. Eligius Roll from Noyon of mid thirteenth-century date), pp. 169–70 (for a comparison of the group of the Kremsmünster Master with the Mainz Cathedral portal of Madern Gerthner of *c.* 1425). See also C. T. Little, 'Ivoires et art gothique,' *Revue de l'Art* (1979), 58–67, for a similar approach.

18 Inventories seldom specify the origins of works of art, but account rolls can be more informative. For instance, I have recently been sent a reference from Miss Elizabeth Gue to a payment (36–37 Henry III (1251-2)) *'pro tribus libris et dimidio eboris ad faciendos imagines ad opus regine per manum Ricardi Scriptoris'.* 13s.5d. Robe and salary for Richard (PRO. E 101/349/18 (Queen Eleanor's household account)).

Epilogue

Let me first of all express our gratitude to the Society of Antiquaries for initiating this Seminar, to its President for opening and attending it and to its General Secretary for devoting so much of his time and energy to the details of the arrangements, the programme and the exhibition. Next, let me congratulate the three Chairmen who presided so ably over their respective sections. Above all, let me express my appreciation for the labours of those who presented us with the results of their research on various aspects of medieval sculpture.

Since much discussion has already taken place on the papers read to us today, it is unnecessary for me to comment any further on them. But I should like to say how heartening it is to see so much young talent devoted to the study of sculpture. Until comparatively recently, the book by Prior and Gardner, published in 1912, was still the last work on practically all aspects of English medieval sculpture. Fortunately, this is rapidly changing, since considerable advances have been made and there is promise of further thorough research in many directions.

Unfortunately, we are all working a little in the dark for lack of a *Corpus of Medieval Sculpture*. The Anglo-Saxon period is lucky in this respect for, as many of you will know, Professor Rosemary Cramp is heading a team of scholars, who are preparing a six-volume *Corpus*, to be published by the British Academy. Many years ago, together with Professor C. R. Dodwell, I was planning to work on a *Corpus of English Romanesque Sculpture*, but for various reasons, chiefly financial, this project had to be abandoned. I hope, however, to revive it before too long. In the meantime, a number of scholars are working on Romanesque sculpture in various counties, for instance in Yorkshire, Kent, Somerset, Cambridgeshire and Dorset, and their research can form part of a future *Corpus*. Gothic sculpture, for some obscure reason, was for a long time out of fashion and attracted little attention from scholars. But this is a thing of the past and much is also happening in this field.

Not only is our understanding of medieval sculpture better, but, thanks to excavations, new material, as some of the papers read today have demonstrated, is being discovered. Such discoveries will continue and there must be great surprises buried and awaiting the spade of the archaeologist. But discoveries can also be made above ground, and I will mention here one such case, which came to my notice, thanks to Mr. Richard Halsey. It is a mid twelfth-century figure of St. Michael (pl. LXXXIX*a*), the patron saint of the church at Mere in Wiltshire, which is in a niche over the north porch. The niche, with a rich fourteenth-century canopy, was obviously made especially for the figure so it was there for everybody to see for many centuries. How this figure, of very high quality, related to the reliefs on the outer doorway of Malmesbury Abbey, escaped the notice of scho-

217

lars, is difficult to understand. I am happy to report that thanks to local initiative, the figure is being cleaned and its preservation assured.

By far the most important event in the field of the conservation of medieval sculpture is the work at Wells Cathedral. Thanks to the enlightened policy of the Dean and Chapter, a committee of experts advises on various aspects of the work and it is hoped that the experience gained at Wells will be of lasting value for the whole country and even beyond. Unfortunately, not all those responsible for the care of churches are as enlightened as the Dean of Wells and his Chapter and, in many instances, important sculpture is allowed gradually to decay, without anybody bothering to take appropriate action to prevent it. The damage done to sculpture through indifference and neglect is great and widespread. No less depressing is the damage or even destruction through ignorance. Mr. Dufty and I were once asked to act as patrons for a restoration appeal of a well-known Romanesque church. To our dismay, we discovered that the restoration resulted in replacing weathered carvings of the tower by copies and the destruction of the originals. It was only under the threat of resignation that we prevented the replacement of the famous Romanesque doorways of this church.

It seems to be the general practice that restoration leads to replacement of sculpture by copies. It is arguable that in some cases this is permissible, provided the originals are preserved. This is, after all, what has been done in Strasbourg Cathedral and is being done at Chartres. Some years ago, a choir buttress of York Minster was replaced and the carved monsters copied, but the originals were sold for rockeries or any other use. A splendid fourteenth-century sculpture from this buttress is in the Courtauld Institute (pl. LXXXIX*b*)—a better location than a rockery but how much more appropriate it would have been if it had been kept in the Minster, for instance in the splendid Museum recently created under the building.

One can argue that selling unwanted sculpture is better than storing it in some corner of a churchyard, where it is soon overgrown, decaying and frequently used to fill holes in paths and roads. And yet many such pieces of sculpture, when cleaned and placed in an appropriate location, could not only be preserved but also provide an added attraction to the church. Many years ago, visiting a church in Somerset, I found a good Romanesque corbel head in the churchyard, and not being able to find anybody about, I carried the stone to the vestry and left a note, apologizing and explaining that this piece was of considerable importance and should be preserved. Two years later I found the corbel again in the churchyard and, with the incumbent's consent, I took it to the Courtauld Institute where it decorates, rather absurdly, the window-sill of the Conway Library, beside the grotesque figure from York Minster.

I speak about this with some bitterness because for a long time I have been trying to persuade various authorities to set aside storage space, for instance a disused church, for such unwanted pieces of sculpture or architectural features, where they can be available for study on request. I was promised many empty churches but given none. It is true that I was offered a church in London on condition that I spent £30,000 on repairing the roof and paid £3,000 a year rent. Obviously, the time has not yet come for the creation of such a rescue centre for sculpture and, in the meantime, much is being dispersed and destroyed.

Apart from one or two museums such as at York, Salisbury and Reading, the

PLATE LXXXIX

Photograph: Courtauld Institute

a. Mere, Wilts: twelfth-century figure of St. Michael in niche over north porch

b. York Minster: fourteenth-century figure of monster from choir buttress (now in Courtauld Institute)

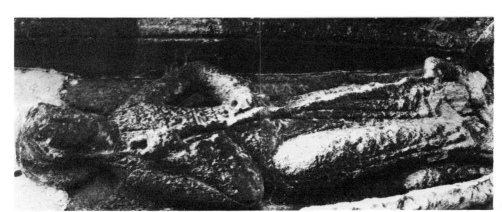

a

b

most important collections of English medieval sculpture are to be found in cathedrals. Not all church authorities appreciate such possessions and, for instance, sculpture found in excavations in one cathedral building has been transferred to the local museum. There would be nothing wrong in this, but the transfer was carried out without any supervision and two lorry loads of sculpture were tipped out with predictable results. Other cathedrals, proud of their heritage, plan to display their sculpture in proper conditions. This is about to happen at Winchester and, I am told, a diocesan museum is planned at Hereford. If this is true, it would be a most welcome development.

The recent exhibition, *Sculpture from Norwich Cathedral*, in the Sainsbury Centre for Visual Arts gave a good idea of how an intelligent and tasteful display of sculptural fragments can be both exciting and teach us a great deal. Alas, once the exhibition was over, the fragments were returned to their obscurity in the cathedral's triforium with a few pieces used as forlorn ornaments in the cafeteria.

The object of my talk is to put everybody on the alert to do all we can to ensure that sculpture is not allowed to decay, or be destroyed through negligence or ignorance. Scholarly research in the field of sculpture should go side by side with the conservation and preservation of sculpture, otherwise future generations will be left with no option but to study photographs of originals no longer in existence.

GEORGE ZARNECKI

Index

Compiled by PHOEBE M. PROCTER

221

Old Sarum (Hants), cat masks from, 96

Ornament: pre-Conquest: animal, 16, 18, 19, 20, 22, 35, 36, 41, 44, 50, 178, 180; bird, 13, 16, 20; figures, 20, 29, 30, 33, 34; interlace: abstract English, 5, 20, 22, 35, 36, Irish, 3, 5–16; inhabited, 18, 22; plant: acanthus, 22, 28, 29, 30; bush, or tree scroll, 20, 22, 28, 29, 43, 44, 45, 46; flower, two-petalled (trefoil), 46, 49–50; vine scroll, inhabited, 16, 30, 34, 36. Romanesque: animal, cats heads, 87, 96, lion 190, 194, monkey-devil, 95; annulets, 85, 86; arcading, 71, 85; archery, 57; chevron, 71, 73, 74, 95; drapery, 58, 87; figures, 58, 71, 73, 86; foliage, 67 (acanthus), 194–5; fruit and flowers, 58, 85, 86, (trefoil) 58, 95; geometric, 71, 73, 96; medallion chain, 194; mouldings, dice and billet, 67, beaded fillet, 194, keeled, 67; polychromy, 74, 85, 86, 87, 95, 190; 'Union Jack', 85. Gothic: animals and birds, 103, 206, 198, (beak-heads) 202, 206; chevrons, 103, 206; drapery, 101, 115, 125, 126, 127, 143, 144, 145, 175, 208, 213, 214; faces, 166, 174–5; figures, 100–15, 165–6, 174–5, 198, 201, (angels) 123, 125, 127, 128, 143, 144, (caryatids) 102, 115, 126, 143, 144, 152; (musicians) 125; flower and foliage, 103, 104, 113, 123, 124, 125, 128, 152, 198, 206 (ball-flower) 143, 144; mouldings, 125, 127, 206, 208, (wave) 163; nailhead and trellis rolls, 104; naturalism, 166, 174; polychromy, 102, 103, 122, 123, 165

Oswald, St., relics of, brought to Gloucester, 41

Otley (Yorks.), pre-Conquest crosses at, 180; Viking piece from, 186

Oviedo (Spain), 12th-century figures from, 102

Oxford: Ashmolean Museum, pre-Conquest slab from, 45; Bodleian Library, 12th-century MSS. from St. Albans in, 86, 195; Merton College Chapel, east window, 207; New Examination Schools, 10th-century grave slab from, 28

Pächt, Otto, cited, 195

Page, William, and Sir Charles Peers, cited, 193

Paris, Louvre, ivory Virgin and Child in, 213

Patrington (Yorks.): Gothic ornament at, 125, 128; Madonna figure at, 145

Paul de Caen, Abbot, work at St. Albans of, 71, 192, 193

Peers, Sir Charles, cited, 32; see also Page, William

Penshurst (Kent), wooden figures at, 174

Percy tomb, Beverley Minster, 122–46; possible attributions of, 124

Pevsner, Sir Nikolaus, Buildings of England by, cited, 99

Phillips, Derek, excavations at York Minster by, 178

Philp, B. J., on Reculver, cited, 32

Pitney brooch, the, 57

Plummer, Miss Pauline, cited, 174

Potesgrave, Richard de, 152

Poulson, G., cited, 127

Preston-by-Faversham (Kent), pre-Conquest cross shaft from, 36, 37

Prior, E. S., and A. Gardner, cited, 98, 122, 126, 128, 143, 144, 146

Priors Barton, Winchester (Hants.), Anglo-Saxon shaft fragment from, 22, 28, 30

Prophet figures, 114

'Raehabul', runic inscription, Sandwich, 30

Ramsbury (Wilts.), Anglo-Saxon sculpture from, 18

Reading (Berks.): carved shafts at, 86; Romanesque trefoil motif from, 58

Reculver (Kent): 7th-century columns from, 30; drum-built shaft fragments from, 30–5, 36

Redundant Churches Fund, Billesley maintained by, 198, 201

Rheims (Marne): decorative heads at, 174; jamb figures at, 115

Rites of Durham, cited, 96

Robert of Gorham, Abbot, work at St. Albans by, 71, 74, 85, 86, 193, 194, 196

Robert of the Chamber, monk at St. Albans and father of pope Adrian IV, 74